THE ART OF
BILL VIOLA

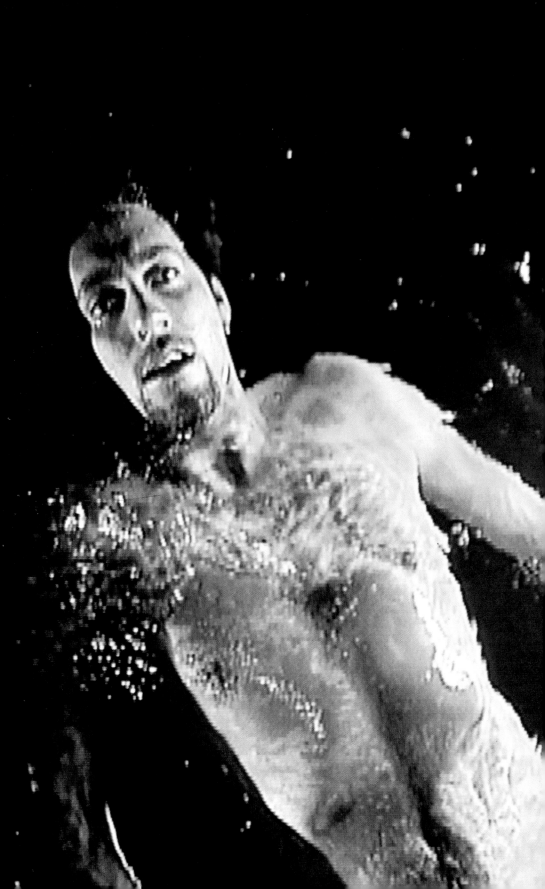

THE ART OF
BILL VIOLA

edited by

Chris Townsend

with 60 illustrations, 55 in color

 Thames & Hudson

CONTENTS

Frontispiece
The Messenger, 1996 (detail)
Video/sound installation
(Photo: Kira Perov)

First published in 2004 in paperback in
the United States of America by Thames &
Hudson Inc., 500 Fifth Avenue, New York,
New York 10110

thamesandhudsonusa.com

Library of Congress Catalog Card Number
2003111309

ISBN 0-500-28472-5

Printed and bound in Singapore

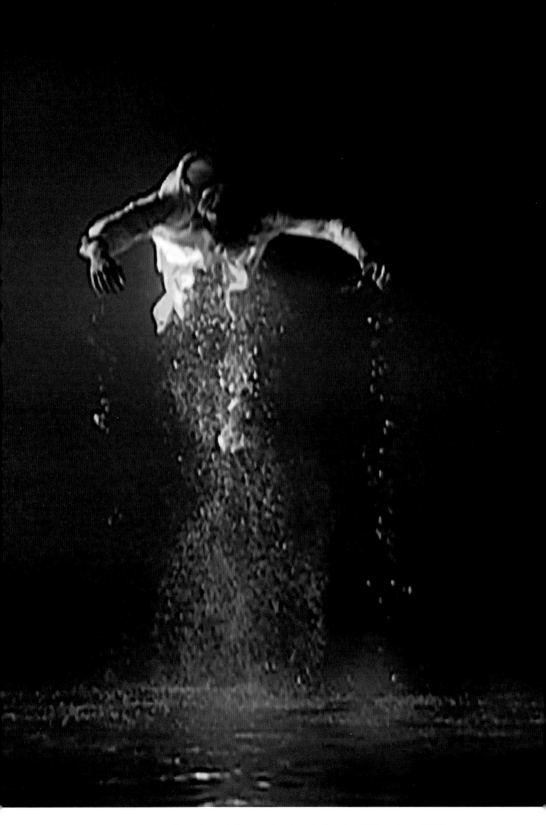

1 'Ascending Angel' from *Five Angels for the Millennium*, 2001

INTRODUCTION

CALL ME OLD-FASHIONED, BUT...

Meaning, Singularity and Transcendence in the Work of Bill Viola

CHRIS TOWNSEND

'We do no harm in wishing to show the invisible by means of the visible.'

Gregory the Great, Lib. IX, Epistola LII Ad Secundinum

There is a story about Bill Viola's installation of *Five Angels for the Millennium* (1) at Anthony d'Offay Gallery in 2001 which, whether or not it is apocryphal, is revealing of the artist's singular popularity. Seeing the crowds who had flocked into the complex of spaces just below London's Oxford Street that made up the gallery at that time, d'Offay is alleged to have said: 'I shouldn't be putting this on, this is the Tate's job.' The numbers attending that show may be as difficult to confirm as the story, but former d'Offay employees estimate as many as 40,000 in a couple of months: a quite ridiculous number of visitors to a commercial exhibition, and a figure that most curators in public institutions would yearn to achieve. From my own visits, I would attest that people were often sitting three or four deep in front of some screens, and that many of them appeared to have come to spend a considerable amount of time in the exhibition. That is, the duration of their attention to the work at least reflected the duration of those works: they had not come for a quick glance at an image.

Anthony d'Offay was quite right (and during 2002 the Tate, in partnership with the Centre Georges Pompidou and the Whitney Museum of American Art, indeed purchased *Five Angels*); he needed only four hundred visitors to his space, provided they were influential critics, curators or collectors. No matter that they are often a useful window on the work of artists who have yet to receive institutional approval, commercial galleries are not established to sate a general public appetite, nor are they usually in a position to provide the kind of scholarship that 'explains' works of

art to a public. That there is, and has been for nearly two decades, an enormous appetite for Bill Viola's work at galleries throughout the world is a given fact. What is a more intriguing aspect of that fact is the extent to which Viola's works both resist and, I'd suggest, don't necessarily need, the kind of explanation that art institutions feel obliged to provide. This is not to suggest that the artist's works are simplistic. The essays that follow suggest an extraordinary degree of depth, of rich complexity and of compositional sense, both in the individual work and in the oeuvre as a whole, that would undermine such a proposition. However, these are works that connect with their audience in ways that are as much visceral or emotional as they are intellectual. If anything, it's the sedulously modulated, often banal, explanations offered by what Dave Hickey categorizes as 'the therapeutic institution' that are inadequate to the work at hand.[1]

Viola's art, if it is anything, is an art of affect. It is rare, at least in the kind of museums and galleries that I visit, to witness anyone weeping before a work of art. Yet at almost every Bill Viola exhibition that I have visited I have seen either someone in tears, or else so profoundly moved that, but for the mores that bound crying in public in Northern Europe, they might as well have been. And crying (at least on those rare occasions I have experienced it as an adult: Colline's farewell to his old coat in *La Bohème*, which gets me every time; learning that my dearest friend – a woman with whom I endured the direst production of that opera – had survived 9/11) seems to me the corporeal consequence of a complex set of emotional and intellectual stimuli that can no longer be readily accommodated within those registers. For all its obsession with 'liminality' and 'transgression', modern art rarely takes us to such limits, far less exceeds them. Cynthia Freeland, no stranger herself to weeping in front of Viola's 'The Passions', introduces the now rather unfashionable philosophical category of the sublime as a means of appraising the artist's oeuvre. For Freeland, there is in Viola's work a quality of 'aboutness', a sense of force and presence, that engulfs our faculties, but which nonetheless stimulates other sensibilities. The sublime is not simply a terrifying phenomenon, but rather one that moves and uplifts us even as it puts us in awe of its spectacle. This relationship to the sublime is something that gives Viola a commonality with those mid-twenti-

eth-century American painters such as Mark Rothko and Barnett Newman, who sought similar effects. And there is something about Viola's art, despite its appeal to universal spiritual values, that is distinctively 'American': something that is recognized, perhaps with a degree of ironic naivety, by the young Russian artists described here by Antonio Geusa in their initial encounters with his oeuvre.

We might characterize Bill Viola's work, therefore, as 'excessive': not only does its scale of presentation increasingly tend towards the grandiose, but the effects of encountering it may exceed our capacity to contain our responses. His, then, is an oeuvre that challenges two tendencies in contemporary art: firstly the refusal of emotion and a concomitant privileging of intellectual response; secondly the careful regulation of portion-controlled 'meaning' that is often doled out to art's audiences. (And yes, I'd go so far as to say that this volume, even in its 60,000 words or more, remains limited in its response to Viola's work.) If it undermines one pole of that simple binary between emotionalism and intellectualism, if at first it seems to resist critique, Viola's work nonetheless sustains careful and even difficult analysis.

There has been an insistent, if subordinate, strain in modern art – most often manifested in less satisfactory depictions of bohemia than that of Puccini, Giacosa and Illica, I'd suggest – which succeeds largely through the solicitation of pathos by and for its subjects. Consider, for example, work as diverse as the sad saltimbanques and harlequins of Picasso's Blue Period; the left-bank habitués of Ed van der Elsken; the East Village denizens of Nan Goldin's work from the late 1970s and early 1980s; and that entire body of contemporary 'pity me' art, so often autobiographical, so often body-centred, so often 'political', that is equally so wonderfully debunked in the work of Cary S. Leibowitz (a.k.a. Candyass). This is art that depends upon the viewer's sympathy, the 'movement' of its audience, as much as any genre painting by Jean-Baptiste Greuze elicits a 'dangerous communion' with the suffering but seductive body of the other.[2] Greuze's *La Piété filiale* of 1763, did, after all, move its audience to tears.[3]

Viola's work clearly rises above this ontology of pathos. Even with a series such as 'The Passions', as Freeland observes, what motivates empathy in the spectator here is not the imaginary bridging of difference, but rather a recognition of mutual experi-

9

ence. But neither does Viola's work fit the requirements of an art that necessitates nothing more than intellectual appraisal, an art whose apprehension is perhaps only fully achieved in critical activity and which therefore is restricted in its appeal to those with enough time on their hands, such as academics, to realize its implications. There are some works of art that are better written about than seen, though that writing may be only marginally more or less accessible than the art in question. There is a great deal of contemporary art where, through the cultural attenuation of its capacity to apprehend images, to understand historical contexts, to think critically for itself, an audience is thrown back upon the hermeneutical activity of specialists who tell it what to think, how to feel. Without wishing to undermine the activity of the contributors to this volume – whose essays, precisely because they do not tell you what to think or how to feel, will enrich your encounter with Viola's art – I would say that one of the joys of Bill Viola's work is that it is capable of grabbing its audience's attention without platitudinous explanation: it works on you at a visceral level. You have to see it.

Viola's is an art for 'everyman', rather than for cognoscenti; an art of affect rather than distanced appraisal, but not an art of pathos; an art of duration and absorption rather than of immediate satisfactions and revelation; an art that refuses the spectator control over the image, but which embeds its audience within its structures – an art, then, that refuses transcendence to the spectator, but which attracts us by its own inquiry into transcendence. As several contributors to this volume stress, Viola's is an art that addresses 'big issues' – that life, death, 'why are we here?' stuff – and addresses them without the kind of embarrassment or self-referential sense of parody manifested by this sentence. But those are, of course, the kind of questions that 'everyman' continues to ask up to death.

In general, then, aspects of Viola's work run counter to the dominant tendencies not just in Western art history since the mid-nineteenth century, but, I'd argue, counter to the dominant tendencies in the relation of spectators to visual subjects in general, over much the same period. Viola is concerned with the meaning of art, or more strictly with the role of art in life's continuing, and never satisfied, search for meaning. It's no longer fashionable to look for meaning in art, apparently.[4] (A situation that solicits the question of what much contemporary art might be providing

instead, since it's clearly not concerned with either visual pleasure or the elevation of technique for its own sake, nor even with an effective critique of history.) Dave Hickey suggests that prior to the decisive rhetorical displacements of modernism, 'pictures were made primarily *for* people, not against them'.[5] In the age of bourgeois capitalism that turn might have been justified, but Viola's work, in the response it generates from its audience as well as in the rhetorical forms it deploys, suggests it is an art *for* people; a project counter to the modernist endeavour. Yet, despite this 'conservative' strain, Viola's art is produced within the most innovative, most con-temporary of media. The technological apotheoses of modern image-making – video, the plasma screen, sophisticated recording, and relation of sound and image – are put to use, in part, against what are apparently the prevailing intellectual and artistic traditions of the last one hundred and fifty years. Viola's success in this project suggests that human beings are perhaps older, wiser and slower than their technological innovations, or indeed their art movements; suggests that despite all that change which art sought to justify, represent and allegorize, we've changed less than we imagine. (Or if you are an ideological cynic, you might suggest that 'we' (itself a questionable collectivism) have evolved the kind of constraints that allow 'us' to disavow change, even as 'we' make it.)[6]

Viola's strategy here, with its emphases on affect, on pleasure in looking and on the pursuit of profound spiritual meanings, is largely at odds with the dominant tenets of the institutional forces – such as museums, universities and art colleges, and governmental organizations – that have increasingly shaped the public reception of art in the West for half a century. But this has not undermined Viola's enormously popularity, both with a general audience, and with museum directors and curators. This is art that escapes those institutional forces that seek 'to neutralize the rhetorical force of contemporary images',[7] and nonetheless is enthusiastically endorsed by those institutions. One purpose of this book is, however tangentially, to explain this dichotomy through examinations of content, technique and historical context.

To understand the degree to which Viola's work runs counter to the temporal and absorptive characteristics of art, and of a wider domain of visual imagery, since

the early nineteenth century, we need to return to those members of the audience in Anthony d'Offay's gallery in July 2001, who had brought coffee and sandwiches with them; who had, in some cases quite literally, settled in for the duration. So riddled with contradictions and paradoxes is this historical trajectory – that of the nature of attentiveness – that it is not easy to elucidate it within a single book, far less a single paragraph. However, we might argue that one feature of the culture of modernity is a lessening of critical attentiveness, and that this diminution of attention goes hand in hand with the emergence of spectacular technologies that not only substitute for real experience in the perceptive capacities of the individual, but which promise him or her transcendence over that reality. Putting it bluntly, we're a lot less prepared to spend time scrutinizing or experiencing phenomena when their analogues are on offer. The matter is far more complex than that, and we can argue, as Jonathan Crary does, that 'modern distraction can only be understood through its reciprocal relation to the rise of attentive norms and practices'.[8]

We can characterize the post-Enlightenment evolution of visual modes within culture in terms of spectacle. (Things get bigger: consider the shift from the Panorama in the 1800s through ever larger cinema screens up to the IMAX; consider also the ever growing width of the TV screen – it's no longer a box in the corner, now it's half a wall.) We can at the same time understand this schematic history in terms of verisimilitude. (Things get realer: a Panorama may look real, but it cannot make the same claims on the recording of presence as the photograph or the film). We have not yet, and hopefully never will, reach the state satirized in *Brave New World*, but Aldous Huxley's 'feelies' are a chilling reminder of the blind aspirations of mediation within modernity: the substitution of its wholly convincing analogue for reality, with the added guarantee of spectatorial control. In such a scenario, you witness the world without really experiencing it; and though you may be absorbed by this world, you do not pay critical attention to it.[9] Crary suggests that 'spectacular culture is not founded on the necessity of making a subject see, but rather on strategies in which individuals are isolated, separated, and inhabit time as disempowered'.[10] In the same moment as the mode of seeing promises you transcendence (you believe you're in control), it removes your critical faculties (believe

me, you're not). Attentive in one place, whether the factory or the office; elsewhere you need only be absorbed by spectacle.

Viola, however, seems to proffer an archaic mode of visual engagement – you have to spend a long time looking at many of his works for them to be properly apprehended, even if he does not necessarily offer a new model of critical apprehension, and even if, as we'll see, he persistently makes his works spectacular. As Otto Neumaier points out in his essay, a work such as *To Pray Without Ceasing*, 1992, 'is impossible to grasp... in its temporal totality because, as a matter of practicality, no one will devote twelve hours to watching an entire projection cycle'. Yet Viola's mode of engagement is effected with precisely that technology that promises the most authentic simulacrum of reality and, therefore, perhaps the least attentiveness from its audience. His media are the most sophisticated products of that technological impulse to arrest and replicate the world, which first manifests itself in the camera obscura, and which evolves through photography, sound recording and film. Central to his project, then, is the use of the technology of spectacle against one of its historically manifested aspirations. Again, we might cite *To Pray Without Ceasing* as an example: a work whose 'visual perceptibility (the very feature we primarily expect from the medium of video) is reduced to almost zero for much of the time'. Perhaps more than any other artist who has used video as their medium, Viola is conscious of the subversive effects of temporality against the post-Enlightenment tradition of immediate satisfaction. In his own essay 'Video Black', he writes of 'a video camera that has not been shut off for the last twenty years... In another society, this camera, with its accumulated existence would be graduated to an object of power to be venerated and reciprocated.'[11] Within Viola's art you cannot only be absorbed; the work demands your attention, although at times the work deliberately seeks to counter absorption. The organization of time and space is crucial to this activity, as Neumaier demonstrates in his overview of their treatment in Viola's oeuvre.

Bill Viola's installations have been hugely important in the emergence of video art as an international art form. One might, in the terms of Jonathan Lahey Dronsfield's critique, see the euphoric institutional reception of Viola as a recuperation of video art's critique of art as object – another aspect of that embrace which

has institutionalized Marcel Duchamp's and Piero Manzoni's critiques of art's institutions together with 1960s Conceptualism. Those media and strategies that sought to subvert the dominant politics of exhibition have been brought back under the aegis of the institution through their presentation as spectacle or as object of specialized knowledge. We might understand Viola's work as part of this process. His recent works are spectaculars: the result of work by large-scale production teams, with experience in other fields of spectacular culture. A Viola work involves not only 'the artist', but cameramen, lighting operators, production designers, wardrobe assistants and production managers: all the logistical support of the feature film. Viola is not alone in this of course; nor is he the only video artist whose recent scale of production has been the singular, epic installation. We might compare the logistical organization of his output to that of Doug Aitken, Pipilotti Rist, or Isaac Julien. What differs is that Viola offers a radically different content – a profound spiritual reflection – from any other contemporary artist working in this way. The form seemingly remains the same, but the message is changed. What all these artists do seem to be doing, however, is re-investing the work of art with presence, with what Walter Benjamin called 'aura'.[12] You have to see and feel installation art: its effects, its affect, cannot be mediated in secondary forms; it cannot exist beyond the singular work, or at most the limited edition. Benjamin believed that what vitiated 'aura' was the invention of mechanical reproduction of the image – there could be no 'aura' for a film or photograph, infinitely reproducible. First generation video artists celebrated this removal of the veil of 'presence': an installation such as Richard Kriesche's *Wirklichkeit gegen Wirklichkeit*, 1977, for example, both literalizes it and ironizes it as the artist stands reading a copy of Benjamin's essay beside a TV monitor that shows him reading Benjamin's essay. But current artists of video and installation achieve an aura for art which is made in exactly those media, and their evolutionary forms, that Benjamin saw as subversive of such an effect.

If Viola wants us to revert to an older way of seeing and experiencing art, such a step backwards does not in itself bring a challenging way of thinking critically about the meaning and context of images. The auratic affect of the work may overwhelm any other response except awe (a point elucidated in this volume in Jonathan

Lahey Dronsfield's perceptive critique of the artist's work). In Viola's case, however, I'd suggest that it is the very act of seeing in this way, of experiencing auratic effects, of connecting artistic representation to questions of spirituality, that is itself critical and, strangely, 'political'. Even allowing for a recent resurgence, the representation and examination of the 'spiritual' has been largely off-limits to artists since the deaths of Kandinsky and Rothko, and, despite a few exhibitions lately, I'd suggest that there is a corresponding critical interdiction on the topic. To create works that have a spiritual affect, at a time when the institutionally approved styles of contemporary art have been almost wholly directed towards secular and cerebral discourses, seems to me not only subversive but extremely brave.

For Jonathan Lahey Dronsfield, 'bravery' is perhaps not enough. This is a sharp challenge to Viola's work, undertaken in the context of a debate over responsibility in art that is his wider project. Lahey Dronsfield astutely diagnoses that Viola's return to an art of aura and symbolic values is not necessarily a responsible critique of the language of art that he abandons. Viola, he asserts, substitutes one language for another, reverts back to an older rhetoric, emphasizing its 'truth' to the human condition rather than analyzing the search for truth as an aspect of that condition. To assert the spiritual in this way, according to Lahey Dronsfield, is to foreclose the possibility of the spectators' participation *in* the artwork. You may be witnessing a spectacle with a rhetorical form that is radically different to the one proposed by the dominant discourses of contemporary art, but it is nonetheless a spectacle that takes your breath away, and, perhaps with it, your critical faculties.

For David Morgan, like Lahey Dronsfield, the issue of the body – the one seen and the one doing the seeing – is vital to video art. At first, it seems as though the one aspect of Viola's work on which the two might agree is its fascination with what Morgan calls 'the epic sandwiched in the ordinary'. But ultimately both agree on the theatricality of Viola's work: for Morgan 'much of [the] oeuvre is best described as Baroque'; elsewhere he examines debts to the Wagnerian *Gesamtkunstwerk* and Romanticism. Morgan, though, diagnoses a different intention at work in the installations. As he puts it, Viola 'is intrigued by the power of estrangement to illuminate'. The act of estrangement is to take the spectator out of the world and put him not

15

in a helpless passivity where no questions are ever asked, but rather in a place where he may meditate. Viola, then, seeks to 'repristinate' secular culture through work that is, at its core, redemptive. It offers us a second chance, another way to see the time and space in which we live.

Perhaps one of Viola's most distinctive and spectacular effects in recent years has been his use of extreme slow motion. In her essay on *The Greeting*, 1995, Jean Wainwright shows how this extension of the moment works against the climate of brevity and temporal verisimilitude that characterized industrial modernity, despite the attempt by modernism – at its best in the works of Proust and Joyce – to vitiate the notions of a standard structure and mode of time. Time in the nineteenth century, before the interventions of Einstein and Bergson, was imagined as uniform in its direction and constant in its pacing.[13] Even now, for most people, most of the time, that's how we still experience it; whether it's in the TV schedules or the requirement to be at work or, if you're lucky, to catch a train at a particular hour. It's worth remembering that in order to achieve a high-quality image at slow projection speed, Viola shot *The Greeting* on high-speed film, rather than video. However, that technical demand might, in the context of the work, be understood to have a symbolic value. Film emerges from a discourse that stresses the atomist theory of time, where it is understood as composed of infinitely small yet consistently sized units. With its insistence on a regular division of time into representational space, whether 16 or 24 frames per second, we might understand film as having a one-to-one correspondence to such units. But in *The Greeting* Viola is, once again, working with the materials of modernity against the very notions that both spawned his media and towards which their sense of reality has contributed.

Modernity's conception of linear, uniform time is anathematic to Viola's practice, and to his ideas of human spirituality. What we see in *The Greeting* is the extension of the significant moment: where the density of life so sediments the flow of time that it slows to an almost imperceptible process. Paradoxically, Viola could not so easily achieve this reversion to what is, more or less, a medieval idea of time, without using film. As Wainwright points out, if, in works such as Duchamp's *Nude Descending a Staircase* or Balla's *Dynamism of a Dog on a Leash*, modernist

painters sought to translate the dynamic effects of film into painting, Viola seeks to translate the stasis of painting into film.

The complexity of space in Viola's work is the subject of Chris Townsend's detailed consideration of *Room for St. John of the Cross*, 1983. Here, Viola uses space as a narrative element to confuse the apparently straightforward polarities of private and public domains, interiority and exteriority, and, one might add, private religious faith and its public manifestation. Comparative studies of video works that stress their affinities to a tradition of practice within the newly emergent medium are still rare. Central to Townsend's argument is a discussion of the way in which Viola puts to work the self-reflexive acknowledgment of space and time, a staple theme within the post-minimalist use of video in the late 1960s and early 1970s. There, the most important task for this strategy is the highlighting to the spectator of their role in the artwork. In *Room for St. John*, however, Viola skilfully embeds this critique of the relation of spectator to art within a narrative space, one in which the elements have symbolic values. This occlusion allows Viola to 'move' the spectating subject within the narrative of the work, as well as 'moving' them through identification with the ostensible subject of the piece.

17

Just how Viola works through such carefully thought out strategies, the rhetoric of the installation, becomes the topic of Rhys Davies's essay on the use of sound. Davies isolates a single component in a complex mix. As a young artist Viola emerged in an era when video, as a nascent art form, was often limited by its technology, as much as by any necessarily self-reflexive acknowledgment of 'realism' within low-grade production values. One strand of thought by artists of this era concerned video's inherently democratic, anti-authoritarian potential: video could subvert both the unique status of the art object and the controlling effects of mass culture through its capacity for reproducibility and broadcast, whether in the multiple copy or the local and alternative TV station. (As Nam June Paik put it so succinctly: 'Television has been attacking us all our lives, now it's time to attack it back.') That ethos led to a type of video production – beginning with the work in Howard Wise's 1969 exhibition 'TV as a Creative Medium' – that was immediate and cheaply made, and that aimed to use television for the dissemination of

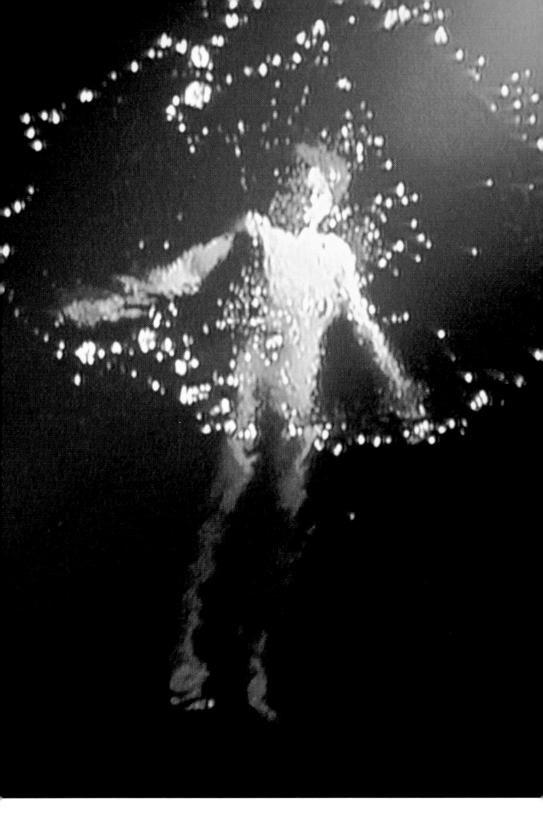

2 *The Messenger*, 1996

utopian artistic provocations, rather than for the social pacification which seemed its principal role within mass culture. (As Paik asked in the 1970s: 'How soon will artists have their own TV channels?')

That utopian political aspiration has long since dissipated. In its wake, rather than utilizing the same type of established channels of broadcast for video art as were used by TV productions, artists successfully negotiated a niche for the broadcast of their work in the very institutions which had seemed least capable of that dissemination: art galleries. Part of the price of that negotiation has been a radical distancing of much video art from the utilitarian ethics and aesthetics of the 1970s. As Davies points out, the break with the two dimensions of the TV screen in the 1980s and 1990s was made possible by developments in video projection and high-definition imaging. So it is that we now look to video for the properties traditionally associated with painting and sculpture. This situation perhaps receives its ultimate acknowledgment in the National Gallery in London installing an exhibition of Viola's 'The Passions': Viola the first living artist to receive such an honour, his work equated to that of the Old Masters, both in its aesthetic content and emotional effects. That paradox depends upon another paradox: that the attainment of the auratic properties of the individual artwork – which include both those characteristics of the work and the audience responses, observed, in particular, by Cynthia Freeland – in the medium least likely to manifest them, involves a level of sophistication in the medium similar to that found in mass culture. Davies notes the parallel paths of sound engineering followed by George Lucas (with his Star Wars films) and Bill Viola – the one making works for mass audiences, the other seeking to affect the spectator's experience through their being in the presence of a unique work of art. Yet, as Davies writes: 'By 2003, Viola had reached the point where his tools – if not his budgets – were much the same as those employed by Lucas in *Attack of The Clones*, 2002, namely Hi Definition Digital Video and hard disk-based editing systems.' And, like a Hollywood director, Viola now, when appropriate, uses a professional sound design team, who introduce a vast array of sounds in the post-production process.

Viola's concern with the totality of things is reflected in his attention to detail in that sound-palette: sound is as vital to the experience of his work as the image, or

the temporal and spatial structures of the artwork. And what is generally true of Viola's recent approach to the visual (in an installation such as *Five Angels for the Millennium*, for example) – that if you take an image and reduce or magnify it to the point where cognitive recognition is no longer possible, then it becomes visually abstract – is true also of the use of sound in his work. That abstraction of the sound is an aspect of Viola's work which again suggests an aesthetic affinity to those earlier practitioners of an American visual sublime – Aaron Siskind springs to mind. Given this common concern, it's no accident that Davies should write about the archetypal sound as vital to Viola's art. Rothko and Newman, in particular, were seeking to touch some primal condition of experience through painting that transcended the spectator's complete control, at the same time as their critical boosters, and indeed Newman himself, were talking up Abstract Expressionist imagery in terms of the Jungian archetype.[14]

Davies demonstrates not only how sound amplifies the effect of Viola's imagery; he illustrates how much of the sound is carefully designed to complement the images we see, rather than being naturally associated with them. Even in an early work such as *Migration*, 1976, what at first seems 'natural' – the chime that accompanies a drop of water falling – is in fact a substitute for the natural sound. By the time he makes one of his first masterpieces, *Hatsu-Yume (First Dream)*, 1981, Viola is using treated and designed sound in highly sophisticated ways, so that it becomes a creative statement in itself. This production of sound does not, of course, draw attention to itself; rather it contributes to the overall effect of the work. But what seems natural, simple and obvious is, in fact, fantastically complex; and all that effort, that complexity of the work is elided in its affect. We might say that the thematic paradox at the core of so much of Viola's work – what we could, following the poetry of St. John of the Cross, diagnose as 'lose to find' – is also a technological paradox. The complex work cannot easily be examined critically, cannot be taken apart, because its structures are lost behind the simplicity of its effect.

Elizabeth ten Grotenhuis offers a detailed study of Viola's relationship to one aspect of spirituality that repeatedly surfaces in his art – his use of Eastern, and in particular Buddhist, art. Ten Grotenhuis traces the debt Viola owes to the thought

of D. T. Suzuki and Ananda Coomaraswamy, a debt that oddly includes the introduction of Western medieval mysticism in the form of Hildegard of Bingen and Meister Eckhart. These were figures with whom both Suzuki and Coomaraswamy discovered affinities while studying in the West. Viola's spiritual pursuit is perhaps to further develop those affinities, seeking a synthesis of religious impulses from around the globe. Although he relies heavily at times on the motifs of Western art (especially that of the early Renaissance) and of a wider Christian culture in general (for example in *Five Angels for the Millennium*) Viola eschews traditional Christianity as a personal belief. Viola certainly seems to share a philosophy of 'pure seeing' that has much in common with Suzuki's Zen Buddhist thought. Ten Grotenhuis, however, is concerned to point out that what we see as 'Zen' art, as a consequence of Suzuki's popularizing activity, strips away a wider, richer culture in Japanese art, and appropriates the art of non-Zen traditions, such as Dao, to an ill-defined category whose terms of construction are wholly Western, even as they apparently avow Eastern philosophies. That generalizing effect has been typical of the Western cultural encounter with the East in the last fifty years – we see it most obviously in the influence of someone like Alan Watts on the Beats and sixties counterculture. At this point ten Grotenhuis might seem to share Lahey Dronsfield's scepticism towards Viola: that he co-opts the 'authenticity' of others in the quest for a universal, but personal, truth. However, she goes on to point out that it is to Viola's credit that his appropriations are 'creatively misunderstood' rather than reproduced in a half-baked form: they become the basis for further creative activity, for synthesis, rather than the unproblematized embedding of the artist in an alien culture.

One consequence of Viola's spiritual synthesis is that he is, to an extent, alienated from all religions that proclaim a singular tradition. David Jasper's essay on *The Messenger* (**2**), installed in Durham Cathedral in 1996, looks at how one major work fitted into a distinctively Christian architecture. That fit was into both a space and a topos of ideas: Christian theology. As Jasper acutely observes, the installation, not directly subscribing to the demands of faith and yet responsive to a sacred tradition, highlighted a wider ambivalence about the function of architectural space. Far from being a work that placated or entertained its spectators, *The Messenger*

as 'scandal' (both theological and, briefly, moral) raised important questions about the institutions and structures of faith, and their social implications. In the end, 'the venerable space of Durham Cathedral extended to art a hospitality which, it seems, our theologies and established moralities have barely begun to recognize, let alone understand'. The dream-like experience of watching *The Messenger*, Jasper rightly reminds us, called forth another dream. Perhaps this is the nub of Viola's work: the significant content behind the synthesized spirituality, and lavish visual and aural effects. It is the small voice of inherent possibility, the subtle prompting of 'something outside the limits of the imagination to which our eyes and ears are closed', as Jasper puts it. In *his* art of the spectacle Viola makes dreamworks, and yet, unlike the Spielberg or the Lucas movie, he dares us to dream, to venture beyond what's on offer.

Hollywood movies are sold all over the world, mostly to the detriment of national cinemas. In the last decade 'installation art' has become a kind of international standard in the artworld, the touring exhibition of work on the grand scale that progresses from New York to London to Paris or Berlin. It is, as I've suggested, often work that appeals to the same aesthetics, the same spectatorial responses as the blockbuster movie, and work that often employs the same personnel. There is a blending of borders, a loss of national distinction as the same artists, and the same works, are shown in one country after another. Antonio Geusa's closing essay examines the impact of Viola's reception in a country in which 'videoart' was an unknown concept only a decade ago. Works by Viola were among the first to be shown in post-Perestroika Russia, the first that might influence young Russian artists. That importation brings Russia into the circuit of international art exhibition and, perhaps eventually, into the circuit of the international art market. But whilst it is part of that circuit, Russia – with a tradition of religious art that is being actively revived in the post-Soviet era – produces videos that manifest little affinity with Viola's work, even as that work is profoundly admired. Russian video artists seem instead to sit at an earlier point on an evolutionary trajectory, making works that scrutinize the rhetorical capacities of the medium, through the medium. In a culture where the language of the installation has still to be learned, the installation that offers transcendence

and singularity, the installation that is charged with 'meaning', generates neither fresh attempts at spectacle nor recalls of an abandoned rhetoric.

It may be that Viola himself is a unique artist. Although he uses the forms of contemporary installation art, and seems to refine to a new peak, in a new place, the tendency for spectacle manifested by mass culture for the last 200 years, the content with which he endows that spectacle is in revolt against its form. The meaning of the art is at odds with the medium that bears it. One might say that Viola's art is different *because it imagines it has meaning* – it continues that utopian strain of art that speaks of a world as it might be. This is an art at odds with much of the installation art it might superficially seem to resemble, and that conflict might explain its popularity: it seems to work with its audience, rather than against it. With the media of the modern world, Bill Viola gives us an art that is 'old-fashioned': it is singular in the age of the reproduction and the multiple; it seeks profundity rather than glib entertainment; and it towers over us, transcendent, when we would seek to control all that we see.

23

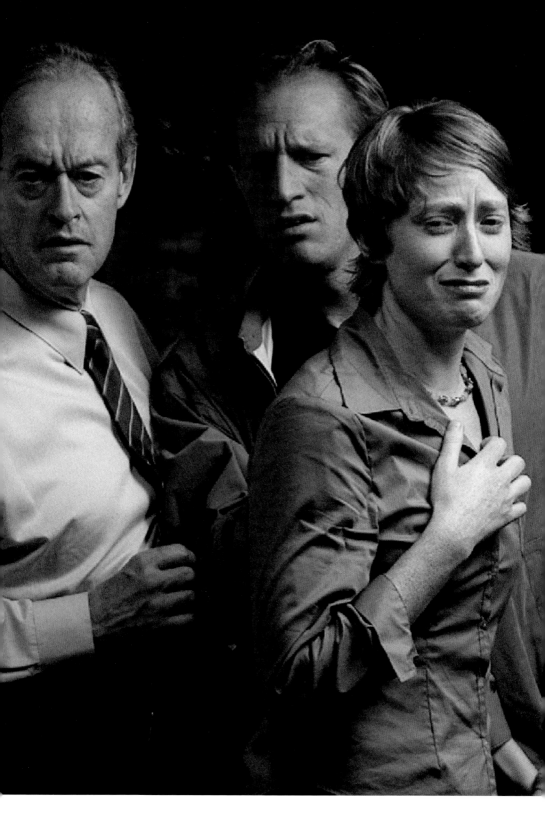

3 *Observance*, 2002

PIERCING TO OUR INACCESSIBLE, INMOST PARTS

The Sublime in the Work of Bill Viola

CYNTHIA FREELAND

Bill Viola is unusual among contemporary artists for tackling profound philosophical and religious matters.[1] His works address the big questions: mind, perception, reality, meaning, purpose, the soul, death, transcendence. You could say this makes him sound more like a philosopher or theologian than a visual artist, but that would not be true. For example, *Chott el-Djerid (A Portrait in Light and Heat)*, 1979, depicted the slow materialization and dematerialization of mirages in the desert; the installation *Room for St. John of the Cross*, 1983, made mystical experience real, with harsh images and sounds evoking the mystic's ravaged ecstasies. Viola can present images of strange beauty – a beauty some viewers find excruciating. Jean-Christophe Ammann, in his introduction to a collection of Viola's writings, comments of *Chott el-Djerid*: 'The beauty of landscape, water, light, and colour is so unbearable that one wants to scream.'[2] In a review of that book, I suggested that 'sublime' was a more suitable description for Viola's works than 'beautiful'.[3] This term better captures the way in which his sensory effects can overwhelm viewers so as to induce a state of fear and trembling – while remaining uplifting.

In this essay I extend that examination of the sublime in Viola's work by focusing on two pieces from his series, 'The Passions'. Ostensibly these works, *Observance*, 2002 (**3**), and *Dolorosa*, 2000, seem more mundane than the two pieces I've already mentioned. They are literal and realistic, more accessible than Viola's earlier abstracted meditations on death, consciousness and religious experience. The more recent pieces portray human faces undergoing recognizable emotions. However, I suggest that these works, too, evoke the sublime.

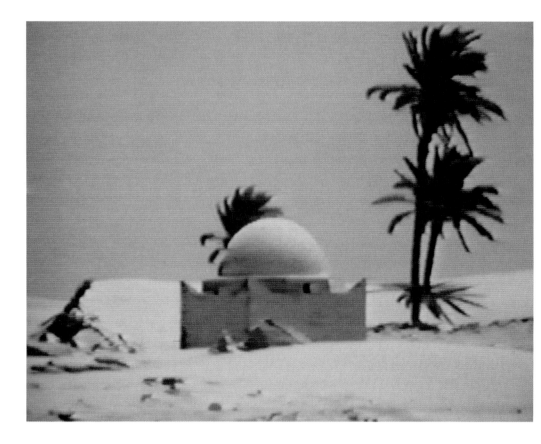

4 *Chott el-Djerid (A Portrait in Light and Heat)*, 1979

The term 'sublime' denotes an aesthetic value very different from the 'beautiful'. The root of this difference involves pain rather than pleasure. In art this renews the fundamental question that arose two millennia ago for Greek tragedy: how can a painful artwork be valuable and enjoyable? Why force visions of extreme passions like grief and sadness upon our fellow humans? What does a viewer take from such an experience? And why create art to evoke it – or recommend that art to others?

Seeking answers to these questions, I trace below the important historical roots of the notion of the sublime in works by those vital Enlightenment figures, Edmund Burke and Immanuel Kant. My history lesson will run the risk of making the sublime seem very remote from us, a relic of the eighteenth century.[4] Although Kant's view has received more philosophical attention, I think that Burke's account also affords interesting avenues for exploration. It is also more readily updated to fit within contemporary interpretations of the mind.

To provide an initial foothold on the rocky territory of the sublime, I can sketch an account I developed concerning its application to cinema.[5] Three connected elements are essential to sublimity in a film: (i) the presentation of something so extreme and overwhelming that at some point it leads to (ii) a gap or disruption of the very medium of representation, evoking (iii) a deep moral response from the viewer. In the same way, Viola's *Chott el-Djerid* (4) presents visions that stun the eyes so much that they seem to break apart all our preconceptions of what can be seen and depicted, of what it means to see. This work also has moral dimensions because it prompts reconsideration of such notions as journeys and goals, asking whether our assumed end-points (like oases in the desert) are real or illusory. Below I will develop this basic framework to further explain why I apply the label 'sublime' to some of Viola's newer works.

In *Observance* Viola has created a gripping expression of grief. A solemn line of mourners is framed in a tall, narrow display, like one of the wings of an altarpiece. They slowly approach the front of the line and pause briefly to confront some terrible vision. 'Slowly' is an understatement: extreme slow motion brings their procession down to a glacial pace. Though facing us, they do not see us, witnessing instead some atrocity, tragedy, or loss – something terrible, we-know-not-

what. They look ordinary and represent different ages and ethnicities, banded together only by their need to witness and pay tribute. Each confronts the anticipated but unknown vision of utter pain alone. We view minute stages of their mental preparation and anguish. Sometimes, thankfully, another person's hands reach out to take an arm or pat a shoulder, providing comfort.

Seeing *Observance* in 'The Passions' exhibition at the Getty Museum, I was shaken and deracinated. I began to weep uncontrollably (with some embarrassment). I could not leave the spot but watched the work over and over, trying to come to terms with it. I stood to the side to hide my streaming face. I am not a weeper-in-art-galleries but it seemed impossible not to experience the grief these people were expressing as real. It was impossible not to demand to see what they were observing –- not to feel obliged to do so in order to help them witness. I can still scarcely believe what I have since read in the exhibition catalogue, that these were actors assembled in a studio, given instructions by Viola, and that they walked forward to emote while looking at a vase of flowers on a table.

My confession of tears here is inspired by tales recounted in James Elkins's odd but charming book, *Pictures & Tears: A History of People Who Have Cried in Front of Paintings.*[6] Elkins, an art historian and non-weeper himself, narrates stories told by others who have wept in museums. Most did not do it often, and many could not explain why it had happened when it had. Elkins remarks that: 'Crying is often a mystery... The first thing that needs to be said about crying [is that] no one really understands it... Crying is also hard to think about.'[7]

Pictures & Tears offers a typology of weeping before paintings, sketching a quick and dirty history of painting and tears in the West. Elkins notes that during the Renaissance, theorists like Alberti and painters like Michelangelo warned against weeping before art. Earlier, Northern painters like Dieric Bouts had encouraged it. (It is no accident that such artists are cited by Viola as influences on his recent work.)[8] Elkins thinks that, like the Renaissance, the twentieth century was one of 'stoic intellectualism' opposed to weeping. These two periods celebrated the ideas and skill of painters more than their emotional impact on viewers. Certainly weeping was the last thing one ought to do in front of a Jackson Pollock,

according to a critic like Clement Greenberg. Modern art was about cerebral matters such as the edge or the plane of representation. Exceptions, such as Barnett Newman and Mark Rothko, could only be fitted uneasily into the Abstract Expressionist camp. Newman unabashedly claimed that 'the sublime is now', and Rothko sought a reaction of 'ecstasy alone'.[9]

Observance inevitably conjures comparisons with the ceremony held in New York to mark the first anniversary of the tragic events of September 11, 2001. Television viewers followed a slow-moving, solemn line of mourners as they approached a particular point where they could pray or reflect and leave tributes. Nothing specific marked that spot; there was nothing to see. The mourners, in mismatched groups and assorted clothes, had only one thing in common: their loss. The ritualistic aspects of *Observance* make it seem natural to envision its people witnessing a similar scene of carnage, emerging with shocked faces, their new world consciousness.

But as it happened, when I saw 'The Passions' I had been lecturing on the ethical issues surrounding the Andrea Yates murder case, then on trial in my home city of Houston. To outward appearances Yates was a woman from a pleasant suburb, whose husband worked at NASA, until one morning she killed her five children (all under the age of seven) by drowning them in a bathtub. She called the police to confess. Like many feminists, I was initially sympathetic to Mrs Yates, who seemed like an abused wife oppressed by religious fanaticism. She had suffered postpartum depression but kept having children while coping with heavy burdens of child care in near isolation. Religious guilt apparently drove her to the deed, since voices told her she was a bad mother and that the children would be better off dead. Many were surprised when the Texas jury found Yates guilty; since if an insanity plea did not apply to her, it seemed doubtful that such a plea could ever succeed. Commentators explained her conviction but citing the shocking details that indicated deliberation and forethought. Among the grisly pieces of evidence shown to jurors were photographs showing that each small child had been drowned in the same bathwater filled with the urine and faeces of their previously murdered siblings. The horror of this woman's deed, of what her children suffered, and of the crime scene itself,

were unimaginable to me. And so it happened that I also viewed the observers in Viola's piece as stepping forward to acknowledge the enormous human tragedy of five small bodies in a filthy bathtub – and, by extension, of all the disrupted, despairing lives of abused or deranged women and suffering children.

My associations here might seem eccentric, and the description unnecessarily lurid, but it needs to be said that the people in *Observance* are not simply grieving, they are actually flinching from what they see. They see aspects of life that are terrifying and horrific. Facial and bodily reactions make this clear; fearful upon their approach, the people must draw on all their inner resources to face the dreaded sight – a sight which will, to quote Burke on the sublime, 'pierce to [their] inaccessible and inmost parts'.[10] What they are experiencing is, to my mind, sublime, and it is also what we experience in watching *Observance*.

I want first to apply to *Observance* the three components I outlined above as crucial for the sublime. First, it presents something overwhelming: the slow-motion vision of person after person confronting deep loss is almost unendurable to watch. Secondly, the work creates a sort of rupture; it passes beyond certain limits. The very thing that the mourners observe, the source of their grief, is unseen and unrepresentable – but no less real for that. Finally, the work has significant moral dimensions. It presents a vivid picture of human vulnerability, of our need to acknowledge loss and somehow move on. *Observance* not only depicts moral interaction and witnessing, it elicits it. It calls forth empathy.[11]

The second work I was struck by within 'The Passions' was *Dolorosa* (5). In two small, hinged LCD panels, displayed like leaves of a late-medieval devotional book, we see, on the left, a woman, and, on the right, a man, both weeping. Their faces, slightly larger than life size, have a dazzling clarity, illuminated from the side with a golden light that brings out their every detail: pores, eyelashes, strands of hair, glistening tears. Both are gorgeous, contemporary yet reminiscent of images from the canon of Western art.

The young woman has porcelain skin, full rosy lips, and an aureole of red curls. She is one of those rare and enviable women who appear beautiful while crying; her large blue eyes are red-rimmed but remain luminous and soulful as they

seep tears. She wears a soft magenta flowered dress, shoulders draped by a gauzy grey-blue scarf. To reinforce the obvious Marian reference of the title, she resembles many Biblical women - Eve, Judith, Mary - painted by Northern Renaissance artists like Cranach and Memling.

The man (perhaps the Son?) has dark skin and glossy black hair. He is bearded and 'ethnic' in an indeterminate way. He looks ordinary yet profound, wearing a blue denim work shirt, open to reveal his throat and the thick chords of his neck. His weeping is also beautiful to behold: although he is consumed by tears, his grief is not so much intense as a persistent fact about his condition.[12]

Because they are shown as a pair, we understand the cycle of these two people's grief as somehow related. As each grieving process is played out in extreme slow motion, they sometimes turn their heads slightly, so that, while they do not actually interact, they appear to acknowledge the other. They are always weeping, always going to weep. Again, we inevitably experience their emotion as unutterably real and as directed at an unknown something. This mysterious, all-consuming 'something' needs attention, and is crucial to what I think makes this work, with *Observance*, qualify as sublime.

I have thought for some time about why these pieces most affected me among all the varied works in 'The Passions'. Viola has said that, in preparing his first series of extended work involving actors, he was interested in stripping the depiction of emotions down to something very pure and simple, like an artist who wants to show pure red rather than, say, a red rose.[13] To do this he often withdrew context and narrative. I feel this withdrawal weakened many of his other pieces in the exhibition. The close-ups of single or multiple heads often seemed mannered, studies of the emotions rather than exemplifications. The people were all too obviously actors emoting. It was curious to see their faces changing, but the overall effect was, to be blunt, a bit silly, while in groups where the subjects were all expressing distinct emotions the result was very confusing.

The people in *Observance* and *Dolorosa* seemed instead to be undergoing an actual experience, producing a more forceful, coherent impact. I don't think this was because there was more narrative or plot to these pieces – neither *Dolorosa* nor

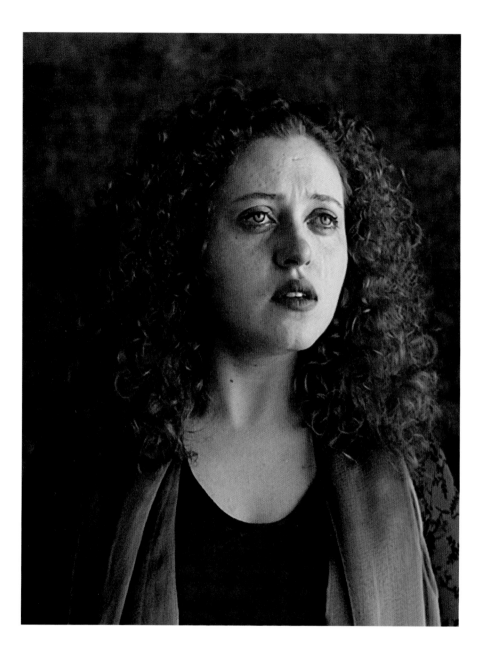

5 *Dolorosa*, 2000

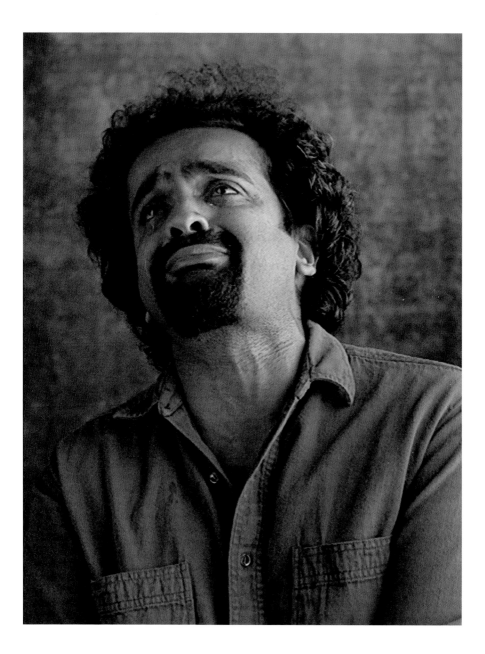

Observance has a narrative, although the latter has more temporal structure. What makes these works stronger is that in them the emotion in question – grief – has some mysterious object, an 'aboutness'. There must be some *reason* why these people are weeping or flinching and mourning; even if we cannot see it, it exists. The realism of the emotions we witness in the videos requires us to conceive of some disturbing source of their pain. I have described my associations between *Observance* and the New York 9/11 memorial, or the Yates murder case. Other viewers will bring their own associations to comprehending such grief, whether public and political, or private and personal.

Emotions in life do not occur without cause; the idea of a 'pure emotion' ripped from all context is self-contradictory. Abstracted, emotions become curiosities, lacking the power to move us, symptoms perhaps of madness.[14] Even crying has its purposes: Elkins remarks that 'crying is on the continuum of normal human responses to the world... We think while we cry, and we feel while we think: it's really that simple, and people who believe otherwise may be trying to defend themselves against some dangerous influx of passion.'[15]

What is striking about *Observance* and *Dolorosa* is that they manifest 'aboutness', but it remains obscure. This is what I pinpoint as the rupture in representation that makes these works sublime. They simultaneously represent something and show that it cannot be represented; it is a mystery to be solved. In another art form, opera, it has similarly been suggested that perhaps the sublime, most emotionally affecting moments are those when the singer's voice somehow rises above or breaks through the medium of words to become expressive in some other way:

> Listeners sense that the singer's voice has almost broken free
> of language, and at the same time they know that the voice can
> never break out of language... only angels can sing and still not
> make sense; if human singers could actually move outside of
> language the result would be a wild screaming, something
> dangerously close to insanity.[16]

The emotions which *Observance* and *Dolorosa* exhibit are 'real' because we can see the people's grief – but of course we can never really see someone's emotion. I do not

mean that emotions are locked 'inside' somewhere; rather, emotions extend beyond persons to colour their world. Viola has thought hard about traditions of mystical or religious work in which artists tried to 'paint the invisible', within Spanish visionary painting for example. Sometimes this was achieved by displaying a person's astonished reaction to something left outside the frame.[17] Viola's method is similar here: 'aboutness' is real but is left outside the screen. Even so, or perhaps because of this, the passions extend far beyond his crystal diode displays to affect viewers like me, altering the very tone of our world. It remains to be explained why this was not an altogether depressing experience. Such an explanation demands a historical review of thoughts on the sublime.

The sublime was a notion that, in Arthur Danto's terms, 'rocked the Enlightenment'.[18] Given new currency by the rediscovery of Longinus's ancient work *On the Sublime*, the concept was further theorized by both Edmund Burke and Immanuel Kant. Key to the idea of the sublime, functioning as a kind of undertow to Enlightenment rationalism, was a certain Romanticism. The sublime was overwhelming, something that might sweep one away with its vast size or power. Whereas the beautiful was smooth and soft, the sublime was rough and jagged. Stormy oceans and jagged mountain peaks were typical examples.

Although the sublime achieved popular usage during the eighteenth century, it has largely disappeared from recent discourse in aesthetics and art criticism, mentioned only by the occasional artist like Barnett Newman or philosopher like Jean-François Lyotard.[19] Recently, however, interest in the sublime has been revived; referred to in discussions of its companion concept, the beautiful, by both Arthur Danto and Elaine Scarry.[20] Danto emphasizes that the term was re-introduced into twentieth-century mainstream art theory and criticism by Newman, who scorned beauty and sought the sublime in his large 'zip' paintings. Danto comments:

> It was entirely correct of Newman to connect the idea
> of beauty with perfection. The mark of the sublime
> by contrast was ecstasy or enthusiasms... the idea
> of the sublime collided with the sphere of the tasteful
> as a disruptive force.[21]

Newman aimed at sublimity in part through the scale of his works. The viewer who saw them close up, as the artist intended, was almost enveloped by the vertical canvases. Mark Rothko similarly wanted viewers to experience his paintings from just eighteen inches away. Elkins believes that if a scientific survey were attempted, Rothko would emerge as the twentieth-century painter whose works most often elicit tears from viewers. He speculates that this may be because certain Rothkos can overcome the viewer with a sense of emptiness, a 'suffocation of the senses'. Rothko said he wanted to put the viewer directly into the work.[22] This echoes Viola's account of why he designed *Dolorosa* as he did. Its small scale was unusual for him, but he had noticed how absorbed people become in the screens of their laptops.[23]

Danto describes the sublime as something that elicits a combination of wonder and awe, deference and fear.[24] He sees terror as crucial to the sublime experience: 'The mark of being in the presence of sublimity is, as with Stendhal, the swoon.'[25] However, Danto doubts that many viewers really do feel terror in art galleries. Thus he pokes fun at Lyotard's account of the sublime:

> One cannot but wonder – I at least cannot – how often Lyotard
> can have had this feeling ['an admixture of fear and exaltation']
> in front of works of art. If it is like ecstasy, it cannot be something
> we can be overcome by several times in a single visit to a gallery
> of art. My sense is that Lyotard was overcome by the literature
> on the subject rather than by actual aesthetic experiences he
> had on the rue de Seine in Paris.[26]

Unfortunately, Danto has oversimplified the relation between terror and the sublime in art. His discussion of Newman is also problematic because it suggests that sublime art cannot be representational: 'Though sublime things can be represented, they cannot be represented as sublime.'[27] Danto traces this claim back to Kant, for whom the sublime characterized nature and not art. Calling Kant unimaginative in expecting all art to be representational, Danto nonetheless implies that it was only with the development of abstract painting that the sublime could appear in art: 'Modernism opened up the possibility of an iconic painting, and this somehow brought with it the possibility of sublimity as an attainable aesthetic.'[28]

If Danto were correct, Viola's works in 'The Passions' would be excluded from the sublime, since those works are all representational.

We might note in passing that Danto's take on the sublime suggests links between works like Newman's paintings and some of Viola's videos. This account works well in describing *Five Angels for the Millennium*, 2001, a work related to 'The Passions'. The five huge video panels on display in a darkened room do depict something – a human body entering or emerging from water – but not recognizably so. Through their size, lighting, use of colour and sound, and extreme slow motion, they become abstracted, not easily readable. At the Getty, I saw them as visions of a large city at night (influenced perhaps by my vision of LA when I flew in by night a few days earlier).[29] But not all the video pieces have to achieve sublimity in the same way.

Let me now explain my comment that Danto has mischaracterized the sublime, both in emphasizing the requirement of fear, and in excluding representational art. True, in standard eighteenth-century accounts the sublime involves something fearful: but it does not involve a human response of fear.[30] Kant and Burke maintain that if you feel fear in front of something, you cannot experience it as sublime. As Kant put it: 'Someone who is afraid can no more judge about the sublime in nature than someone who is in the grip of inclination and appetite can judge about the beautiful.'[31] Burke remarked: 'When danger or pain press too nearly, they are incapable of giving any delight, and are simply terrible; but at certain distances, and with certain modifications, they may be, and they are, delightful, as we every day experience.'[32]

For Kant there are two sorts of sublimity: the dynamical and the mathematical. Kant's dynamical sublime is concerned with power and overwhelming natural forces. The mathematical sublime, by comparison, concerns numbers and size, and reveals the imagination's inadequacy at presenting an idea of the whole. Kant explains how we can have a non-fearful apprehension of something terrifying by drawing upon a very complex theory of our diverse human, cognitive, emotional and perceptual abilities. He held that the sublime produces a strong tension in the functioning of our various mental faculties.[33]

Thus, on the one hand, when we are faced by something vast or powerful like a mountain range or storm, what Kant calls our faculties of sensibility and imagina-

tion become overwhelmed. They cannot take it all in. But on the other hand, we have another cognitive faculty, reason, which feels uplifted by the experience. Reason, which is also the source of morality and freedom for humans, somehow identifies with the vast object. But this does not involve actual cognition, which is done by yet another faculty, understanding. No faculty is adequate to the sublime experience. It is as if instead reason makes an intuitive leap to embrace the sublime object without actually conceptualizing or recognizing it – and we ride a resultant surge of energy. Through this experience, Kant said, we sense our own superior moral powers. This is why the sublime is pleasant and not painful, reassuring and not frightening.[34]

> In this way external nature is not estimated in our aesthetic
> judgement as sublime so far as exciting fear, but rather because
> it challenges our power... Therefore nature is here called sublime
> merely because it raises the imagination to a presentation of those
> cases in which the mind can make itself sensible of the appropriate
> sublimity of the sphere of its own being, even above nature.[35]

In Kant's theory, then, the sublime is not actually 'out there' in the world; it is in us. He says: 'Thus, instead of the object, it is rather the cast of the mind in appreciating it that we have to estimate as sublime.'[36]

Let us consider how Kant's framework might apply to *Five Angels for the Millennium*. The viewer is overwhelmed by sensory experience in the darkened room. Each of the gigantic panels dwarfs us, but they are also dispersed, so that one cannot view them together. We cannot take in what we are seeing or hearing. We cannot make sense of what is showing on any one screen, nor understand how the five are related. The low roars and bubbling sounds seem to speak an alien tongue, something like the language of whales. The sensory overload presents an intellectual conundrum. Despite this, we may feel exalted because the pieces are so stimulating. They are exhilarating because of their carefully coordinated scale, vividness, their sheer bursts of energy. At certain points when we dimly grasp that a body is emerging whale-like from the water, the works suggest the enormity of our own creative powers.

Before leaving Kant, I want to stress how crucial his faculty psychology is to his account of the sublime. Kant's faculty psychology now considered both byzantine

and antiquated.[37] Yet without these details, his account of the sublime threatens to collapse. What we can take from Kant, still, is a basic idea of the duality of the sublime: it causes both pain and pleasure. We feel pain at experiencing something so overwhelming that it is hard to grasp. Yet we are also uplifted by the sublime; something in the experience heightens awareness of our own humanity.

We can find in Burke a similar duality. His account of the sublime did not rest on such an elaborate view of human perception and cognition as Kant's. Rather, Burke focuses on how different sensory experiences can cause pleasure or pain. This more physiologically based account means that Burke's take on the topic is easier to fit within current theories of the mind – those from, say, cognitive science or evolution-ary biology. The opening of Burke's treatise makes his instinct-based approach clear, announcing that his account rests on two basic passions: pleasure and pain. Pain is more relevant to the sublime, pleasure to the beautiful. Pain is mainly aroused by threats to our self-preservation. Here is Burke's actual definition of the sublime:

> Whatever is fitted in any sort to excite the ideas of pain and danger,
> that is to say, whatever is in any sort terrible, or is conversant
> about terrible objects, or operates in a manner analogous to terror,
> is a source of the *sublime*; that is, it is productive of the strongest
> emotion which the mind is capable of feeling...[38]

In Burke's account, like Kant's, the experience of the sublime is incompatible with fear. The sublime requires distance. But there is a crucial difference between these two thinkers' accounts of why the sublime is enjoyable. For Kant, our pleasure in the sublime is complex and involves a special consciousness of our own moral vocation. Burke's account emphasizes our human response of empathy. To see how, we should note first that in addition to a basic instinct of self-preservation, Burke holds that there is a fundamental human social instinct.

> For sympathy must be considered as a sort of substitution,
> by which we are put into the place of another man, and affected
> in many respects as he is affected; so that this passion may either
> partake of the nature of those which regard self-preservation, and
> turning upon pain may be a source of the sublime or it may turn

upon ideas of pleasure... It is by this principle chiefly that poetry, painting, and other affecting arts, transfuse their passions from one breast to another, and are often capable of grafting a delight on wretchedness, misery, and death itself.[39]

How would Burke's theory of the sublime apply to works like *Observance* and *Dolorosa*? First, Burke believes that the pleasure we get from the spectacle of someone else's suffering is something very basic to our human nature. Next, he says this occurs both in reality and in representation. Here, Burke is opposing a standard, Aristotelian analysis (such as the classic theory of katharsis) that emphasizes the distancing effects of fiction. Aristotle would hold it unseemly to enjoy an actual person's suffering as we do, say, within *Oedipus Rex*. But Burke says:

The satisfaction has been commonly attributed, first, to the comfort we receive in considering that so melancholy a story is no more than a fiction; and, next, to the contemplation of our own freedom from the evils which we see represented. I am afraid it is a practice much too common in inquiries of this nature, to attribute the cause of feelings which merely arise from the mechanical structure of our bodies, or from the natural frame and constitution of our minds, to certain conclusions of the reasoning faculty on the objects presented to us; for I should imagine, that the influence of reason in producing our passions is nothing near so extensive as it is commonly believed.[40]

Burke's account emphasizes human instinctual responses over the intellectual. But what is it exactly about our physical constitution that 'gears us' to enjoy the spectacle (whether real or artificial) of a fellow human's pain and suffering? Here is his analysis:

Terror is a passion which always produces delight when it does not press too closely; and pity is a passion accompanied with pleasure, because it arises from love and social affection. Whenever we are formed by nature to any active purpose, the passion which animates

us to it is attended with delight, or a pleasure of some kind, let the subject-matter be what it will; and as our Creator has designed that we should be united by the bond of sympathy, he has strengthened that bond by a proportionable delight; and there most where our sympathy is most wanted – in the distresses of others. If this passion was simply painful, we would shun with the greatest care all persons and places that could excite such a passion; as some, who are so far gone in indolence as not to endure any strong impression, actually do. But the case is widely different with the greater part of mankind; there is no spectacle we so eagerly pursue, as that of some uncommon and grievous calamity; so that whether the misfortune is before our eyes, or whether they are turned back to it in history, it always touches with delight. This is not an unmixed delight, but blended with no small uneasiness. The delight we have in such things, hinders us from shunning scenes of misery; and the pain we feel prompts us to relieve ourselves in relieving those who suffer; and all this antecedent to any reasoning, by an instinct that works us to its own purposes without our concurrence.[41]

Burke's response to the duality of the sublime is complex. He emphasizes that the sublime involves something terrible and frightening, something that speaks to both of our two most basic passions or instincts: self-preservation and the social instinct of sympathy with others. The sublime especially evokes threats of death, calamity and misfortune. When we see depictions of these threats occurring to someone else, we are both safe, and thus happy to be alive, and yet deeply concerned because of our fundamental social instincts. We fear for ourselves, are relieved not to be at risk, and then seek to relieve our own fear by an empathetic response reflecting a basic instinct for assisting others in pain. Consider *Dolorosa* and *Observance*: both obviously depict a person or persons undergoing a form of intense suffering. Witnessing this, the viewer is naturally touched by their pain. It is neither pleasant to observe grief nor to imagine its sources. The viewer

may readily associate the loss expressed on screen with losses in real life, as I did when *Observance* made me think of five small murdered children.

Much of Burke's treatise goes beyond these general emotions of pleasure and pain to provide detailed suggestions about specifics that affect our senses in such a way as to be sublime. One example, which applies well to Viola's *Five Angels for the Millennium*, is darkness or obscurity. Burke explains:

> To make anything very terrible, obscurity seems in general to
>
> be necessary. When we know the full extent of any danger, when
>
> we can accustom our eyes to it, a great deal of the apprehension
>
> vanishes. Every one will be sensible of this, who considers how
>
> greatly night adds to our dread, in all cases of danger...[42]

Another characteristic Burke mentions is infinity. Here, he explicitly describes the way in which not only sights, but a sustained noise can affect our minds: 'After a long succession of noises, as the fall of waters, or the beating of forge-hammers, the hammers beat and the water roars in the imagination long after the first sounds have ceased to affect it; and they die away at last by gradations which are scarcely percepti-ble.'[43] This too is relevant for many of Viola's pieces, such as *Five Angels* or *Room for St. John of the Cross*.

Yet another quality that can evoke the sublime is vastness, something Kant emphasized in his treatment of the mathematical sublime in particular. Burke also notes that the miniature – vast minuteness – can evoke the sublime. He states: 'As the great extreme of dimension is sublime, so the last extreme of littleness is in some measure sublime likewise.'[44] I think this observation applies to works like *Observance* and *Dolorosa*, in a way that Burke perhaps could not have imagined: their slowness. Their extreme slow motion, like that of Egerton's stop action camera recording an 'explosion' in a drop of milk falling, creates its own fascinatingly minute vastness. We observe more details of the development and expression of emotions in 'The Passions' than we ever could in real life. (Safeguarded by the screen, we are also allowed to stare at grievers in ways we would not allow ourselves in real life.) The details of their emotions become remarkable in much the same way as do observations through microscopes, about which Burke commented:

When we attend to the infinite divisibility of matter, when we pursue animal life into these excessively small, and yet organized beings, that escape the nicest inquisition of the sense; when we push our discoveries yet downward, and consider those creatures so many degrees yet smaller, and the still diminishing scale of existence, in tracing which the imagination is lost as well as the sense; we become amazed and confounded at the wonders of minuteness; nor can we distinguish in its effects this extreme of littleness from the vast itself.[45]

A final example of a feature eliciting the sublime is discussed by Burke under the rubric 'Succession and Uniformity'. For succession to be a source of the sublime, Burke says, it is 'requisite that the parts may be continued so long and in such a direction, as by their frequent impulses on the sense to impress the imagination with an idea of their progress beyond their actual limits.' [46] This would explain why the repetition of the parade of mourners in *Observance*, or the ceaseless nature of the weeping in *Dolorosa*, is so affecting.

Within a contemporary scientific framework, it is fairly easy to update Burke's approach to the sublime by alluding to fundamental facts about human expression and response. Ever since Darwin's *The Expression of the Emotions in Man and Animals*, biologists and psychologists have been studying the human capacity to express and read emotions through facial movement and behavioural gesture.[47] Among primates, crying is unique to humans.[48] Such emotional capacities are unusual in the animal kingdom but innate to humans; infants develop such abilities at an early age.[49] It is even thought that certain rare people with impaired abilities to express emotions with their faces are also likely to experience serious difficulties in experiencing the corresponding emotions. Jonathan Cole's recent book, *About Face*, illustrates this through fascinating, if disturbing, case studies of a variety of rare neurophysiological disorders.

Not only do humans have an unusual ability to comprehend a dazzling range of the facial expressions of emotion in others (some scientists claim there are up to 6,000 of them!),[50] we also have a natural tendency to empathize. As Paul Ekman

puts it: 'We are constructed to respond to emotion with emotion; we usually feel the message.'[51] Ekman and his associates have begun to differentiate 'real' from 'simulated' facial expressions of emotions, but they note that this is either difficult or impossible in normal circumstances.[52] For everyday viewers I don't think such a concern arises: works like *Observance* and *Dolorosa* have such extraordinary verisimilitude they are affecting even when one knows that the participants are actors. This relates to Burke's notion of the function of 'difficulty' in making something sublime. Viola's works become all the more impressive – sublime – when we realize the effort that went into the preparation, performance and filming of something so disturbing.

But what, we can still ask, makes works like *Observance* and *Dolorosa* valuable? Where does their specific pleasure lie, and why recommend them, if they will be a source of pain? Recall that for both Burke and Kant, it is something important about ourselves that we are shown in the experience of the sublime. For Kant, it provokes a specific recognition of our own moral nature: 'Therefore nature is here called sublime merely because it raises the imagination to a presentation of those cases in which the mind can make itself sensible of the appropriate sublimity of the sphere of its own being, even above nature.'[53] Burke comments, similarly: 'Whenever we are formed by nature to any active purpose, the passion which animates us to it is attended with delight, or a pleasure of some kind, let the subject-matter be what it will.'[54] The purpose that Burke has in mind here is our important social instinct, which he calls sympathy.

Of course, the pleasure we take from something sublime, in nature or in art, is never simple – it is not 'unmixed', to use Burke's term. Witness the variety of terms associated with the sublime: it is something that evokes terror, fear, horror, awe, reverence, admiration, astonishment. We have seen that there is something overwhelming about the sublime that leaves reason behind. Burke remarks: 'In this case the mind is so entirely filled with its object, that it cannot entertain any other, nor by consequence reason on that object which employs it.'[55]

This seems apposite in characterizing my own experience of *Observance* and *Dolorosa*. I confessed to my own response of weeping precisely because it is unusual,

even extreme, to cry in front of pictures. To say that the sublime outruns reason, though, is not to say that our response to it is irrational. Earlier I cited James Elkins's remarks about how crying can be a way of thinking about something. Viola has said that much of his work in 'The Passions' grew from an extended and ongoing process of mourning the deaths of his parents.[56] Coming to terms with such a loss (if one can ever do so) is a matter of much time, whether that loss is private and personal or collective and public, as with the tragedies of 9/11.

Time is a crucial element, then, in what creates the sublime in 'The Passions'. In them, our normal time has been significantly altered; slowed to the point where any one of the panels could, at a quick glance, look like a painting. People might hurry past the screens and miss their movements, but they do not. A surprising number of visitors in the Getty were standing or sitting stock-still, absorbed in the works for long periods of time. This is another remarkable aspect of 'The Passions': unlike television screens, these videos require and reward patience, attention, and slowing down to ponder and marvel, or perhaps to weep. Their subjects present 'reality television' in a wholly different sense from that recently popularized genre. What occurs on screen is obvious in one way, but mysterious and unnerving in another. The faces shown in *Dolorosa* and *Observance* reveal great depths of loss and suffering, and their pain continues without pause. We can't be sure what they are responding to, but we do recognize and respond in turn to their feelings, as a part of our own experience of life. The result is gripping, relentless, breathtaking and gorgeous. In short, it is sublime.

45

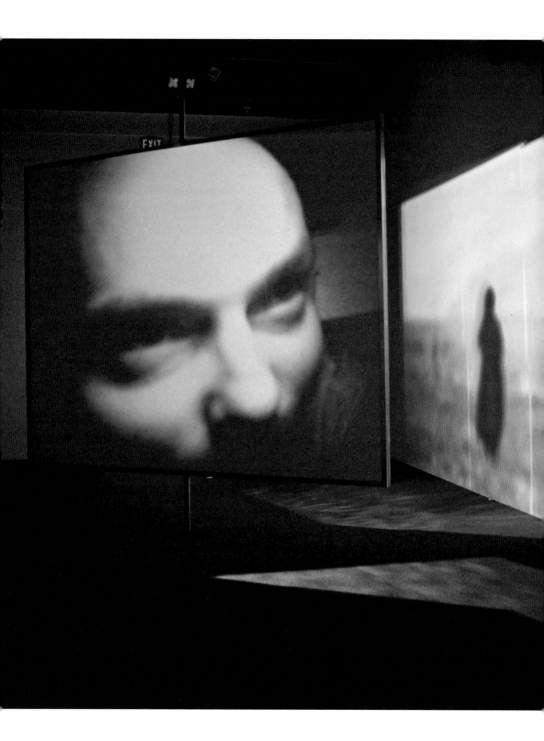

6 *Slowly Turning Narrative*, 1992

SPACE, TIME, VIDEO, VIOLA

OTTO NEUMAIER

Bill Viola belongs to that group of artists whose work seems intended to make us aware 'of our own mortality which defines the nature of human beings'. Since 'human beings, as all living beings, are essentially creatures of time', the medium of video 'is very well suited to expressing these concerns' because of its specific temporality.[1] From the very beginning, the artist has also used the spatial aspects of the medium because he 'started immediately with making installations'.[2] In the following essay, I would like to illustrate some of the ways in which these dimensions contribute to Viola's efforts at 'connecting us back to the fundamental questions of birth, death, existence, and so on'.[3]

Although Viola considers 'art to be a branch of knowledge', he does not regard his works as some sort of theoretical endeavour, but as spiritual exercises. Such exercises contribute both to the experience of what it is to be a human being, and to our understanding of what it is to enquire into that experience. The questions of *conditio humana* have almost disappeared from our awareness in the Western world. Since we are able to answer many of the questions that are commonly posed in everyday life, as well as in science, we are inclined, on the one hand, to think that all questions can be answered, and, on the other, to expel from our consciousness those questions which we are unable to answer, in particular the 'big' questions of our existence. Viola emphasizes that those questions have no answers: 'Ancient people call them…the Mysteries. These are not to be answered. There is no answer to birth or death. They are meant to be experienced, they can be approached and studied, but not finally answered.'[4]

The class of questions that are not meant to be answered, but to be experienced, contains, for example, those of the temporality of our existence, the questions of 'why we are born or why we die'. Viola finds it natural to ask: 'Why isn't my mother

here right now? Where did she go? Even though science tells me the reasons why the body stops functioning physically, I still have those questions. The question is the spark, the provocation that exists to push you to discover, to learn.'[5]

Among Viola's works, *Slowly Turning Narrative*, 1992 (**6**), appears as a spiritual exercise par excellence. From one end-wall of a dark room the image of a man is projected on a 9x12-foot screen rotating around a vertical axis in the middle of the space, while from the other end-wall a fast changing sequence of images is projected on the same screen. These colourful images show a wide variety of life's situations: a wedding, children playing, a fairground, a house burning, a car crashing, a heart and an eye being operated upon. Through different sounds corresponding to these situations, a man's voice emerges giving a litany of countless possibilities of human attitudes and kinds of behaviour, from elementary needs to the most intellectual phenomena, from the noblest motives to thoughts from the dark side of our inner life, all of them embedded in the phrase 'The one who...'.[6] This, and the fact that the viewers see themselves again and again on the other side of the turning screen, which is a mirror, obliges them to experience all those situations as parts of their own lives in all their diversity and contradictoriness. *Slowly Turning Narrative* also illustrates a particular way in which space can function in video art: it shifts the experience of art away from the TV screen to the space of the experience instead.

Like several other contemporary video artists, Viola increasingly renounces the use of the classical means of representation in the medium, namely the TV monitor, and instead creates spaces – even in those works where he still makes use of monitors. And, even in these cases, they are often employed by Viola in unusual ways. In *The Sleepers*, 1992 (**7**), for instance, the sleeping people are shown on black-and-white monitors lying at the bottom of seven white tin barrels, filled to the brim with water. In *Heaven and Earth*, 1992 (**9**), two TV tubes are installed directly into wooden pillars that grow towards each other from the floor and ceiling. At eye level, there is a gap of only a few inches in which to discern the face of an old woman dying, shown on the upper screen, being mirrored in the face of a newborn baby, displayed on the lower screen (and vice versa).

The usual way of engaging with the monitor is undermined to an even greater

7 *The Sleepers*, 1992

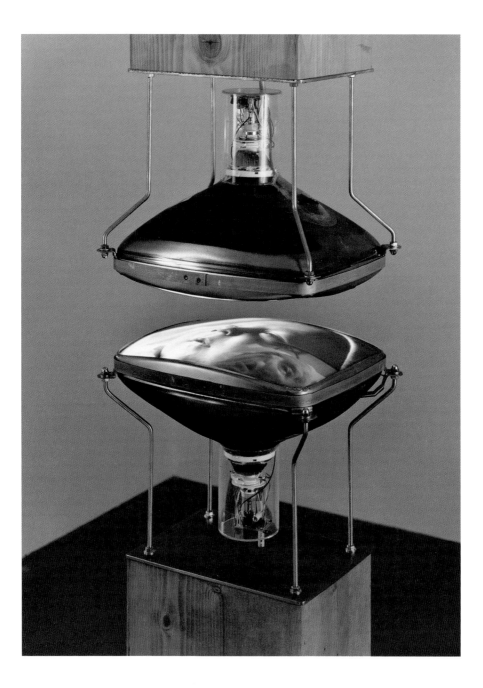

8 *Threshold*, 1992 (left)
9 *Heaven and Earth*, 1992 (right)

extent when the images become part of the architecture itself, sometimes filling the walls of a room, as in *Threshold*, 1992 (**8**), *Tiny Deaths*, 1993, *Pneuma*, 1994 (**10**), or *Interval*, 1995.[7] *Tiny Deaths* reveals human figures projected on three walls of a dark room. At first extremely shadowy, the images are suddenly exposed to a charge of high-intensity light so that, for a fraction of a second, they can clearly be recognized before 'burning out'. At irregular intervals, a figure, gradually emerging from darkness, is shown on one or another wall. This process begins in extreme slow motion, the intensity of the light on the individuals' bodies increasing only gradually. A dramatic acceleration causes the figure to be consumed by a burst of saturated, blinding white light that washes out the projections on the other two walls. The room then returns abruptly to darkness until one of the images on the other walls undergoes the same transformation. Although each cycle lasts only about thirty minutes, the relationship between the three projections is constantly renewed because the films all differ slightly in length. As a result, it is only after several hours that the figures light up on the walls in the very same sequence. More significantly, we can scarcely foresee when and where in the room the 'blossoming' and 'burning out' of a person will next occur.

In almost all of Viola's works, the images become part of the architecture; they exist in space and as space. In some instances, Viola combines images with objects, using the space to provide a context for meaning. In *Science of the Heart*, 1983, a brass bed, with red-and-white covers and a white pillow, stands in front of a wall in a dark room. On a screen on this wall we see a human heart laid open during an operation, beating slower and slower until it stops. Commenting on this work, Viola found that:

> The object becomes more like an image and the image becomes
> more like an object. The image becomes very physical, the heart
> beating, and then the bed becomes an image symbol referring
> to many things. So, there is a kind of dialogue between the
> material object and the immaterial image.

He goes on to describe a similar effect in his 1987 piece, *Passage*:

> There is a big screen built into a small room that shows a child's birthday

10 *Pneuma*, 1994

party for seven hours. It's playing back in extreme slow motion, and all there is is a room where one whole wall is an image. It is one of the first works I did where the image became a part of the architecture itself.[8]

Many of Viola's works are essentially rooms, and it is vital to understand them as such. While many of them share a kind of structural simplicity that gives them a mystical quality, other rooms are more elaborate. In *Slowly Turning Narrative*, the complexity is not so much provided by the spatial dimensions of the room as by the rotating screen and the secondary projection of images onto the walls. *Room for St. John of the Cross*, 1983, exhibits a different kind of complex structure. The room of the title is, strictly speaking, a room within a room; a physically inaccessible chamber, like a 'room of one's own' that must be respected by others if a person is to flourish. The dark, outer room – which is accessible to us – is filled with the sounds of a ferocious wind or white noise, relating to a large image of the snowy, cloud-covered Mount Whitney. By contrast, the small inner room is filled with light and silence, from which a voice emerges, reading texts of the Spanish mystic.

'Buried Secrets' owes its structural complexity mainly to the integration of five different installation rooms into one work, forming a cycle. When the work was shown at the Venice Biennale in 1995, the wings of the pavilion were connected by a roof that invited visitors leaving the last sub-installation, *The Greeting*, to return to the other side of the building and begin the viewing process again with *Hall of Whispers*. Here, for the first time, Viola integrated several installation rooms into one 'meta-work', into a cyclical unity in terms of form and content.[9] This cycle of rooms perfectly illustrates the concept of temporal cycles that plays such a central role in the artist's work.

Furthermore, Viola uses space as a means to stimulate us into seeing things from an unfamiliar perspective. This is a particularly striking feature of *Pneuma*. In this work, flickering black-and-white images are projected into the corners of a dark, square room. Initially, these images give the impression of TV 'snow'. It is only after some time that you get a vague impression of figures appearing on the walls; that you recognize defamiliarized, dreamlike images of clouds, trees, water-lilies, fountains, buildings, deserted rooms, and bodies and faces, mostly of children. The

swarms of images appear as the grainy, grey, visual counterpart to the acoustic white noise also filling the room. But what is most striking to our senses is that our attention is drawn to the corners of the room. We enter the room at one of its corners, and the images are projected into the other corners, not into the middle of the walls where we conventionally hang and view pictures. This contributes to their distortion, but it also gives rise to the suspicion that it is essential to change our point of view, to abandon our well-loved habits, beliefs and prejudices if we want to see, and to understand ourselves and each other. We necessarily displace our gaze from what seems self-evident to look into the corners of our experience where the various lines of sight come together, cross each other or simply end. We have to illuminate the 'corners', the depths of the soul. It is no coincidence that the title of this work borrows the Greek term for a certain aspect of soul. Pneuma refers not so much to the emotional or intellectual sides of our inner life, but rather to the 'breath' or 'breeze' of life; to something that underlies and penetrates all living things, but remains as transitory as a breeze, and as hard to grasp.

55

Hence, the spatial and visual form of *Pneuma* encourages the viewers to face what they are usually not aware of, either because it's too deep for them to grasp or because they expel it from consciousness through fear. Only when we expose ourselves to our *conditio humana* do we find that the more we attempt to understand it, the more we have to acknowledge that we are finally unable to know anything about it. There is always a cloud of unknowing between us and the foundation of our existence.[10] This motif is further developed in *The Veiling*, 1995, where the cloud is transformed into a veil of unknowing. More precisely, this work confronts us with several layers of such veils, since images of approaching and departing people; of landscapes, trees and water are projected from two opposite sides of the dark room onto nine large veils, hung one after another, among which the viewers can wander. But from wherever they are viewed, the images can barely be seen because of their transparent nature.

By creating images that exist as structural elements of a space it is also possible for Viola to connect outer and inner spaces. This is true, firstly, in the purely physical sense. For instance, *To Pray Without Ceasing*, 1992 (11), takes on a different life

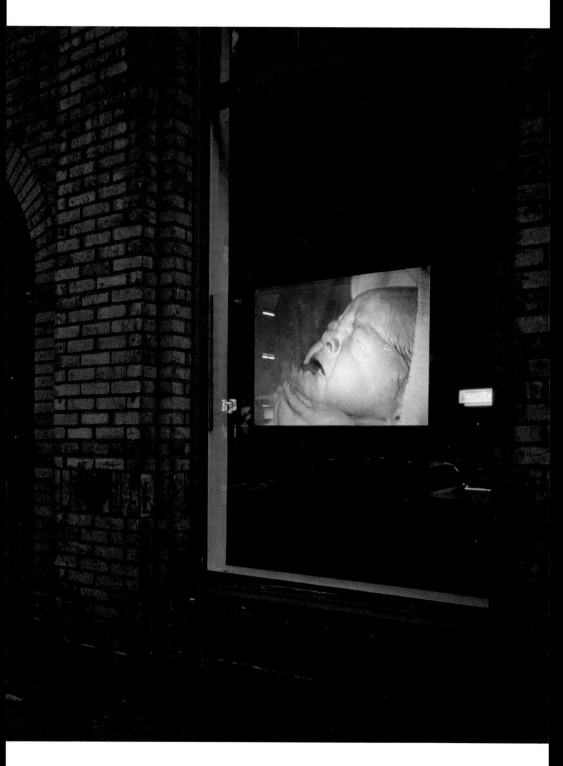

11 *To Pray Without Ceasing*, 1992

when viewed from outside the exhibition space. In this work, sequences of images – depicting light and fire; darkness, water, nature, birth and decay; individual and social existence – are projected onto a window. These images can only be seen clearly during the night; during the day, only a pale, vague idea of them lingers: however, we can still hear a voice, both inside and outside the space – reading passages from Whitman's *Song of Myself.*

There is an even stronger connection between outer and inner spaces in the psychological sense, if we consider that the space within which we experience art represents our inner spaces. A number of Viola's works refer to this inner space of experience to which we are rarely given access, to something that 'sleeps' at the bottom of our souls and makes our lives what they are. Nonetheless, the extent to which Viola allows us to approach this space varies greatly. *The Sleepers* can only be watched from a distance and only through water: we are denied any closer contact with what is within. In other works, viewers are embraced by the (outer and inner) spaces of the installation. The first barrier we cross in *Threshold* is an electronic text line scrolling across the wall, bringing the latest news from the wire service. We must then pass through a narrow black doorway to a dark room, where we will gradually come to perceive the shadowy images and breathing of sleepers projected onto three walls. In *Pneuma*, we are embraced by inner events in a deeper sense. Here, Viola does not so much gesture from the outside towards that which we barely suspect, but rather opens a window onto our inner life and confronts us with images that, in their vagueness, strangeness and transience, remind us of dreamlike apparitions.

We are made anxious by the nature of these images as well as by their spatial situation, the more so since they remind us of the obstacles which limit our experience of this kind of art and its subject. When viewing works like *The Stopping Mind*, 1991, *Threshold, Tiny Deaths, Pneuma, Interval* or *Going Forth By Day*, 2002, we stand inside their respective spaces. As a consequence, we are unable to accommodate everything that is projected into that space. Wherever we look there is always something happening outside of our fields of vision, or even behind our backs. We can't perceive the entire work, only parts of it. We may grasp neither the work as a whole nor its subject. This causes some irritation, which is further intensified by additional

properties specific to each work. In *Tiny Deaths*, this is caused by the unforeseeability of existential processes. Similarly, in *Interval,* serene images of a man washing and drying himself are interrupted at ever-shorter intervals by conflicting images of frightening natural powers, which are projected onto the opposite wall. *Pneuma* uses yet another technique to hinder our comprehension. Compelled to stand in a beam of light wherever we are in the room, our shadows are endlessly cast by one of the projectors onto one of the walls. The closer we approach the walls, the larger our shadows become; they not only distort our impression, but are themselves increasingly distorted. The more we wish to bring ourselves into play – the more we attend to ourselves through our shadows on the wall – the less we see of the work itself or transcend the ego-situation which normally hinders our perception.

It is not only the spatial condition of video installations, however, which prevents us from experiencing them in their totality, but also their temporal dimension. Since a work like *To Pray Without Ceasing* is projected day and night onto a translucent screen, with conditions of light changing cyclically, its visual perceptibility (the very feature we primarily expect from the medium of video) is reduced to almost zero for much of the time. (The only possible advantage of this, in terms of traditional apprehension, is that we can focus our attention on Whitman's texts.) Along with several other works, Viola conceived this piece as an endless loop so that its temporal extension is potentially infinite. Thus, it is impossible to grasp such a work of art in its temporal totality because, as a matter of practicality, no one will devote twelve hours to watching an entire projection cycle (let alone a day, much less an entire exhibition, during which the cycles of images and texts are continually repeated).

Nevertheless, we should be aware that a work of video art necessarily exists in time in just the way a piece of music or drama does. That is, if we were just to glance at it for one moment, we could not justifiably claim to have seen the work; it is necessary to watch at least one whole cycle of projection. However, the installation of a video piece in a room, because of its relationship to the exhibition of pictures, induces us to assume that it can be grasped by 'just glancing' at it. This misunderstanding also influences our way of dealing with 'motionless' images.[11] It seems that we are more willing to take into account the temporal dimension of video works if we view them on TV.

In addition to attentiveness, we must be ready to let the work have an effect upon us, or to enter into its world. This takes time; the more so if acquaintance with a work of art is conceived as a kind of spiritual exercise, as in Viola's case. The time required to achieve any depth of understanding extends beyond the duration of a single work. It is necessary to devote oneself to a work more than once and to deal with its relation to other works as well. This is particularly true of Viola's work because, in its entirety, it forms a greater unity, not only with regard to its subjects, motifs and formal properties, but also insofar as it seems to unfold from one 'plan'. Given that such a plan cannot be accomplished within a human lifetime, it is natural to presume that it is the very aware-ness of the biological limits set to the realization of such a work, or plan, which underlies Viola's emphasis on the unity of nature. This unity, too, can only be grasped fragmentarily in some of its appearances, and the artist's work, which forms one part of it, refers to that fact by its very incompleteness. Thus, strictly speaking, Viola's oeuvre manifests itself in singular 'works', but it is one whole, a work in progress.

Certain motifs – the natural elements; particular landscapes, plants and animals; humans, often the artist himself or even members of his family – crop up time and again in Viola's work. Some of these are obviously quotes from other works. One such line of motifs has been running for more than twenty years: at the beginning of *Vegetable Memory*, 1978–80 (**13**), a man plunges into water. Images of divers passing through, or merely suspended in, water recur continually. They are an essential element of both *The Passing*, 1991 (**12**), which is based on the artist's expe-rience of his mother's death, and *The Arc of Ascent*, 1992 (**14**), in which the video of a floating man is slowed down to such an extreme level that he appears to be drawn out of the image by some enormous power. The man returns in the central screen of the *Nantes Triptych*, 1992. He jumps into the water several times and floats there for a while, gently undulating and occasionally interrupted by turbulence, while we can see the birth of a baby on one wing of the triptych, and footage of Viola's comatose mother, a week before her death, on the other. The motif of the diving and floating man is continued in more recent works, such as Viola's film to accompany Edgard Varèse's composition, *Déserts,* 1994. In the complex installations *Stations*, 1994 and *Five Angels for the Millennium*, 2001, the motif is extended to a group of five persons.

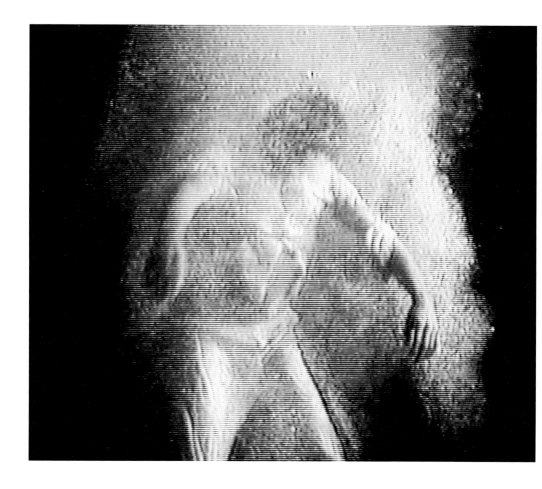

12 *The Passing,* 1991

13 *Vegetable Memory,* 1978-80

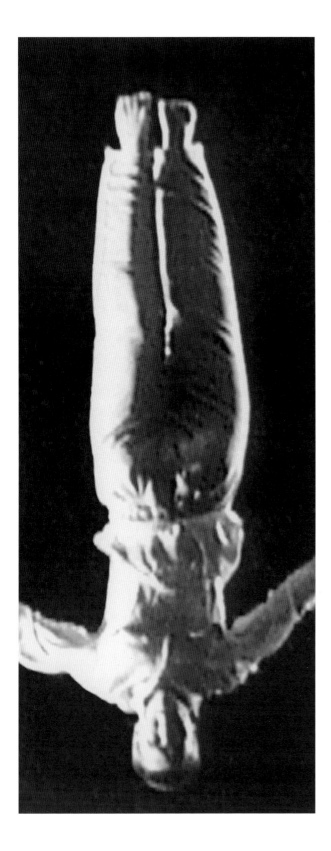

14 *The Arc of Ascent*, 1992

In the former, women and men, young and old, can be seen on large cloth screens, floating upside down in water, while their image is mirrored (and thus righted) in correspondingly large slabs of polished black granite on the floor.

Once Viola has established a motif, he combines it with others he has previously employed. For example, the dive at the beginning of *Vegetable Memory* is the prelude to images of the 'afterlife' (that is, the processing) of fish. A further development in *Hatsu-Yume (First Dream)*, 1981, links the 'afterlife of fish' motif with the motif of attraction to light which brings with it death. In *Sweet Light*, 1977, insects are attracted to their deaths by light, whereas in *Hatsu-Yume* it is fish which are attracted by the light of the fishing boats (and the humans by the lights of gambling dens).[12]

We could, of course, attempt to explain the existence and prominence of such 'motif lines' by assuming that Viola's creative work constantly circulates around the same phenomena and that he is looking for various aesthetic realizations of one and the same idea. This suspicion is perhaps not entirely false (and seems to be supported even more by Viola's most recent works); it is, however, somewhat superficial and simplistic. The conceptual or spiritual ground that appears in the works may be identical, but it is not presented in identical ways. The works exhibit, rather, different aspects of it, like the *conditio humana* (which is, in any case, a complex of problems so deep that artists of all times and cultures would never be able to exhaust it). The citations in Viola's work do not function as ends in themselves, but put one work in the context of others and of Viola's creative work in general. They transfer the content of a work (or aspects of its meaning) to other works and thus appear as elements of a language or sign system which we come to understand by becoming acquainted with the totality of Viola's oeuvre.

These 'motif lines' thus seem to be related to the song lines of the Australian aborigines, those paths that cover the whole continent of Australia, but are invisible to our Western eyes. It is along these lines that 'legendary totemic beings...wandered over the continent in the Dreamtime, singing out the name of everything that crossed their path – birds, animals, plants, rocks, waterholes – and so singing the world into existence'.[13] According to the aborigines, our world is, even today, recreated when those who have inherited certain song lines sing them again. These ideas

of a 'dreamtime' and of 'song lines' seem to play a role in Viola's work; they are referred to, for example, in the subtitle of *Hatsu-Yume* (*First Dream*) and in his essay 'History, 10 Years, and the Dreamtime'.[14] These concepts should not be totally unfamiliar to us, however; philosophers such as Baumgarten and Nietzsche have discussed a comparable idea: that art creates a kind of heterokosmos, a specific 'metaphysical reality' which supplements natural reality 'in order to overcome it'.[15] While this is true of Viola's work, like the song lines, he goes further than this, recreating in each piece the whole of his oeuvre as well as parts of the world we experience.

If we accept that these considerations are sufficiently plausible, we can conclude that Viola's work demonstrates the possibility of conceptions of time other than the one of an objectively measurable, linear sequence of temporal points with which we are familiar from our contemporary scientific episteme. In fact, Viola not only exploits the available electronic media to create a defamiliarized representation of movement (through slow motion and time-lapse, acceleration and deceleration), but the installations he creates in space also serve to depict different images at the same time and the same images at different times. Viola doesn't simply use such techniques for their own sake; he employs them to show the temporal dimensions of the *conditio humana*. This can be demonstrated in greater detail by considering the following examples:

(i) In some works, Viola inverts the direction of time by showing images backwards or in reverse sequence. For instance, *Ancient of Days*, 1979–81 (**15**), starts with a kind of Creation act. This seems to suggest itself, since 'Ancient of Days' is an expression for God in English translations of the Bible. But in this work, that act turns out to be the inversion of a process of destruction. It is more reasonable, therefore, to suggest a reference to cyclical creation myths found in cultures outside of the Judeo-Christian tradition. In Hinduism, for example, Brahma (the Creator of the World), Vishnu (its Preserver) and Shiva (its Destroyer) are ultimately regarded as emanations or appearances of one and the same divine power. Another significant characteristic of *Ancient of Days* is the difference between timeless tranquility and motion in time, between natural daily cycles and measured or conscious time, as well as the interpenetration of these different temporal phenomena. This is mani-

15 *Ancient of Days,* 1979-81

fested in the final part of the work, in which the regular ticking of a clock contrasts, on the one hand, with a cyclically changing landscape and, on the other, with a bunch of flowers which seemingly stands immutable in a vase.

(ii) The most striking feature of *Tiny Deaths* is the seemingly sudden switch from darkness, to which we are just becoming adjusted, to blinding brightness. This process takes place in an acceleration which, like the curve of evolution, is in turn continually accelerated and thus corresponds to the subjective impression we have of the process of ageing. In *Vegetable Memory*, Viola does just the opposite. The processing of fish is shown ever more slowly; time-lapse images (which correspond to the bustle of human activity) decelerate into extreme slow motion (which gives the impression of time freezing in the same way that the vegetative processes in the bodies of the fish come to an end).

(iii) In several works, Viola contrasts temporality and duration. In one of the long sequences of *Hatsu-Yume*, a rock is filmed at decreasing speed, from extreme time-lapse over normal speed to extreme slow motion. This effect can only be observed, however, by watching the action of clouds and humans; the rock itself appears invariable.[16] In *Interval*, Viola shows temporality and duration from another perspective. As I mentioned above, images of a man washing on one wall are constantly interrupted by frightening illustrations of the power of natural forces (as well as of men who are exposed to them) on the opposite wall. The lengths of successive projections are reduced exponentially (decreasing from one minute to one thirtieth of a second), while the frequency of their alternation increases accordingly. In the end, an interval below the threshold of perception is reached, extinguishing the horrible powers and giving a continuous duration to the images of purification. Nonetheless, we are left with a feeling of the acceleration of our vital processes.

(iv) *I Do Not Know What It Is I Am Like*, 1986, reveals an evolution of the mind as well as our integration into the processes of nature. Images of inorganic matter are followed by those of animals and of the artist reflexively dealing with this very piece. Images of the spiritual practices of Hindu fire dancers on the island of Suva, which occupy a large part of the work, then lead us back into the cycle of nature again in the guise of a fish rotting in a wood. The specific human faculty which

Viola calls 'the ability to extend the self into time with the capacity to anticipate and to recall',[17] plays an essential role in this piece. In the central episode, we watch the artist at work, evaluating and cutting sequences that are shown before or after. In the 'Riddle of the Sacrifice' – the 164th hymn of the first book of the Rig Veda to which the title of this work alludes – the simultaneity of things past, present and future in the human consciousness is expressed in the seemingly arbitrary change of grammatical tenses. With this in mind, it is not surprising that we find the same feature in Viola's text of that title.[18]

(v) It should be clear by now that temporal cycles – whether daily, annual or whole life cycles – are a crucial aspect of Viola's works. Viola frequently uses a cyclical structure in his works to express this idea. *Science of the Heart* provides a good example: '[We see] a human heart beating slower and slower until it stops. Then it comes to life and starts again. It's a difficult image to watch, but it is not negative or pessimistic. It contains sides of life. A circle is not negative or positive, it's a circulation.'[19] By embedding human life into the cycles of nature, Viola does not necessarily promote the idea that there are individual cycles of existence, but that we should experience ourselves as elements of a greater unity. This idea is already contained in the concept of the installation *He Weeps for You*, 1976 (**16**). Viewers are confronted with their own image, seen through a water drop, which, slowly growing, being stretched more and more, quivering before it falls, disappears, then reappears in another drop. In this process, the viewer forms a unity with the other elements of the system: 'A dynamic interactive system is created where all elements (the water drop, the video image, the sound, the viewer, and the room) function together in a reflexive and unified way as a larger instrument.'[20]

(vi) Viola also uses the possibilities of video technology to represent the temporal structures of life. In the *Nantes Triptych*, for instance, the existential interconnection of birth, life and death is represented simultaneously on three panels. This work illustrates the totality of life as well as the different structures of its elements. There is a correspondence between the installation's symmetrical design, and the temporal and spatial symmetry of the central panel through which the directedness of life towards its poles of birth and death is formally emphasized. The inevitable impact of

16 *He Weeps for You,* 1976

the beginning and end of life is underlined by the fact that the outer monitors of the triptych show video films in colour, the centre in black-and-white. While, on the right wing, the dying woman is encircled by the camera in a slow approach, her face filling the entire screen, on the left, the temporal phases of the birth are characterized by pushes, and the child eventually proclaims its existence by crying. Acoustically the laments of the woman in labour are predominant at first, but then the noises of the water (which is the medium for the diving and floating man shown on the central panel) and the calm, but laborious, breathing of the dying woman increasingly come to the viewers' attention. If the spectator is ready to experience at least one entire cycle of the *Nantes Triptych*, then the initial voyeuristic curiosity transforms into an awareness of the temporality of their own existence and the recognition that the cycle of life is a natural fact.

(vii) Like *The City of Man*, 1989 (**17**), or *The Greeting*, the *Nantes Triptych* takes up the tradition of classical panel paintings which so often also have as their subjects birth, death and other elements of the *conditio humana*. But if we are confronted with such phenomena today by viewing painted images, we are inclined, Viola suggests, to see them 'as subjective views, personal interpretations of these events', since they 'have been depicted many times in history'. By comparison, modern media have 'a very high accepted truth factor in our society' and can thus perform the same function as panel paintings in earlier centuries.[21] Perhaps no work reveals this better than *The Greeting*, which evidently has as its model *The Visitation*, 1528-29, by Jacopo Carucci (called Pontormo) for the church of San Michele in Carmignano.[22] This announcement of a birth is not just put into motion, however; it is magnified by an extreme slow motion that adds intense meaning to each gesture and facial expression. Consequently, the work evokes the whole range of human experience from birth to death (which seems to me to be announced by the image of two male figures standing together in the background).[23]

(viii) According to Viola, images gradually became temporally invested objects over the history of art: with the invention of perspective they were 'personified', that is, bound to the persons of artists and viewers. A new aspect of this temporality came into play with the use of movie cameras, since such images are transitory and exist as a whole only in the mind of the viewer:

69

17 *The City of Man,* 1989

The viewer sees only one image at a time in the case of
film and, more extreme, only the decay trace of a single
moving point of light in video. In either case, the whole
does not exist (except in a dormant state coiled up in the
can or tape box), and therefore can only reside in the
mind of the person who has seen it, to be revived
periodically through his or her memory.[24]

As Viola emphasizes, the temporal existence of video images is comparable to that
of living beings: 'Images are born, they are created, they exist, and, in the flick of

a switch, they die.'[25] Yet the sensual appearance of *all* works of art is transitory, therefore the representation of the temporal aspects of the *conditio humana* cannot be restricted only to video art. This is confirmed, at least indirectly, by Viola himself, since he stresses that 'if artists are drawn to these themes in their life and work then, yes, they will find that video is very well suited to expressing these concerns. But these issues go beyond a specific medium and become a reflection of our times.'[26] Nonetheless, it is perhaps a specific merit of video art that it is able to make us aware, not only of the transience of all art, but also of our own transience. More than any other artistic approach, video art is suited to bring to our minds, to reveal the fact, that human existence is determined by time.

ON THE ANTICIPATION
OF RESPONSIBILITY

JONATHAN LAHEY DRONSFIELD

'The Indian sat on the front seat, saying nothing to anybody, with a stolid expression of face, as if barely awake to what was going on. Again I was struck by the peculiar vagueness of his replies when addressed in the stage, or at the taverns. He really never said anything on such occasions. He was merely stirred up, like a wild beast, and passively muttered some insignificant response. His answer, in such cases, was never the consequence of a positive mental energy, but vague as a puff of smoke, suggesting no responsibility, and if you considered it, you would find that you had got nothing out of him. This was instead of the conventional palaver and smartness of the white man, and equally profitable.'[1]

<div align="right">Henry D. Thoreau</div>

What if I were to say that Bill Viola's work esteems the silence of Thoreau's North American Indian, but at the same time answers for him, feigning the demeanour of the Indian with all the smartness of the white man? I am not sure I do want to say these things, but then again I am close to saying them, and do not know yet what it is that is stopping me. Apart, that is, from its being something about the images, and my responsibility towards them. What I am sure I want to say is that, if he does do these things, Viola does them in the name of what he calls responsibility, and it is this which motivates me to attend to his work more closely than I otherwise might. Were it not for the artist's writings and interviews, I am not sure I could hold my attention to the images long enough to do so. It is an allotment of the challenge of

writing about Viola's work not to allow its mysticism, its overt symbolism, its attempt at transcendentalism, its ready access to original states and its moral certainty to relieve the critic of the responsibility to do justice to those moments when its images overcome these baleful constraints. And while this is a justice redeemable simply by looking at the images – for some of them do indeed emerge from that haze of limitation – it is important, I think, to say why. Viola's works imply a certain conception of responsibility, one that is acknowledged with a different explicitness in his writings. Part of the purpose of this essay is to question the sense of responsibility presupposed by his videotapes and installations, and appealed to in the writings and interviews, and to do so by assisting Viola's representations to do something they find difficult to do by themselves: become self-critical.

I want to begin with a handful of citations which, taken together, sketch Viola's understanding of responsibility. Chronologically, they cover a thirteen-year period up to 2003, and are to be found in interviews in artworld journals and websites:

> I would sum it up as "responsibility". Responsibility to myself,
> to my family, and the community, friends and strangers.[2]

> We have this thing called the "artworld", which has a very rarefied
> atmosphere, much like academia, and which stands in isolation from
> the community at large. Artists of my generation who have picked up one
> of the dominant tools of communication – television – and attempted to
> make art with it have taken a radical step which we haven't seen since the
> Renaissance or possibly the Baroque period. In 1975, my first work to be
> broadcast on television was seen by half a million people. That creates an
> incredible opportunity. I don't know if I can use the word "responsibility",
> but it certainly necessitates a contact with people that is going to bring
> into focus all the issues of the avant-garde position.[3]

> One of the greatest dangers in our lives today is the objective eye...
> Rational objectivity is distancing us from the moral, emotional

responsibility that we have towards other human beings.

The detached eye is a dangerous instrument.[4]

> The big responsibility right now is to develop an understanding
> and awareness of the effects these images have. We are in a
> situation now culturally, whereby the people who have created
> this huge image machine which is inundating us, flooding us with
> images – every night every hour every day all around us – have no
> knowledge or awareness or understanding of the real effect those
> images are going to have on us... We must pass through the body,
> you can't let the appetite of desires control you which is exactly what
> advertisers and corporations are going for, because these tools are
> so physical and visceral... The entire society is illiterate, and they
> are being controlled by the people who can read, that is the
> controllers of these images, the image-makers.[5]

In brief, Viola's responsibility would seem to be a 'subjective' responsibility – or at least one that would oppose a scientific or technical responsibility, or indeed an objective responsibility. At the same time, however, that responsibility would seemingly include remaining responsibly mindful both of the publicity of the language of his works and the relation his works have to the history of art. One necessarily presumes, as one presumes of all artists in order to write effective criticism, that his works are a responsible response to that history. One senses, too, an all-inclusive responsibility within the work that extends to the moral and emotional embrace of the stranger, the other. This responsibility is revelatory of the real effect images can have on the 'other'. It eschews the use of advertising effects and, remaining immune from appropriation by advertisers and perhaps even the artworld, stands both as something of an antidote to the reality of those images and as a new way of reading them.

Now, the important thing is not to refute Viola's arguments (such as they are here) for responsibility, nor to point up their inconsistency or inherent contradiction. This is not because that would be both facile and futile, but because Viola is no

privileged spectator of his work, and no less an interpreter of it than I am, or anyone else. It would be like asking the artist the meaningless question of why he made this or that work of art. The more significant questions to ask concern what comes of the work: whether an alternative notion of responsibility than that which Viola espouses can be derived from his work, or fitted to it; whether the work itself achieves a responsibility with respect to itself. This is not the same thing as holding the artwork to be responsible; no artwork can answer for itself. Its responsibility would consist, rather, in the artwork's demonstration of the limits to our being able to answer for ourselves, and for the work. That is a question of our finitude, of our being able to become the apt agents of the sorts of responses the work makes possible.

Already you will see that I am emphasizing a real difference in Viola's work from that presupposed by the artist, despite his insistence that he is indistinguishable from his tapes and installations in terms of responsibility. His is an inclusive responsibility. So inclusive, indeed, that it might be understood to deny the viewer a response: the artwork speaks for him, reassured by its good conscience. But is it not irresponsible to believe that one's work, simply by virtue of its being vouchsafed by the intention to be responsible, is ipso facto responsible? Would Viola accept responsibility for his work if it could be shown to differ from the responsibility to which he appeals in his interviews to the press? Moreover, how could he accept responsibility for such an unforeseen effect of his work? As Viola remarks, 'The invisible is always much more present than the visible.'[6] With its focus on the 'invisible', with its promise of revelation and its invitation to reflect on what else might exist in this world of objects, and its confident expectation of an explanation for man's religiosity, Viola's work makes great play of the mystical and the messianic. But Viola's is a messianism without the eschatological promise. There is no sense of anticipation, or if there is then it is decided in advance what is anticipated. The address has programmed the response of its addressee; the addressee is passive.

It might be said that one way of distinguishing modern from contemporary art is that the latter is made less to be looked at than to be interacted with. But there is, increasingly, no space for interaction in Viola's installations. The recent pieces (*The Messenger*, 1996; *Nantes Triptych*, 1992; *Five Angels for the Millennium*,

2001) especially are seen as sheer spectacle, because of what Viola likes to call their 'transcendent' quality.[7] These works are rather like Greek tragedy without the chorus. The images are laden with content – a content that is immoderately identifiable and determined – and directed in their intent. There is little room in Viola's recent installations for spectatorial judgment, or the possibility to come to a decision about them: the atmosphere is not conducive to the viewer's intervention. Nevertheless, like Greek tragedy, we are being asked to consider the way in which we are always responsible, responsible for our being in the world beyond any consequence we are able to foresee in our actions. But this situation should not come at the expense of excuses or virtues with which to mitigate that responsibility. Yet this is precisely what is denied when the viewer's participation is negated, when he is not invited to come to a judgment.

One criticism we might make of Viola's work is that it does not, on the whole, invite interesting responses: it neither opens up challenging routes of explanation, nor makes possible original modes of communication, nor invents new concepts. Rather, his works are asserted, literal, illustrative, dogmatic answers to which the spectator can merely assent; such is the danger of being an artist who places his faith in the work's capacity to say 'I believe'. None of this, of course, makes Viola an irresponsible artist. Indeed, we might say that the elision of any demand for critical response, coupled with its capacity for absorption, goes a long way towards explaining the popular response to the work. The problem, I think, is that Viola fails to displace the world, does not bring it sufficiently into contact with the viewer. This is, perhaps, partly because Viola has no feeling of responsibility towards his medium. This may seem an odd thing to say of someone with such an articulate grasp of the history of the medium and of the technical structures of perception.[8] But it is the artist's work which is expressive of his or her recognition, or not, of a responsibility towards video as a medium, and I would argue that what is expressed by Viola's work is a lack of such recognition.

Theodor Adorno remarks that the only philosophy which can be 'responsibly practiced' is 'the attempt to contemplate all things as they would present themselves from the standpoint of redemption', as they might 'appear one day in the messianic

light'.[9] This is impossible, of course, for we can say nothing about how the messiah might 'see', or indeed whether he sees at all. But an artist, imaginatively, could show that. One way in which art has always sought to estrange the viewer from the world is to put into question the materiality of its own medium, to bring the viewer into a felt contact with the medium itself. This is a strategy of conservation: not to use the medium up, as it were, as a means to the end of representation, but to allow the materiality of the medium to exceed the content, to escape narrative service to the world. Something of the material of the artwork is permitted to remain with the viewer after the process of its making has come to an end (at least for the artist as artist, rather than for the artist as viewer or interpreter).

This situation is made more interesting and complex in the case of video art because its inception coincides with the debate over whether we can speak meaningfully of artworks having a medium at all. (Indeed the nebulous properties of video could be said to be the inception of that debate.) The medium-specific argument is precisely what video stands as a challenge to. Perhaps video is not definable in terms of its medium at all. If we can speak of different media in art, then they are not necessarily definable in terms of the material properties specific to them. If video is a medium, then one of its material properties could be the body: the body as subject being in some way constitutive of the medium of video itself. It is not for nothing that almost all early video art has the camera trained on the artist, normally in the privacy of the artist's studio, or during a performance of which the artist's body is the locus. Consider as examples the now canonical oeuvre of Vito Acconci, or Bruce Nauman's studio-based performances. Furthermore, one of the histories of video art is the history of the movement away from the artist's body towards that of the viewer or participant; towards the inclusion of the participant's body in the work itself. Is the history of video art thus the history of the body and of the participant's part in the making of the history of art? One way of interpreting Viola's insight that 'video may be the only art form ever to have a history before it had a history'[10] is to say that the history of video art is a history of the artists themselves, or of the spectators themselves as embodied participants in that history.

It is interesting to note that Viola's career spans almost the entire history of

video art. He began making videotapes in the early 1970s, barely half a decade after their first appearance in the artworld. He admits to being drawn initially to the work of 'body artists' such as Acconci, Terry Fox and Dennis Oppenheim.[11] As with these artists, Viola's early work used movement to show what images can do to themselves, to illustrate what makes framing possible. For Viola, Acconci, Fox, Oppenheim et al employed what he calls the 'device' of the body 'to frame experience'. But already, with this remark, it can be seen why Viola moved away from the body: he did not see it as the very frame and surface of the work. Rather, he conceived of the work as the frame of the body.

The early concern with the conditions of the possibility of representation was to become displaced, in his installations, by the fixation and isolation inherent to representation. Viola may see sensuality as 'the basis of [art's] true conceptual and intellectual nature...inseparable from it', but it is the representation of sensuality, not the sensuality of the medium itself, which is a central theme of his work.[12] He does not intend that the visual be 'always subservient to the field, the total system of perceptual/cognition at work'. On the contrary, in Viola's work it is possible for sensuality to be incorporated and framed by the image itself, where sensuality is material for representation. This is why, I think, Ann-Marie Duguet is driven to ask of *Passage*, 1987: 'Could this be the last installation belonging to the realm of representation, just before the virtual space that the body itself enters?'[13] The artist's comments on this work reveal what he took himself to be presenting to the world: 'an image which transcends human scale in time as well as space'.[14] The more an artist is convinced of his own framing power in this way, especially when the image is shrouded in 'mystery' and born of an overwhelming humility towards the world, the less interested he will become in the 'interactive' aspect of his work.

Viola's gradual movement away from the body culminated in its eventual eschewal: 'We must pass through the body, you can't let the appetite of desires control you...'[15] The body is resistant to touch in Viola's recent installations: it has hardened into the immaterial subject of representation. At the same time, Viola is a dealer in images, and some of those images will exceed his authority as artist to claim an autonomy that enables them to rejoin the history of modern art's transition

78

to the contemporary. The force of an image, for Viola, will always rest on its representational content. But his images are simultaneously so laden with the reference to our experience of them – what it is like in that particular place, at that particular time – that it is sometimes difficult not to feel them, not to feel the heat. At that moment, something of the experience exceeds the image's ability to capture it, such that the viewer must begin to feel what is presented there. *Chott el-Djerid (A Portrait in Light and Heat)*, 1979, is a fine example of this, where, despite the effacement of its materiality, the medium is so covered over by content, so submerged beneath Viola's faith in representation – 'I have never lost my faith in the image'[16] – that it resists with such force as to burn through the image.[17]

An artwork's materiality consists not merely of its techniques or material base, but in how it succeeds in transforming the place of materiality in the world – the material world as such – so that we feel the work in the world, so that our sensibility is renewed by it. Viola's emphasis, however, is on revealing the materiality of the world. It's an emphasis which runs hand in hand with the 'meditation' on death throughout his work: I'm thinking especially of *The Passing*, 1991, and *Nantes Triptych*.[18] But so over-determined is this attention, so certain is the work that it can show the material experience of mortality, that it seems to take the life out of death; it takes away from death what it is that cannot be anticipated about it. There is a sense in which Viola presents us with beautiful deaths, as if we could offer to ourselves photographs of the right moment to die. Such is the weight placed on mourning in Viola's work that what we mourn over is the passing of death. An overly expected arrival, death in Viola's work is more like a reminder that death has happened: there has been death, there will have been death. But is this not anyway the condition of the image, whether of death or not? An image of anyone is of someone who will die; an image is almost certain to continue to exist after the passing of that person. Every image of a person is one haunted by that person's death and, as such, is a picture of that person marked by his disappearance. The anticipation of our disappearance is part of our participation in our representation. It is precisely this essential mark of the image, its ambiguous fatality, which is covered over by the insistent representation of death. What the viewer is

looking for is a new way of showing this essential mark. The interesting work of art might be one continually capable of transforming this necessity.

I would argue that, deep down, Viola is a sceptic. A symptom of this scepticism is that nowhere are there other minds in Viola's work. Consequently, there is no communication, no concern with or wonder at what makes such communication possible or impossible. What Viola does, with his emphasis on technique and the technical conditions of perception, is to substitute a different language game. He takes advantage of the properties of moving images to utilize different sets of rules, ones which need have no relation to a context of use other than that given it by the work of art.[19] Now, sometimes this is the very success of a work of art, the way in which it reveals how precisely that same move (to substitute rules) is possible in the world in which we live. The artwork shows how it is allowed for by those conventions that would otherwise, for the most part, seek to exclude it. But Viola's work is not party to such deconstructive strategies.[20] On the contrary, it seems to refuse to recognize the contingency that is the relation to convention. Instead, the director simply stipulates another set of rules. It is this denial of context, I'd suggest, that marks Viola's as the work of a sceptic, as if there were no before, and no after (apart, that is, from the mystical resolution).[21]

In its place, perhaps, there is the presumption of an experience shared. The emphasis on experience is such as to negate the autonomy of the images. This is an autonomy all images have: the finitude that comes with there being representations at all. It is an autonomy which is also their dependency; a relative autonomy, for in being framed they need human beings to assist them in doing something they cannot do for themselves, that is to become self-critical. As I have stressed, there is nothing 'yet to come' in Viola's work. There is no sense of the possibility of our making a contribution to the image, no way we can intervene and assist it in this process of critical judgment. We are left only to identify with the experience, or not; we are left merely to 'share', or not, in the experience of what is represented there, but not to come to a judgment about it. The emphasis on the universal, on so-called 'basic experiences', far from opening the work out to everyone, denies one a glimpse of the possibility of oneself as a self, and as a consequence nowhere is

18 'The Space Between the Teeth', from *Four Songs*, 1976

one exposed in Viola's work to the otherness of being an 'I'. At the same time as Viola's work perhaps engages and opens out a new spectatorship for art, it closes down another audience altogether.

The camera can show only what is shown to it; but Viola's work perhaps lacks this basic humility. Instead, there is the revelatory feel of being shown something for the first time, as if it were the invention of the camera. By contrast, there is something akin to the opposite of revelation, an objectivity and authority, which would have it that the camera can show us whatever it wants, and by implication can choose not to show. Viola's images are perhaps too dualistic, in that the objects they depict are not really allowed to participate in the making of their appearances; or else they are not dualistic enough. By this I mean that one sometimes has the feeling that Viola believes he has seen things as they are, that we are being given 'things-in-themselves', and perhaps for the very first time. For while there is no lack of reflection on the origin of things, of the origin of their meaning in ritual (*Hatsu-Yume* (*First Dream*) from 1981, springs to mind), this comes at the expense of any real questioning of them. This would be a questioning that held out the possibility of an answering, rather than merely the prelude to a guaranteed answer. This would be a questioning that created a time and a space in which to try out an answer, rather than one that creates for itself the room for one answer only – the final answer – or leaves us no route at all for explanation, only the asserted mystery of things.

What can our relation to the world be in Viola's work? I must admit to being unclear. It is not that I do not recognize myself in the points of view he makes available; it is that I find he denies points of view at all. His is a sceptical view of the world, a this-worldly scepticism which maintains that we cannot achieve, with any certainty, confirmation of our existence in a world of everyday or ordinary objects. The BBC introduced a recent feature on Viola's work by claiming that he 'says that he tries to share the question, not draw any conclusions'. But I would say that part of the reason Viola misses the finitude of the objects he shows is precisely his not protecting them with questions that would lead to anything other than determinate answers. Were he to open pathways of explanation, then the objects and events of which he treats might better be able to show themselves. In some of the earlier

19 *I Do Not Know What It Is I Am Like*, 1986

works one could almost hear Viola asking himself questions about this, asking himself what he is doing, and perhaps not being able to answer, for instance with *The Space Between the Teeth* (**18**), one of his 'Four Songs' from 1976. But later works such as *I Do Not Know What It Is I Am Like*, 1986 (**19**), and *Déserts*, 1994, stamped by an authority which is not theirs to bear, answer in such a way as to dispense with the questioning, and thus forego or negate the questioning force of the very objects and events represented. Rather than allow those objects the finitude of a question, Viola asks them to bear the weight of an infinity that of necessity remains nebulous. That burden disables them from arriving at their own relation to the world.

In the praise given their incessant but peculiarly consistent 'putting into question' of the distinction between the illusory and the real, Viola's videotapes and installations would seem to be the occasion for critics of a magnificent scepticism – the sceptical expression the moving image has been waiting for. One might ask of that 'putting into question' if the existence of the distinction between the real and the illusory can really be shown, or if the illusoriness of it can be proved, or if it is indeed worth making the distinction. But Viola's scepticism is as scepticism will always be, the occasion of nothing if not the assured demonstration of his own position. One might believe that Viola hasn't quite thrown off the desire to remain in control of the answers. But he wouldn't dream of it: as with the acts of the best magicians, we may not know how Viola's transfigurations of the world are carried out, but we remain in no doubt that something has been carried out. The representational content of the world has been thrown into question; something about it has been carried out, and the spectacle we are proffered in place of the 'real' or the 'actual' really happens. In this respect, Viola's images do give us something new, but they do not give us something new enough to question what it is that exists, and how it exists.

The Austrian writer Von Hofmannsthal wrote: 'The ability to ask certain profound questions can develop in us by the presentiment that they might be answered, by encounters – even by the anticipation of encounters.'[22] The encounter is certainly a crucial moment in many of Viola's works. But, again, it is presented as answer, without the anticipation of our being able to be affected by what might be encountered there. This is a question of performativity. Viola's dismissal of the performative

in favour of the existential is revealed by the following remark: 'Like writing about sex, you can't do it and write about it at the same time.'[23] Much of the history of video art is performative: the question of the body as medium, of the body's relation to the medium, is rehearsed in the very making of the piece, such that the problem is performed in this process. However, Viola's work is more illustrative. The image acts as an illustration of a way of thinking, maybe of an ideology, or else of the impossibility of telling the real from the illusory. The viewer is allowed not to involve himself in, take responsibility for, the way in which Viola's images mean – an observation it is the responsibility of the critic to draw out.

Despite the appeal to universal experiences, Viola's art – like all art – recoils from the objective world. But most art that we regard as 'great' does not leave the world; it broaches this antagonism at the level of form. Viola's work, on the other hand, takes itself to 'transcend' the world, to adopt a mysterious view from nowhere. Thus it cannot ask questions about the world or put to it questions about it. 'If artworks are answers to their own questions, they themselves thereby truly become questions': but Adorno is not quite right here, I think.[24] Artworks certainly invite the response of a purely aesthetic evaluation, which is in fact to misperceive them aesthetically, as if their autonomy is a given. But they only achieve their autonomy if they do pose a question, and the posing of the question is their essential link to us, the viewer. In displacing the world, or else by displacing itself from the world, the artwork, in its essentially questioning nature, is the utopian answer to the sceptic. The artwork's question is never simply the artwork's own. In order to be a question, it has to be of the world; the artwork has to be as real as a question.

Viola might say that this 'view from nowhere' is the point of view of the other, of the stranger, which presumably he would counterpoise to the irresponsibly objective view. But what can we say of the other's view, if, that is, it is other? If the view of the stranger is opposed to the objective, then this is no less a determination of that view than is the determination of it as objective. We do not represent otherness. We try and grasp it or we welcome it in what anyway comes to us; otherness in the same, not opposed to the same and residing in some world other than this one. All possible views are views of the other, views with which I am always

inundated, views which are the source and focus of my responsibility; not some 'other' content opposed to the objective, the advertisement, the everyday, the ordinary. When I look into the eyes of the North American Indian sitting in the front seat next to me, or into the eyes of the owl in the zoo or in the wild – as does Viola in *I Do Not Know What It Is I Am Like* – I do not see myself. I see the Indian or I see the animal – in any case the other – looking at me. It is no more a reflection of me than it would be if their eyes were closed. I do not recognize myself in the Indian or in the owl, I recognize him or it in me. The acknowledgment is of the other in me, whether he has his eyes open or not; whether his look 'suggests no responsibility', as it did for Thoreau, or not; whether or not the owl's eyes have, as they did for W. G. Sebald, 'the fixed, inquiring gaze found in certain painters and philosophers who seek to penetrate the darkness which surrounds us'.[25] The light cast by the image of another is always an address to my responsibility.

Or is Viola's 'scepticism' truly a response to scepticism, his works a rebuttal of the sceptic's challenge? After all, one senses that Viola's art is attuned to the way in which the realism of the represented world is a function of how the world keeps to itself. The world withdraws itself at the moment a work of art is shown, allows the work of art a time and a space which, while not just its own, is nonetheless a new moment in our understanding of the world. But it is as if that moment is decided in advance in Viola's work, and that becomes the content of it rather than the event of it: again, representation over performance. What is left in Viola's work at the moment of the world's withdrawal, the moment when the work of art might be allowed its autonomy, is some transcendent meaning, or something transcending meaning. I do not see in Viola the affirmation that images can mean ordinarily, mean in the ordinary sense, or in the sense that their meanings can be ordinary meanings: his is no deconstructive pursuit of 'how' things or images mean. If it is a rejoinder to the question 'How do you know?' it is one which retorts 'We cannot', or 'It is an illusion if you think you can'. If Viola is suggesting that objects have no fixed meaning when he remarks 'It's a new idea that images don't represent fixed things'[26], is that remark not expressive of an inability to see objects? Viola, blind to objects! A monstrous claim of one so attentive to the detail of things – but seriously, does Viola want to say that

objects cannot mean visibly in an ordinary sense? Or is Viola suggesting that he wants objects to represent fixed things? Does he want a system of meaning that sits in front of the new – a reversion to a previous way of seeing things? If it is impossible to see objects, this impossibility is at the same time the condition of the possibility of seeing them; such are the lessons of deconstruction. But for Viola this impossibility is merely the occasion to see beyond them, such are the musings of mysticism.

There are times when Viola does insist on experience, in a twofold way: on his own experience and on the absolute experience of the particular. 'My travels have taught me that there is always just one 'right place' where an idea can come to life...'[27] He makes that insistence to deny his works their own moment in the present, the moment when viewers can intervene or make sense of the work themselves. A consequence of this is to miss the moment of the space of presentation – the gallery itself. For the insistence on spatial and temporal particularity is not on the time and space of the viewer's interaction with the work; it is on the time and space of the content of the image. It is precisely this quality of the work which is so reassuring for the viewer who seeks to exemplify artworks in the service of ideology. The atmosphere is one of fixation on the empirical; one that takes the form of images which draw the gaze, a gaze so susceptible to aversion, of those who prefer their art as politics. This I think helps explain why Viola's work is so venerated by the politically correct.

Then it may be that Viola's art does indeed speak something of the truth of art. His having to don the mask of the North American Indian as exotic other in order to do so does not indict the artist; it is a symptom of the times which requires that the truth of art's aspirations, its provocations, be disguised in one way or another. But the worry persists that Viola is never wholly conscious of the necessity of that mask, that he never really doubts that the mask is necessary. I would suggest that Viola's work never seems troubled by what it shows. Rather, there is a sheer affirmation of and faith in the capacity of the image to represent, a joyful but humourless and self-confident affirmation that is the mark of an artist blissfully unaware of, and out of joint with, the times in which he lives.

20 *Passage*, 1987

SPIRIT AND MEDIUM
The Video Art of Bill Viola

DAVID MORGAN

In *Passage* (**20**) a 1987 video installation by Bill Viola, the viewer walks through an unlit, narrow corridor twenty-one feet long to arrive in a small room. Once there, one faces a wall composed entirely of a rear-projection screen upon which appears the videotape of a young child's birthday party. The surface is covered by gigantic faces and bodies that move in extreme slow motion (one-sixteenth normal speed), while a highly amplified sound rumbles in the small space, along the walls, into the body of the viewer. The images are so magnified that the scene dissolves before the eye in ever-shifting patterns of colour and the horizontal scanning lines that comprise the video screen. Since the room in which one stands is only seven feet deep, the viewer cannot gain much distance from the screen. If one backs down the passageway to get a better view of the piece, most of the image is blocked. There is no optimal point from which to view the video and assemble it into a coherent narrative whole even though the subject matter is intelligible.

The obvious questions – Whose birthday party is this? Where is this taking place? What are the children and their parents saying? – are never answered because the viewer is deprived of the narrative framework that would explain the situation. By disjointing sound and image, reducing the soundtrack to ominous, rolling, tympanum-like cataracts of sound, the artist causes the imagery to unfold as if in a dream. The result is the estrangement of a very familiar subject, turning four-year-olds into surreal colossi. Viola undermines the documentary character of video as we in the age of television and photojournalism have come to understand it.

For artworld cognoscenti there is nothing new about video as an artistic medium. Spanning a history of nearly four decades, video installations have become a dominant form of art at the end of the old millennium and the beginning of

the new one. But for the uninitiated, video hasn't lost its strangeness, its challenge. There are several good reasons for this continuing difficulty of video art. One is that video requires the viewer to occupy real time in order to experience the medium. The minutes pass slowly in a video installation. One must patiently watch the whole piece unfold according to its time, which rarely matches or accommodates one's own.

Video requires you to stand as a body in a public space among other bodies and wonder what to do with yourself, your material self, as you spend anywhere from two minutes to an unbearable ten or twenty watching a stream of images on a monitor or projected onto a wall. There is something about the quick or dashing way of looking at art in museums that tends to conceal the body of the viewer from him- or herself. Video installations challenge this by making the viewer self-visible, a social presence confronting oneself, perhaps even as part of the artwork.

The issue of the body – the one seen and the one doing the seeing – is an important one in video art. It's hard to talk about the body and what it knows because its language is visceral, its states ephemeral. Whenever we think about our own bodies we know that we feel, but it is hard to find words to represent those stubbornly inexpressible states of being. So we rely on metaphors to convey the feelings and sensations to others. Movie theatres provide soft chairs and a dark room for viewers to forget themselves, including their bodies. But video installations in gallery spaces are altogether different. They are very often about the act of viewing and the time it takes to do so. They prompt a spatial and temporal self-consciousness whose first impression is frequently an uneasy one.

The time-based nature of the medium is closely related to another reason for the difficulty of video. Artists like Viola are deft at using their medium to anatomize human perception, dissecting its mechanics and ideologies. Seeing the machinery of vision subverted – whether it is clips of eye surgery, rooms darkened to the very threshold of perception, or disorientation caused by sporadically moving imagery and jarring sound – produces an awareness of how commonly we rely on fixed conventions and frameworks in 'ordinary' perception.

Passage, for instance, makes one aware that the solidity and familiarity of the world depends very much on the distance one views it from. Human perception is a

biomechanical construction of appearances. And memory, the perception of time, is a highly interpretive faculty. If the narrow corridor is the 'passage' to the past, which is replayed as the massive image of the party on the wall, the room itself is the inner chamber of memory in which the raw sense data of experience are played and replayed. It's as if Viola has constructed a spatial metaphor for memory in order to show that the 'you-are-there' experience we posit as the authoritative basis of memory, the trace of the original moment preserved faithfully in the mind, is itself incapable of resolution. Or that what arrives at the strictly sensuous level of perception is a confusing welter of data, sensations that do not conform to the conventional regulations of time and space.

A certain strand of Bill Viola's work since the mid-1970s remains reflective about video as a medium and as a search for its metaphorical capabilities. If Viola's work is occasionally 'difficult', it is because of the ideas he wishes viewers to consider as they experience his installations. But on the whole, there is a theatricality and a rich metaphorical suggestiveness in the last twenty years of Viola's output that is both a signature of his work and the reason why most viewers find his work engaging.

Consider *The Crossing*, 1996 (**21**): on a double-sided screen over twelve feet high are projected, one on each side, images of a man (who resembles the artist) walking toward the viewer. The screens begin as dark, wavering fields of black and grey, reminiscent of Mark Rothko's paintings. But these pictures move. They are animated with light and sound, and the small image of the figure at a distance, walking in slow motion. His loose shirt and trousers flicker as he approaches, his image assembled from the ill-defined, shifting patches of video's horizontal linear patterning. When he has reached a position a few feet from the picture plane, standing at a height of seven or eight feet, the man stops and stares at the viewer. On one side of the screen, a small tongue of flame appears between his feet. On the other side, water begins to drip and splash on top of his head. Seemingly conjured by wizardry, the flames leap as the man raises his arms from his side; the drops of water become a torrent. The sounds of crashing water and crackling flames rise in step with what we see. In a moment the flames engulf the figure, consuming him in their roar, his clothing appearing to blacken. A moment

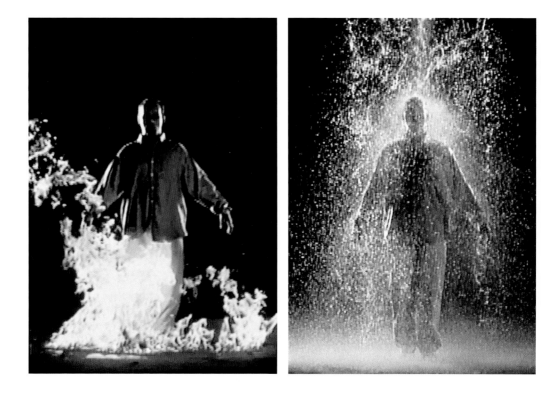

21 *The Crossing*, 1996

later, the figure vanishes in the thick flames and the cascade of water. Then each subsides and the scene is left empty of man and elements.

The Crossing displays in dramatic fashion the immolation and inundation of a man; a towering figure who creates and succumbs to his destruction by nature's opposing forces of fire and water. This brief installation is charged with metaphor. The act of artistic creation may in fact amount to the destruction of the artist as a kind of mythic hero who is utterly consumed by the work. The reference to painting as well as to theatre is strong, and the allusion to a kind of divine creation sequence no less apparent. From the darkness appears a figure who strides boldly toward the viewer. It is difficult not to regard this figure as the artist himself. Stopping at centre stage, looming above the viewer, he submits to the prevailing logic of expressionist aesthetics: the agony of self-emptying, the spectacle of complete submission to the self-annihilating demands of art. A kind of alchemist, wizard, shaman, messiah, God and Wagnerian tragic hero, Viola transmutes the body into art as if the creative act were a cosmic principle engaging the primordial elements of fire and water.

Probably the 'easiest' of Viola's videos, *The Crossing* exhibits characteristics of theatrical spectacle and metaphorical evocation that help viewers think about what the piece might mean. And it is surely no coincidence that far more people gather quietly before this piece and remain there for its duration than most other Viola installations. This fact and the features of *The Crossing* suggest, moreover, that, in contrast to video informed by conceptualism, minimalism, and pop art, much of Viola's oeuvre is best described as Baroque. The spectacular roar of flames and deluge of water would have impressed Gianlorenzo Bernini, who thrilled his seventeenth-century audiences with dazzling stagecraft as well as hyper-theatrical sculptural installations.

The monumental scale, the spectacle, and the dramatic contrast of light and dark are certainly formal Baroque elements. But the penchant for metaphor and sub-limity prompt another association: the Romantic cult of the artist-hero that culminated in Wagner and which is revisited, amongst other places, in the work of Anselm Kiefer. If Viola flirts with the mythic aggrandizement and mystification of art in *The Crossing*, Kiefer has created an entire oeuvre that explores the subject.

93

His canvases are huge, the subject matter consists of pyramids and temples drawn in looming perspective, and the compositions are filled with recondite allusions to history, legend, art, literature and religion. One is intended to exegete these images and to be awed by them. This may make them difficult as far as the need for a lexicon is concerned, but easy in terms of emotional rush and fascination.

Viola avoids the symbolic density and single-minded preoccupation with sublimity that pervades Kiefer's work, yet he displays a significant debt to Romanticism when he plunges the viewer into a kind of *Gesamtkunstwerk* – a Wagnerian 'total work of art' – such as *The Stopping Mind*, 1991 (**22**), in which one is surrounded by four colossal screens and a sound system that alternately fills the space with the whispered, breathless poetry of the artist, then the screeching, metallic noise of rapidly shifting images. It is a work that synthesizes sound, motion, text and image into a single, enclosed space. But if Wagner's opera glorified blood, oath, fate and oedipal confusion, *The Stopping Mind* is not about artistic self-aggrandizement or sexual longing.

Viola's major recent work, *Going Forth By Day*, 2002 (**23**), is also a *Gesamtkunstwerk* that rivals Wagner for thematic monumentality and universal scope. The title is based on the actual name of the Egyptian 'Book of the Dead', 'The Book of Going Forth by Day', which Viola described as 'a guide for the soul once it is freed from the darkness of the light of day'.[1] In preparatory notes to the work, Viola wrote of his desire to create 'a space, an absolutely real, objective representation of the place where death is – or more, to make a work not about death but the place beyond death'.[2] The result was a long room whose walls present five continuous digital loops consisting of epic scenes that are sandwiched in the ordinary: fire/birth, the path, deluge, crossing and resurrection. An endless stream of people walking through a forest recalls the long line of Athenian citizens on the frieze of the Parthenon taking part in the city's famed ritual celebrating its patroness, Athena. Another loop shows a deluge and the frantic scrambling of people to escape its fury. A third narrative views the death of an old man, the sorrow of his children, and his leave-taking across a mythic river to the Isles of Bliss beyond. Beside that, another sequence portrays emergency workers

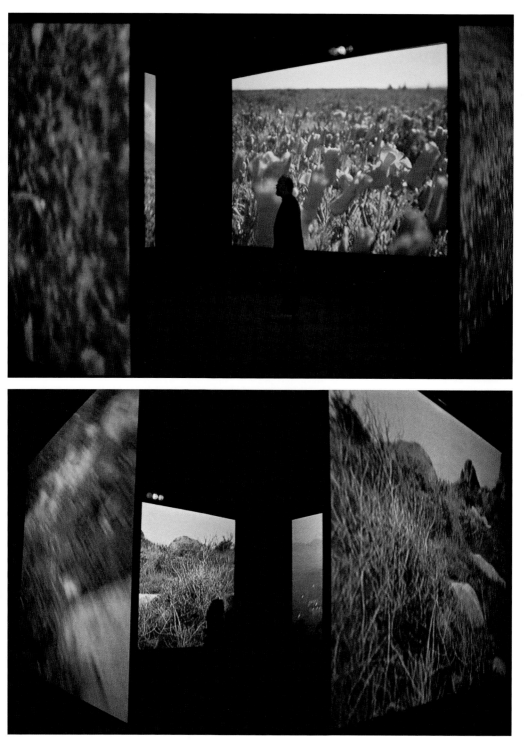

22 *The Stopping Mind*, 1991

23 'The Path' from *Going Forth By Day*, 2002

struggling to rescue a trapped man, whose soul finally rises from its watery grave as the workers sleep.

In every case, Viola's imagery invokes artistic monuments from the past and mythic archetypes: the Parthenon, the biblical flood, crossing the river to the after-life, and the resurrection of Christ (or Osiris or Orpheus). From its conception, the work was intended to draw from the history of art as the grand repository of myth and spiritual quest. The viewer can become overwhelmed by the work's whirl of artistic and mythological references if the art historian's game of iconography is not held in check. As he indicated in his notes for the project, Viola was far more inter-ested in the emotional effect of images on the viewer: 'The sea the swirling waters. Purple Black darkness churning, violent, seething, uncontrollable, threatening – sublime – viewing something harmful close up.... The roaring sound is deafening. A total physical experience.'[3]

For Viola, the sublime is more often than not a way of using darkness and mon-umentality, repulsive imagery, and terrifying bursts of sound and light to jar the viewer into meditation on something the artist finds genuinely enthralling:

the human condition. I say 'human condition' because I believe Viola considers there is one. Not the human situation, as if it might be otherwise. Not human nature, as if it were a timeless essence. The human condition is known by experience as the set of conditions that all humans confront. Interpreting Viola's work, the human condition would seem to consist of the fact that we are embodied beings, yearning but ill-prepared for communion with one another; that we suffer pain and loss; that we struggle to discover our bodies and transcend our suffering by connecting with a larger or inner aspect of reality; and that we die. Bodies, communion, suffering, transcendence and death collectively constitute a condition, in effect a world view, that the artist seeks to investigate in his work. Whether one is Buddhist or Christian or atheist (of the Camusian variety), coming to terms with suffering and fear and our incommunicability presumes an understanding of the human condition, and Viola finds in video a powerful artistic means of exploring these existential facts.

The remarkable retrospective of Viola's work, an exhibition that travelled through the United States and Europe in the late 1990s, offered the opportunity to consider in a comprehensive way the artist's treatment of the elements of the human condition. Firstly, people are alone. They rarely appear together in Viola's work, rarely commune with one another. On the contrary, figures appear to be self-absorbed. For instance, *Slowly Turning Narrative*, 1992, situates the viewer within a single mind, a

darkened room in which a panel revolves in the centre, bearing a screen on one side and a mirror on the other. As a voice recites a long list of phrases referring to the self, projections of a man's taciturn face and other imagery are reflected on the rotating panel as well as the viewer's own body, which is also reflected in the mirror on the other side of the panel. Viola has written that the 'entire space [of the installation] becomes an interior for the revelations of a constantly turning mind absorbed with itself'. The room is the ruminating, self-absorbed mind.[4]

Most of Viola's videos and installations are about the relationship between the artistic act and the viewer standing in or before the work. Engaging himself as well as engaging the viewer is what concerns Viola as an artist. If video is a kind of mirror he holds up for self-examination, it is not for the purpose of narcissism or self-enjoyment, but self-scrutiny and even self-interrogation. Where is the other in this analytical act of self-reflection?

If they are invited to insert themselves in *Slowly Turning Narrative*, to become thoughts reflected in the mind of another, in an earlier work, *Reasons for Knocking at an Empty House*, 1982 (**24**), viewers confront the artist. We enter a room and are able to sit one after another in a crude wooden chair in front of a video monitor from which the artist stares. The viewer's chair is equipped with a set of headphones, which reveal a murmur and the sounds of the artist swallowing and breathing. One sits and beholds the man, who is periodically struck by someone in the darkness behind him, resulting in a sudden explosion of sound. A friend suggested to me that this recalls the practice in Zen meditation of the master striking the pupil who begins to fall asleep. One also thinks of the Puritan monitors who patrolled congregations whose otherwise stalwart members occasionally succumbed to fatigue during long sermons. Yet there is something menacing about Viola's installation. Viewer and artist face one another, as if mutual interrogators, or prisoners of unseen and cruel forces. The viewer shares the artist's quandary if only for a moment, mingles with his body, becomes the resonant chamber of his body's noises. We are in his head and his body, and it is terrifying. Who is he? What has he done to deserve this abuse? What is his disturbing claim on the viewer? Are we like him? Are we responsible for him?

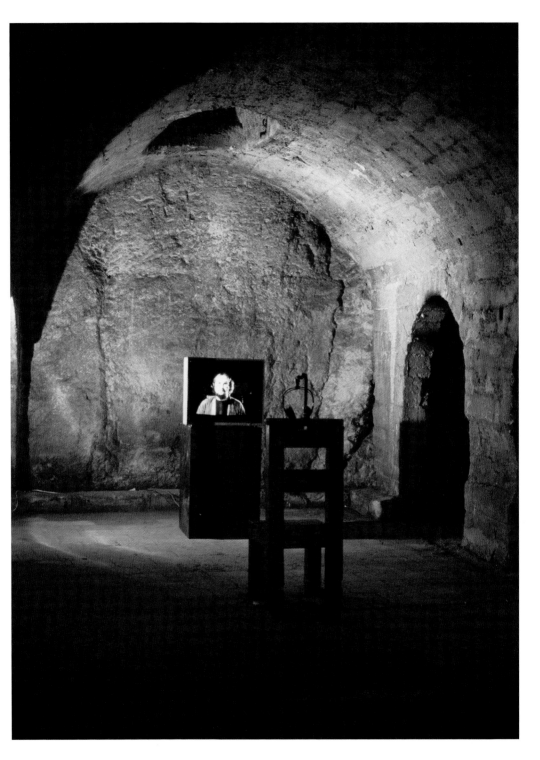

24 *Reasons for Knocking at an Empty House,* 1982

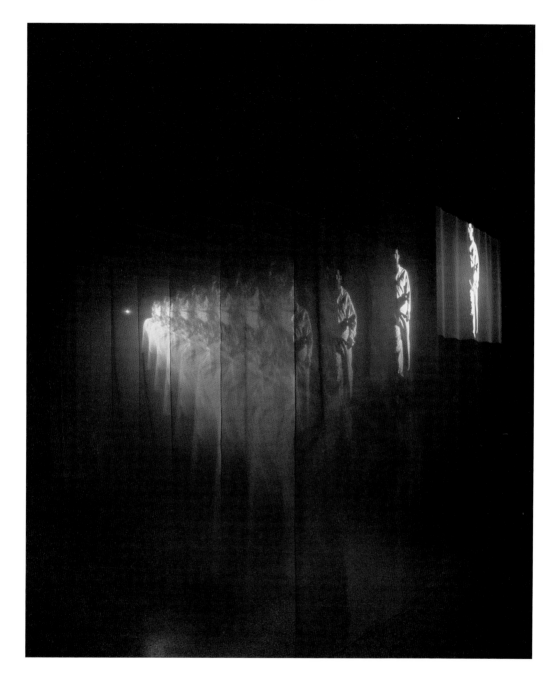

25 *The Veiling*, 1995

Being with others is an ethical state, a moment of action, that the theatricality of self-absorption in Viola's video art questions. *The Veiling*, 1995 (**25**), dramatizes this very well. A delicate, beautiful work that positions two video projectors at either end of a suspended row of nine translucent veils, *The Veiling* materializes in light two different figures, a man and a woman, whose images penetrate each scrim and meet in the central panel. In actuality, however, their incremental dissipation through the array of veils ends in a diffuse intersection. When the two finally meet they pass through the wan light of one another. It is a compelling metaphor of moral relations in modern life. Crowded cities, mobile lifestyles and a capitalist ethic of acquisition have contributed to a modern notion of personal independence that is preoccupied with the autonomy of the self. Autonomy comes at a price. Self-help cures, meditation, psychotherapy: all of these are modern strategies for dealing with crises in personal identity wrought by the isolated self.

Communitarian critics of modern individualism charge that both the cause and its attempted remedies have tended to withdraw allegiance from traditional institutional structures such as family, church, local community and voluntary associations as the dominant frameworks for personal development. Viola himself disavows 'formal adherence to any particular [religious] tradition', but practises Zen meditation and is deeply interested in the texts of Christian, Hindu, Buddhist and Islamic mysticism.[5]

Mysticism can tend to be about the self, or the dismantling of the self through an inward turning that relies on separation from others. Yet Viola's art is not a private retreat. It is public. In a statement written in 1989, Viola proclaimed that: 'The most important place where my work exists is not in the museum gallery, or in the screening room, or on the television, and not even on the video screen itself, but in the mind of the viewer who has seen it.'[6] The work does not belong to the artist, but lives instead in the consciousness of whoever views it. Art commences in the artist's withdrawal and struggle, which Viola likens to 'the cloud of unknowing' or to the 'dark night of the soul'. Then the work belongs in time, where it is a gift ventured in faith, 'faith in that other thing, that something else dimly felt behind the veil of daily life'.[7] Another feature of the world view evident in Viola's work is embodiment. His art is

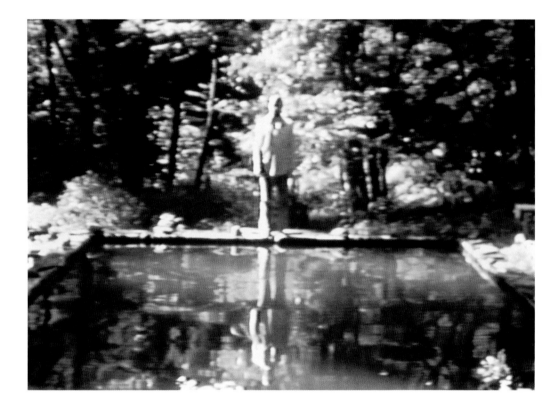

26 *The Reflecting Pool*, 1977-79

about the insides of things, about being within, about mediation. We are rooted in media, we are always in or passing through somewhere: inside one's own body, inside another's head, in bed, beneath the surface of water, in wind-tossed fields of grain, in fire, in dreams, in buildings and corridors and barrels and ray tubes and a mother's womb. Viola's videos frequently include a body submerged in water. Since the late 1970s Viola has been fascinated by the imagery and sound of bodies plunging into water. *The Reflecting Pool*, 1977–79 (**26**); *I Do Not Know What It Is I Am Like*, 1986; *The Passing*, 1991; *Nantes Triptych*, 1992; and *Stations*, 1994 – to name only a few works – present bodies descending into water and floating inertly beneath the surface that call to mind such events as birth, baptism, ritual cleansing, death, recreation, rebirth. Each of these ritual acts takes place in the body. The body is where awakening happens. It is the medium of transformation. Its sensations are the very language of myth, the place where spiritual domains intersect with the ordinary world of time and space. Myth and ritual are grounded in the body, making it the register of transcendence. Descent into water is the operation of mythic metamorphosis, the manner by which the body is turned into a medium for spiritual experience.

Viewing these aspects of Viola's work, one recalls the experience as a young child of submerging in a swimming pool to listen to the modified sounds underwater and to feel the weightless abandon of one's body. The body suddenly seemed useless, the senses one relied on suddenly unreliable. This alienating loss of fit with one's habitat loosened one's grip on the concrete world. The mind suddenly severed from the body, the spirit was disoriented and left to float on its own. Such disorientation can be mesmerizing. The lesson of this estrangement is that our knowledge of the world is rooted in the rudimentary vocabulary of the body. Being deprived of that vocabulary means losing control over the world. This is perhaps why new media cause anxiety: the seamless connection between one's body and the environment seems ruptured by a new medium. But Viola is not content merely to disorient viewers. He is intrigued by the power of estrangement to illuminate. Suffering can yield a breakthrough, a new vision of self and world.

This brings us to the next element of Viola's world view: the place of suffering. If humans appear encased in bodies and alone in much of his work, they are not

abandoned there. Suffering is redemptive. Pain, when transformed into suffering, becomes the point of contact in a world of bodies set apart from one another. We saw in *Reasons for Knocking at an Empty House* that the artist's agony became the occasion for the viewer's self-transcendence: the viewer's concern for the other, or compassion, suffering with another.

A major work of the following year explored the experience of embodiment and suffering. The installation, *Room for St. John of the Cross*, 1983, consists of a small black cubicle placed within a large, darkened room. Inside the cubicle are a chair and a table with a pitcher, glass of water and a video monitor. As we peer through the window, we hear an audio loop of St. John's Spanish poetry, composed between 1577 and 1578 while he was imprisoned in a space the same size as the cubicle. Abducted by a rival element of his religious order and beaten regularly, the Carmelite friar was subjected to what he called the 'dark night of the soul', the result of a deep sense of abandonment not only by humans and the church, but also by God. It was as if God had denied him, turned away from him, left him to dissolve painfully into the dark void of his prison cell. But strangely it was from these depths of loss and solitude that God finally spoke and St. John poured forth his most passionate poetry.

Outside the small cell, viewers, free of imprisonment, are dizzied and nauseated by the quaking projection of a mountain range, accompanied by the unrelenting roar of wind. On the colour monitor inside the cell, a single mountain glows quietly, motionless; at the heart of St. John's anguish and joy is the image of rest, balance and permanence. Paradoxically, viewers find their own incarceration in the larger room and are offered the model of St. John before them in which to discover the meaning of suffering.

Viola's meditation on St. John of the Cross is not a masochistic glorification of pain. Pain is one thing and suffering another. Pain happens to a body, but suffering unfolds as a transfiguration of the pain, a way of living with it. Suffering is the spiritual practise that a body makes of pain it cannot stop. We suffer when we endure pain, when we transmute it into the struggle to live.

Suffering changes us. Those who have suffered see themselves and the world with new eyes. But art need not inflict pain or suffering on viewers in order to prompt a spiritual reflection. Viola's installations bear the conviction that the

conditions of traditional religious ritual can be simulated in works of art, in order to achieve something of the spiritual transformation wrought in the original context. In a note first published in 1982, Viola observed that:

> Initiation rites and age-old spiritual training ordeals (fire walking, days of continuous dancing, circumcision rituals, holy torture, etc.) are all controlled, staged accidents, ancient technologies designed to bring the organism to a life-threatening crisis.[8]

One might call them deliberate accidents because they are created to rupture the normal routine of life with a disorienting violence. Accidents such as car crashes, Viola points out, seem to happen in slow motion, as a retarded time sequence characterized by uncommon clarity. By thrusting the initiate into liminal space and time, the ritual allows passage to a new form of life marked by a novel consciousness of the self. Viola's appreciation of ritual clearly stresses the rite of passage, which often employs pain, isolation, sensory deprivation and suspended time to effect transformation in the initiate. Its appeal to the artist can perhaps be explained by the way that it grounds the transformation of the world in the transformation of individual consciousness, and does so by the manipulation of time, Viola's principal medium as a video artist. He believes that the essential apparatus of ritual metamorphosis is still available to modern humanity in the work of art. Viola's global travel and extensive study of religious texts and rituals from many traditions serve his desire to fashion modern instances of ritual experience. By engulfing viewers in darkness and subjecting them to jarring sounds and random bursts of light, Viola creates moments in which they are pulled away from everyday life and urged to reflect on the profound bonds of suffering, love and fear that are entombed and enshrined in the body, the human medium of the spirit.

Of course, this may be more than viewers care to undertake. To be sure, a sober view of the power imputed to art is prudent. Art is very good at creating imagined situations into which viewers may project themselves. But art is not particularly good at preaching sermons that morally improve the viewer. Sermons themselves, for that matter, may not be very good at moral improvement either, but they are, like art, powerful means of evoking new visions of the world.

What is it that Viola aims to do in his video installations? Would he enrapture viewers? Would he like to impart the *unio mystica* described by the great mystics? Is the purpose of his art to provoke spiritual awakening and ritual rebirth? Since St. John of the Cross and Meister Eckhart, two of Viola's favourite writers, required years of rigorous spiritual calisthenics and precocious introspection to attain enlightenment, it is doubtful that an hour spent one Saturday afternoon in an art gallery will procure the same results.

The intention of Viola's installations seems more modest: to remove museum visitors from the ordinary world for the sake of a few moments of meditation. The long corridor of *Passage* suggests as much: passing through it we leave the present and return to the archetypal past. In the catalogue accompanying the retrospective exhibition, Viola writes that the passageway 'ultimately refers to the original passage through the birth canal' and that the corridor's destination – the birthday party – is 'a contemporary vestige of an ancient perennial ritual'. The party 'regains some of its ritualistic and mythic stature through the manipulation of space and the extreme extension of time'.[9]

Art, Viola believes, is able to repristinate a secular culture, or at least certain moments of it, by reclaiming an aspect of the sacred that has been marginalized in modern life. In contrast to the theory of secularization, which regards religion and the sacred as outmoded vestiges of pre-modern culture, Viola affirms a view championed by Mircea Eliade, whom he quoted in an exhibition statement in 1989: 'The sacred is an element in the structure of consciousness and not a stage in the history of consciousness.' The sacred 'is within us all', Viola concludes, 'intuitive awareness and unwavering belief in this other world.'[10]

Viola's tour of the human soul brings us to the elegy of *Tiny Deaths*, 1993 (**27**). He dismisses his Christian upbringing as mere accident ('I was raised Episcopalian because my mother was raised Episcopalian growing up in England'). However the Zen celebration of sheer existence that Viola espouses in discussions of his work does not, in fact, eliminate a pervasive sense of loss that may owe something to his Christian formation.[11] If Zen teaches one to overcome anxiety about death by realizing the emptiness of self, Christianity finds in death the just wages of sin,

and a severe but endurable test of faith. *Tiny Deaths* captures the randomness and the particularity of death, its smallness and the wave of forgetting that follows so quickly upon it.

Four walls of an otherwise utterly dark room show dim fields of a tone slightly paler than black, against which dark silhouettes of human figures emerge. The viewer wonders at first if they aren't shadows of fellow viewers thrown onto the walls. A din of incomprehensible voices fills the room, something like the sound of a gallery opening or a busy lunchroom. At random intervals a figure appears in grey tones, blurry but clear enough to make out as no one special, someone ordinary, a young person, an older person, a man, a woman, standing and talking, casually dressed. Then, suddenly, the figure flares and vanishes in a burst of white light and a low buzz, before the darkness and din resume. Death comes as a luminous erasure, a small explosion of light that dissolves quickly into a field of shadows and murmurs. All that a person was has gone, swallowed up by the encompassing gloom.

Tiny Deaths feels like a lament. Life is a bleak place on the edge of oblivion and each of us a tiny flash of light. Memory is short, the length of an afterimage. This is among Viola's most difficult works. Visitors don't stay long. In the darkness they feel no more real than those whose being flares for an instant on the murky walls. But the truth of this work is undeniable if by truth one means the honesty to put things as they are, without needing a happy ending to soften matters. Some Christians will miss any reference to resurrection and the life of the world to come. But others will recognize in *Tiny Deaths* a forthright evocation of the terrifying reality of death that everyone must face, believer or not. The overwhelming injustice of death, the finality and the incomprehensibility of each person's extinction resonate in Viola's installation.

But there may be hope. Perhaps this work is akin to the allegory of Plato's cave whose walls are likewise peopled by dim shadows, while outside resides the world of truth that only lovers of wisdom can summon the courage to seek out. Viola embraces a notion of transcendence that refuses to see in death the material end of the soul. Clearly, the theme of the soul's journey after death explored in *Going Forth By Day* is a significant example of his persistent interest in transcendence. In notes to

27 *Tiny Deaths,* 1993

Vegetable Memory, a videotape of 1978–80, Viola referred to the 'brutal afterlife' as the consequence of the view that there is 'no afterlife for the soul, only cold, ugly physical death'. But he went on to describe what he called 'the other choice':

> The spiritual liberation of the soul through death –
>
> death is birth. If we do not believe in spiritual afterlife
>
> then our bodies will rot away into material nothingness.
>
> We will cease to exist. This is hell...the brutal afterlife. s

Hell, for Viola, 'is our non-belief' in the world to come.[12] The world outside *Tiny Deaths* confronts viewers as they leave the installation. They emerge to a second chance. The world awaits and the work of art exists to help them see it.

28 *The Greeting,* 1995

TELLING TIMES
Re-visiting *The Greeting*

JEAN WAINWRIGHT

'Either the well was very deep or she fell very slowly, for she had plenty of time as she went down to look about her and to wonder what was going to happen next.'

Lewis Carroll[1]

Watching Bill Viola's *The Greeting*, 1995 (**28**), necessarily positions the viewer within a complex temporal conundrum. The act of viewing is structured by the following vectors: the time it takes to watch the complete work (10 minutes); the actual length of the film sequence (45 seconds); the recording speed (300 frames per second). Spectatorship seems to take place in the difference between 'real time' – understood in the Newtonian sense of a time that is linear, progressive and consistent – and psychological time (which has no unit of measurement that can be readily placed within brackets). In addition to this temporal dichotomization is the presence of the work in the eye and mind of the viewer, its recognizable affiliations to a tradition of Western painting, and its associations with Bill Viola's known practice and beliefs. In this essay, I want to examine the implications of Viola's extreme slow motion in *The Greeting*, both for notions of time, and for the relationship of video art to painting. For it seems to me that the work not only appeals to a pre-Enlightenment imagination of temporality, but that through the deployment of that imagination in a reworking of Old Master painting it makes a plea for a continuity between media, across time. This suggests that the turn to video by artists, far from being a rupture that radically changes the terms of art, is one that enables and extends the existing concerns of representation within painting.

The Greeting is rooted in both the tradition of Renaissance and Mannerist devotional painting, and in Viola's memory of a fleeting event that he witnessed on his way back from his studio while stopped at the traffic lights.[2] Its most obvious pictorial inspiration is a painting by Jacopo Carucci (called Pontormo), *The Visitation, c.* 1528–29, which provides references for light and colour, the compositional grouping and religious symbolism. However, while Pontormo's work is the clearest influence on Viola's film, we need to place this modern work in relation to a larger body of paintings. 'Visitations' were a common, if minor, genre within the Renaissance. The central subject is the meeting of the Virgin Mary with her cousin Elizabeth. Mary is already pregnant with Jesus; Elizabeth, far older, has for years been believed infertile, but now becomes pregnant with John, who will eventually, with his own prophetic ministry, prepare a way for Christ.

There is, though, an unseen but important factor to consider in viewing a 'Visitation'. The description of the meeting of Elizabeth and Mary comes from St. Luke's gospel.[3] Largely as a consequence of the apocryphal 'Golden Legend', with its story of the Saint's vision of the Madonna, from the late fourteenth century Luke was nominated as the patron saint of many painters' guilds and corporations. Paintings of this vision, in which the Saint hurriedly sketches the nursing Madonna (*Maria Lactans*), were often commissioned for the guild chapels and there is often, within these panels, a degree of self-reference. In the known copies of Rogier van der Weyden's *St. Luke Drawing the Virgin, c.* 1435, there is a *mise-en-abyme* in which the drawing that the Saint is making is in fact the image we see.[4] As Borchert notes: 'The iconography of Saint Luke [afforded] an important model by which painters could visually express the way they perceived their own craft.'[5] Representing the painter as saint with privileged vision of the Madonna was a particular strategy in elevating the status of the artist, as well as a means of making a form of self-portrait, with the artist's identity occluded behind the robes of the saint. In painting a 'Visitation' there is a similar adoption of identity – a sharing of authorship – and an occlusion that here places the artist-as-storyteller outside of the picture. We might note that *The Greeting* was one of the first works in which Viola sought to create an obvious narrative, as well as a symbolic spectacle; the first work in which he used a script.[6]

This attempt at storytelling is based on a genre of paintings that are, themselves, in part about the painter's capacity to tell stories.

Viola has increasingly turned to Renaissance artworks as a source of images. Certainly, *The Greeting* shares with later works such as *The Quintet of the Astonished*, 2000, a similar root in art history – Mantegna's *Adoration of the Magi*, *c.* 1500, or Bosch's *Christ Mocked*, 1490–1500 – and a similar 'arc of emotion'. It is by contrast, despite its 'slowness', a dynamic piece. There is a clear relationship established between the film and painting – a fact that Viola emphasizes. Although we know we are watching performers,[7] we view the work as we would view a painting. When recently installed in the Domberg Museum Freising, a frame was constructed around the work. Film and video might be Viola's materials here, but it is clearly the language of painting that informs the work.

Pontormo was an evocative source for Viola partly because of the brilliant colours that he used, which were almost certainly provided by his patron.[8] There are two other *Visitations* by Pontormo which precede the one that Viola finally chose as his principal source for *The Greeting*. The first, concentrating on the meeting between Mary and Elizabeth, was painted in 1514. The figures fill the frame, their right hands clasp, and Elizabeth's outstretched left arm and hand rests on Mary's shoulder. Elizabeth gazes intently at Mary as she relates the gospel's message and greeting. The women's clothes are rather static; unlike the later version, they do not billow and meet. Except for the arch framing the figures, the structure of the work is almost identical to Albertinelli's earlier Visitation of 1503. Here, the figures of Mary and Elizabeth bend towards each other in an embrace – they clasp hands as Mary puts her other hand up to her chest and Elizabeth puts her free hand on Mary's arm.[9] In two earlier versions by Dieric Bouts (made about 1445), the painter has the women's arms crossed and their hands linked in a mirroring axis. In van der Weyden's *Visitation*, *c.* 1432, the crossing motif is also employed, with the two women touching each other's pregnant bodies. This painting also seems to establish an iconography for the genre, with Mary in deep blue, over a dark red dress, and Elizabeth in orange-red. Yet another version of the event was painted by Lienhart von Brixen in 1465. In this case,

113

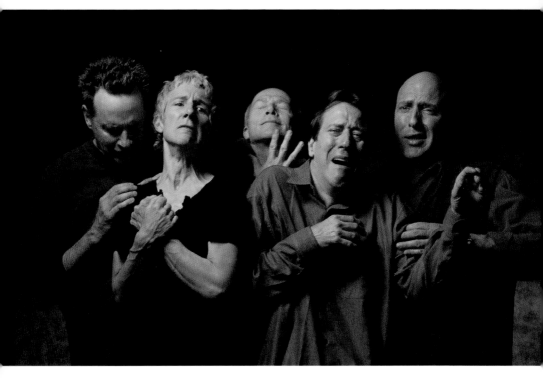

29 *The Quintet of the Astonished, 2000*

the women are physically separated by the wooden frames of a hinged panel paint-
ing. Their hands reach out but do not meet; their babies are shown in the womb,
surrounded by radiating gold lines.

What seems clear is that Viola studied Pontormo in some depth, even going
as far as to trace particular groupings. In Pontormo's second *Visitation*, 1514–16,
the virgin is in profile with an orange headdress, red robe and blue mantle,
with Elizabeth bending her knee to her in a gesture of deference. Mary's husband
Joseph is seen kneeling – the male figures conventionally included in the
paintings are usually presumed to be Joseph and Zachariah, although they do not
appear in early versions of the subject. The two men are always marginalized
(there is no textual support for their ever meeting) and usually painted as small
background figures. They are often depicted sitting and talking. Pontormo's later
Visitation – the more direct source of *The Greeting* – is particularly interesting
because it couples the familiar motif of intertwining arms with billowing
fabric. The two women almost appear to be levitating together, while Joseph
and Zachariah are disproportionately small figures sitting on a stone bench.
Reiterating a familiar criticism of Pontormo's painting,[10] Walsh comments that
Viola's women are not 'weightless sleepwalkers' but real people.[11] This fact is
borne out by an interview in which Viola cites reasons why it was impossible to
recreate Pontormo's *Visitation* scene using a single lens, at the same time as pointing
out that he wasn't interested in re-staging it, but rather 'using it as a guide to
make something new'.[12]

The role of carefully 'stage-lit' colour in both Viola and Pontormo's works is
important: the dark background is retained in Viola's piece as well as the red and ver-
milion of the clothes. Although ultramarine was privileged in paintings of the
Madonna, because of its expense, the cost of dyes meant that red fabric was the most
expensive in the late Middle Ages. In seicento Tuscany, crimson was characterized by
Florentine dyers as 'the first and highest and most important colour that we have'.[13]
Crimson and gold were also favoured within Mannerist art. The specific shade of ver-
milion used by Pontormo is among the oldest pigments – with its synthesis of
sulphur and mercury known in Europe from at least the eighth century CE.[14]

But Viola's *The Greeting* is not a painting. The 'reality' ascribed to his subjects by Walsh obviously stems from the medium employed, rather than from any painterly skill by the artist. It is a consequence of the medium that the subjects move, however slowly, rather than seeming to move in a painting convincing in its appeal to veracity. Knowing that the finished work would run this slowly, Viola chose to shoot his actors on film rather than video. (For installation purposes, the edited tape was transferred to video laserdisc.) *The Greeting* was a departure for Viola as it was the first time he had 'scripted' a work in this way:

> We gave each of the characters names and wrote up a background sketch on each one, along with a background treatment of the action... I couldn't believe I was doing this since my focus was on much broader issues. Suddenly there was a story there and everyone felt comfortable except me.[15]

Although Pontormo is important to the final work, the painting can 'slip' in and out of the frame; the generic artistic interpretations of Luke's biblical narration are therefore perhaps more relevant. Viola's bank of images includes facial expressions and hand gestures drawn from other 'Visitations' and various Renaissance treatments of hands. (Indeed, Viola draws on this painterly thesaurus five years later in his *The Quintet of the Astonished* (29) and other works in 'The Passions' series.) It is interesting in this context to note that Viola spent time in Italy in the 1970s, working for eighteen months at the Art/Tapes/22 video studio in Florence. In an interview with Jörg Zutter, Viola remarked of that time that he liked feeling 'art history come alive off the pages of books' and 'soak' into his skin.[16] He compared the function of classic Renaissance art to that of contemporary television because it was designed to communicate 'well known stories directly to the illiterate masses in highly visible public spaces.'[17] While in Italy, Viola also recorded the resonance of the ecclesiastical space: the whispered words in *The Greeting* reverberate with an afterecho that has traces of both the cathedral and the spirit world.

What we see in *The Greeting*, therefore, is neither a literal translation of the St. Luke's biblical story or of Pontormo's *Visitation*, but a linear trace, which transfers the narrative into a new medium, into the future, while at the same time referring

back all the time into the past. What Viola conveys during the ten minutes of meas-
ured time is an emphasis on possibilities and presence. The work seems to fulfil
Zeno's Paradox to the extent that any single moment from it could be extracted as a
still image, an equivalent to a painting: yet it simultaneously subverts the whole
notion of time as a linear sequence of such equally valenced moments, by dragging
out a brief moment to emphasize its significance, and perhaps to make apparent the
narrative that is compressed within the single moment of the painting.

Film, like photography, is a medium that seemingly derives from the Newtonian
model of time. We could even see each frame as a crude, and even at 24 fps probably
rather too coarse, equivalent to those moments in which time seems to be at rest,
even as it moves forward. Film is, of course, the medium of ultimate reality, at least
within modernity – at least until the next representational mode comes along. Like
the photograph, its image evinces certainty: in the chemical-mechanical image we
cannot dispute that what we see registered is a trace of the presence of objects in
time and space. Unlike the photograph, and unlike the painting, the animation of
the film restores life to the frozen moment. A central discourse around European
painting from the Renaissance on, and one contemporary measure of its quality, was
the degree of its realism. Vespasiano da Bisticci's observation that a portrait of
Federico da Montefeltro by Justus of Ghent was 'lacking only breath' is a typical
example. In film, apparently, we see real subjects in real time.

With *The Greeting*, Viola participates in a particular strategy of filmmakers and
artists that explores the nature of this temporality and its effects. Warhol is a vital
figure here, with early projects such as *Sleep*, 1963, and *Empire*, 1964, stressing the
central issue of attention and absorption by the image. Warhol's work, appearing at
first to be of real objects viewed in real time, contrasts the temporality of the real with
the temporality of the reel. Perhaps having seen some of Joseph Cornell's films at the
Filmmaker's Co-Op, which employed a similar conceit, Warhol projected films that
had been recorded at 24 fps (the conventional speed for sound recording) at 16 fps
(16–18 being the old standard for silent film).[18] Immediately we are made visibly
aware of the arbitrary organization of time, even as we are made aware of the impos-
sibility of absorption in that which is designed to exclusively occupy our attention.

More recent projects, such as Douglas Gordon's *24 Hour Psycho*, 1993, have further hyperbolized Warhol's exaggerations, but through the products of popular culture. When making *24 Hour Psycho*, Gordon noted the experience of dual speed: while most films represent the speed at which we live, we also 'all live in relative speed to one another unless one is in a narcotic state where that doesn't happen'[19] or – as Viola might add – an extreme meditative or absorptive state.

If there is a convention for the treatment of time within film, it applies only to its compression: the narrative depends upon the juxtaposition of significant moments. It is rare for filmmakers to use slow motion for any long period or for anything other than spectacular effect: the plastic properties of recorded time (its extensibility, contractibility or reversibility) are at best an occasional novelty. But in its expansion Warhol, Gordon and Viola use time in a way that has much in common with the modernist avant-garde in other media. The historian Stephen Kern observes that at the beginning of the twentieth century there is a challenge to the Newtonian idea of

time that 'absolute, true...of itself and from its own nature, flows equally without relation to anything external'.[20] This is a return to a notion of time as not only subjective (a position derived from Kant) but as essentially plastic and malleable within that experience. The industrialization of the West and the introduction of mass transport, and eventually (for Kern) mass warfare, depend upon the standardization of time. Modernism's challenge to the temporal imagination of modernity (which is in some places bound to Bergson's rethinking of time, in places perhaps intuitive) is that time has no particular pace or direction. Mostly that challenge is effected through media rendered obsolete by modernity; the novel, the poem, the painting, even - in the work of the Futurist, Boccioni - sculpture.[21] Few artists (the Bragaglias, Man Ray, Léger, Moholy-Nagy, Picabia, Dziga Vertov), and then often only fleetingly, seem to appreciate that the media of the modern age (photography and film) themselves embody the possibility of self-critique. If one aspect of the plasticity of time in modernist art is the contraction (the twenty-year wanderings of Odysseus compressed into sixteen hours of Leopold Bloom's Dublin day in *Ulysses*, for example), there is a corresponding play with its expansion – almost, one might say, with its stasis – in the work of Proust. For the latter, the absorbed, significant moment –

which in atomist conceptions of time passes in a few seconds – may be experienced, and represented, in a form whose duration far exceeds its 'reality'.

An element of the modernist critique of modernity might be seen in painting's treatment of motion. There is a kind of recuperation at work here, since the new media can, it seems, only depict modernity literally, as itself. Modernity, it seems, can only be critiqued and analyzed through an older medium. In the work of Balla (*Dynamism of a Dog on a Leash*, 1912, for example) or Boccioni (*The City Rises*, 1910–11), we might say that painting aspires to the status of film by introducing a mobility that is, because of the limitations of the medium, wholly static. We might say of *The Greeting* that it is film that aspires to the status of painting – not only in its appropriation of aesthetics that mirrors the appropriations of photography and film made by Duchamp or the Futurists, but in its attempt to restructure the temporality of the medium it appropriates.[22] Clearly, Warhol and Gordon are attempting part of this project by concentrating on the temporality of film itself, but neither goes as far as Viola in returning to the traditions of pre-modern painting. This suggests to me that Viola intends something different from his work – what he seeks is not a critique of the perception of time in modernity, but rather the substitution of another way of experiencing time. If the moment is extended because of its significance for both Proust and Viola, for Viola that extension is intended to serve a very different purpose. This purpose is, I'd suggest, one that is both 'spiritual' and 'universalizing' in that, by substituting another, far older, rhetoric for the self-critical awareness of modernity, it proposes the same relationship of artwork to spectator for both painting and photography.

The Greeting was first exhibited in the American Pavilion at the 46th Venice Biennale in the fifth and final space of Viola's 'Buried Secrets' exhibition.[23] There is no narrative in a traditional sense, though there is more 'narrative' than Viola usually includes in his more recent works. There is no story line per se – just a 'meeting' that happens between three women in the foreground, with two men present in the background. We see the raw material of the world, a small event in the bigger scheme of things. What we see in *The Greeting* is the compositional structure of the Renaissance painting transferred first to film and then

to videodisk, the sun-lit arches of seicento architecture transferred, seemingly, into a generic 'industrial Italian town'.

The sky has the dark blue overtones of those moments preceding dusk or just after dawn. The figures in the foreground are, however, brightly lit. Two women are in conversation together. Their clothes too are generic and contemporary: flowing skirts and dresses in various hues of brown, gold, blue and vermilion. One woman is older, exuding confidence; we see her face in profile. Her feet are exposed in open sandals and her brunette hair is swept into a plait. The younger woman's blonde hair is shoulder length and loose, her feet are hidden in black shoes and she has a less confident air. In the background, we see the opening of a passage or corridor, where a man is bending down. This is the 'backstage' greeting that parallels the meeting of the women in the foreground; the casual meeting of two men. There is the lighting of a cigarette, a gesture, a brief passing: these seem to cross-fertilize with events in the foreground. At the moment that the two women's hands first clasp, a light flares and cigarette smoke hangs in the stage light.

A question is posed almost immediately. Why – even with a work moving this achingly slowly – is it difficult to take in everything that is happening? For this is a still, painterly work that is, paradoxically, full of movement. A slight breeze flutters a wisp of hair here, the edge of a scarf there; an arm changes position, hands clasp, eyes roll, lips open. We cannot hear the words that are being spoken by the women but rather hear the noise of a strange 'wind'. The older woman's mouth opens and a look of astonishment or surprise gradually registers on her face – but at this point we do not see what it is that has provoked this emotion. The friends' hands again almost meet. The breeze, which has until then been a background sound, begins to rise – there is a disjunction between the rushing sound of the wind and the gentle movement of the clothes. Then the breeze quickens into a climatic roaring. Wearing a light, vermilion, cotton dress, a young dark-haired woman, clearly pregnant, enters, her outstretched hands visible first. She 'rushes' towards the older woman who moves forward to greet this new arrival. The light scarf worn by the older woman is a darker shade of orange-red than the dark-haired woman's dress.[24] The breeze lifts it from her shoulder, joining the two women with a kind of

fabric umbilicus. The scarf swirls across her friend's body as if immersed in fluid, 'leaping' with a life of its own. The two women are joined together in a compositional axis that completely obscures the small figures in the background, and partly hides the blonde woman whose face reappears between them at a lower angle. The arms of the two central characters cross in a mirroring action and their sandaled feet align. The new arrival whispers in the ear of her friend; the sound is just audible above the wind and is the only time in the work that a voice can be discerned. The whisper is strange and disembodied with a slight echo. Straining and 'stretching' one's ears we may just be able to hear: 'Can you help me? I need to speak to you right away.'[25] The blonde woman in the middle seems pensive and excluded. She turns her attention to the older woman who responds, allowing her to face the newcomer and smile. The muted conversation between the three women then continues in a lower emotional key until the end of the work, which after a few moments repeats its loop, endlessly beginning and ending in mid-sentence.

Several different rhetorical vocabularies are active within *The Greeting*: the nuances of facial expression; the gestural language of hands; the stances of the figures; clothes that seem to take on a life of their own, beyond the signification of their cut and colour. What's notable about the way in which Viola uses the painterly tradition of the 'Visitation' is his incorporation of a specifically Christian iconography. The flame that sparks with the touch of the women's hands is the flame of the presence of the Holy Spirit (a trope that manifests itself in a number of interesting ways in Renaissance depictions of the Virgin). The breeze that flutters hair and clothing (for both Viola and Pontormo) is also a symbol of the Holy Spirit: it is pneuma, the breath of God.

The other filmmakers who experiment with time in the filmic image do so by voiding the artwork of language to examine the structures that organize language. This is achieved either by filming an object breathtakingly devoid of narrative interest – for Warhol, the Empire State Building on a quiet day; the sleeping John Giorno; a seated Henry Geldzahler – or, in Gordon's case, by alienating the spectator from conventional codes of representation. This, generalizing, is largely the strategy of modernism: the self-referential analysis of linguistic structure. By contrast, Viola

uses duration as a property of another form of language altogether. *The Greeting* is a representational coding, the embedding of symbolic meaning into the image. This is, essentially, the condition of Renaissance and medieval painting. With that reversion to symbolism is a reversion to a different conception of time. This is not simply a psychological variability of time – time experienced at differential rates by the subject à la Proust. Rather, Viola insists on the extensibility of time according to the historical significance of the event it contains: this moment lasts longer because the exchange between the two women is of momentous import to them, but also to us as spiritual beings. Never mind the aesthetics, if we have a medieval or Renaissance symbolism that is not merely imported but active within the image, we also have a medieval conception of time. As John Berger writes of this:

> Time appears to pass at different rates because our
> experience of its passing involves not a single but two
> dynamic processes which are opposed to each other: as
> accumulation and dissipation. The deeper the experience
> of a moment, the greater the accumulation of experience.
> This is why the moment is lived as longer. The dissipation
> of the time-flow is checked. The lived durée is not a
> question of length but of depth or density.[26]

There is no question that Viola's practice is deeply embedded in his intuitive awareness and spiritual beliefs – conditions that personally embrace the importance of time in all its manifestations – and the cyclical repetition of the life force. A pregnant woman's baby kicks in the womb in *The Greeting*; a baby is born in real time in the *Nantes Triptych*, 1992, and blinks at its first light – Viola's children grow and transform – his mother and father draw their last breaths. These are the 'great' themes of painting,[27] narratives as 'absolutes' compressed into a single frame, extended by this most 'painterly' of video artist, as he 'sculpts with time' – manipulating our experience in front of the work to speak to us of some universal truth. The coiled up experience is waiting to be 'unrolled' like an ancient scroll.[28] *The Greeting* contains the germination of concerns re-visited in 'The Passions' but also links with Viola's early video practice – testing the medium at ever-slower speeds for

its reproductive limits or, as in *He Weeps for You*, 1976, referencing the physics of perception. Time, Viola has often stated, is the 'water' that we exist in, and there is in extreme protraction a greater awareness of that materiality. We become conscious of the slowing of time, allowing us time to digest more information; the move towards stasis empowers our perception.

The miracle of the Annunciation and Visitation, the changing of water into wine at Cana, a virgin's child growing in a womb: all speak of transubstantive time spans. Viola suggests that the first stages of his insight into time 'were as important as the insight itself': the time of the 'unfinished' thought, the time that 'a painter must go through (not the painting itself)', the time 'behind the façade of all great discoveries'.[29] Viola personalizes his viewing of Renaissance paintings as a wish 'to get inside them': to 'embody' them, to feel them 'breathe'. Their transmutation over time has a spiritual dimension, not a visual form. Their 'Zen' quality becomes for Viola the great hidden tradition in painting; the most 'real' material he knows becomes time.[30]

Sequential viewings of *The Greeting* convince us that we are watching in real time. And as the extension of time becomes 'our' time, we realize how little the ritual of 'greeting' is bound by specific temporality. Viola has solved the painter's dilemma of scaling down an event while maintaining its spiritual force – the weightlessness of Pontormo's figures becomes the weightiness of the synchronicity of past, present and future. There is no rupture here, but the continuity of a lineage stretching from Pontormo to modernism; painting and film and video are rendered in a new alliance.

123

SOMETHING SMALL —
OBJECTS WHICH TALK, MOVE, SPEAK, GLOW
AND HAVE POWER.

Video TV Altar — Electronic Death.

SMALL MONITOR WITH. TINY MAN SCREAMING
MINIATURE VIEWING ROOM

Viewing Stone —

A rock which
I have stared "through"

Build a Magic Lantern
or Camera Obscura
in Video room

LONG BEACH — MAY/JUNE

REASONS FOR KNOCKING AT AN EMPTY HOUSE — installation

ZBS- PROJECT — SOUND, VIDEO

Planning: Shooting Schedule
Computer / Video Disc project.

Image
Circumambulation
Kaaba

EDIT SYSTEM CONSTRUCT, Work room install

INSIDE St. John's Room
WOOD TABLE
CANDLE
5" TV w/ Mt. Rainier (Bolt) on in real time
Audio is
loud outside Room for St. John of the Cross
room

Inside a
whispering voice
reads his poems
(in Spanish??)

The Heart
Poem
of the
self

The Flying Room —
built a small isolation
chamber the size of St. John's
solitary confinement cell
It is black, rough
and thick walled
Inside a small single candle burns
& a slow wood table
Outside — high color film projections of
flying around mountains is shimmering

30 *Room for St. John of the Cross*, 1983. Drawing by Bill Viola.

CHAPTER 6

IN MY SECRET LIFE

Self, Space and World in *Room for St. John of the Cross*, 1983

CHRIS TOWNSEND

If for no other reason than its structure and the variety of its mediating forms, Bill Viola's *Room for St. John of the Cross*, 1983 (**30,31**), is a profoundly significant work in the history of video art. The piece exists only as installation, functions only as installation: it is a work that is apprehended only in its direct experience. It represents a crucial point in the move away from projection or screening of video in the gallery space towards the creation of a total narrative environment in which the spectator is immersed.

The piece is, therefore, also more than video art: the engagement between spectator and art is conditioned not simply by what is projected or screened, but by the environment in which that mediation is placed, and by the objects within it. The setting in which we experience the moving images of *Room for St. John of the Cross* is no mere technical apparatus that guards or guarantees the uniqueness of their mediation. Nor is it, as in some of the early video works of Bruce Nauman or Peter Campus, a critique of subjective relations to the space and time of the installation. It is a setting with aesthetic force and, crucially, I would argue, symbolic values that both attract individual attention and contribute to the overall effect of the piece.

In our experience of the work we cross a certain boundary: we are no longer in the register of 'media art' – if we are to understand that problematic appellation as effortlessly defining a certain type of mobile imagery that is produced as well as experienced through lens and screen. Rather, we are in the domain of a totalizing art, equally dependent on the architecture of sound, on poesis – by which I mean specifically a lexical expression of personal identity and its conscious relation to the world – and on a transference of the symbolic properties of painting into the haptic field of

sculpture. If by no means the first, *Room for St. John of the Cross* was one of the early, successful displacements of video practice into those more vaguely constructed taxonomies of installation and performance that we now take for granted as appropriate milieux in which to embed the moving image.

However, *Room for St. John of the Cross* is also a work in which the spatial, visual and aural dynamics of its installation mirror the historical and spiritual experience of its subject – the sixteenth-century religious mystic St. John of the Cross (Juan de Yepes, 1542–1591), reformer of the Carmelite monastic order of the Catholic faith – and establish similar conditions for the experience of its contemporary subjects. Where the works of Nauman and Campus, inter alia, in the late 1960s and early 1970s are typical of the reach of the post-minimalist critique of space into the temporal regime of video art – in that they make obvious the intercalation of the spectating subject into the work, so that you see yourself seeing and moving – Viola uses the spatial organisation of *Room for St. John* to tell a story about a particular subject. The objects of that narrative certainly produce identificatory effects that might engage the spectator, in much the same manner as might objects within a painting; but the interplay of space and subjects (both subject of narrative and the spectator as subject) within the installation works in the same way as it did for Nauman and Campus. The use of video to reveal the displacement of the participating spectator to himself was typical of pieces such as Nauman's *Going Around the Corner Piece*, 1970, where the dislocation between what was visible on the screen and one's position in the installation produced a profound spatial disorientation, or Campus's *Optical Sockets*, 1972–73, in which carefully aligned video cameras and TV screens upset the self-perception of a spectator in their midst. Another early Campus piece, *Kiva*, 1971, with its careful juxtaposition of monitor, camera and mirrors, led to an 'alternation between direct video image and video/mirror image'.[1] The space of the subject within this installation is deliberately confused by the artist, hoping to lead to a critique of both subjective identity and the spectatorial role in making art.

In *Room for St. John of the Cross*, a work made after the emergence of new forms of reflexively critical narrative in video art during the late 1970s and early 1980s (most notably in the work of Dara Birnbaum), that strategy of confusion is put to different

effect. Rather than the self-conscious revelation of the individual's engagement with the work of art, *Room for St. John* uses space as narrative element, opening out subjective experience into wider imaginative dimensions. Nonetheless, I want to suggest that Viola *does* employ the same strategy as Nauman and Campus to expose the subject. But he uses it here upon the subject of his narrative: St. John. Viola's treatment of space in *Room for St. John* produces a model of private identity that is, to a degree, at odds with the negation of selfhood that surfaces in the Saint's poetry, and is precisely that distancing effect sought within post-minimalism. This critique of the self is effected through an ambivalent representation of the claim, peculiar here to the mystical tradition of Christianity, that in the renunciation of the self we discover our being. In Viola's installation, this relation of private self to public world, and its parallel relation of abnegated self to God, is expressed both in spaces that are simultaneously topological forms and metaphorical structures, and by the systematic intercalation of those spaces.

Room for St. John of the Cross is constructed around two enclosures that themselves enclose images of the world, and which are dominated by contrasting sounds. One of these spaces is public; the other, though it can be viewed, is intensely private. One space is set inside the other: a small black box in the middle of a larger, darkened, room.[2] This space is itself reached via a darkened corridor that effectively separates the installation from any other part of the exhibition in which it is placed. Our public experience of *Room for St. John* is premised by isolation.

The outer room is dominated by a large black-and-white video projection of snow-covered mountains. Shot with a hand-held camera, the image is profoundly unstable, moving up and down and from side to side in erratic patterns, as if the person filming the scene was running, or perhaps being buffeted by the mountain wind. This impression is accentuated by the roaring sound that dominates the room: what is understood to be intangible becomes almost a material property of the space, so comprehensively does it dominate our experience within it. This outer room is, to a degree, deliberately brutish in its effects and its attenuation of experience through an emphasis on one sound and one monochrome vision.

The second chamber, by contrast, is delicate, nuanced and meditative. A small

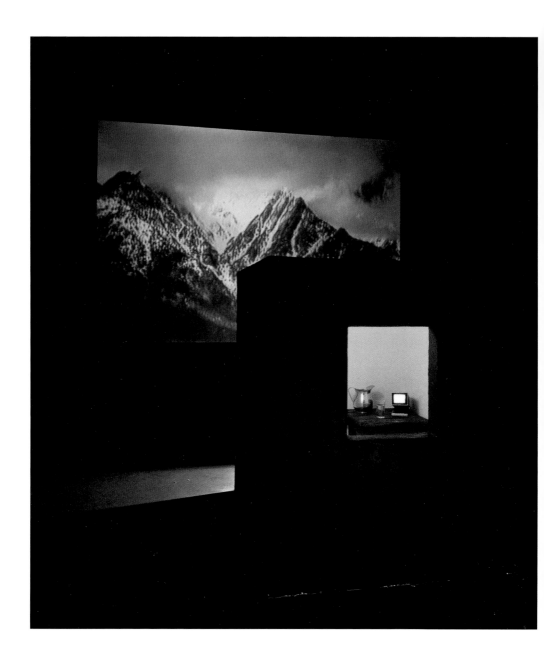

31 *Room for St. John of the Cross*, 1983

window allows us to see inside the structure, although we must bend awkwardly to do so. The act of looking forces upon us an awkwardness that would be the condition of anyone standing inside this box, but that somatic discomfort effectively draws attention back to us as viewing subjects. Our action is not simply a scrutiny of the living space of an individual, but an apprehension of another's corporeally experienced space that mirrors and renders tangible the immaterial condition of their private, spiritual being. The structure of the installation compresses examination and experience: one is no longer merely a spectator, a member of an audience, but a participant.

With one concession, Viola in this chamber has replicated the dimensions of the cell in which St. John of the Cross was confined by elements of his religious order for nine months during 1577–78. The concession is the window: our insight through it parallels the only view that St. John had at that time, save on the occasions he was taken out to be chastised and beaten. This is the view of self-reflection, of the world mediated almost exclusively *through* the self, and projected as it were *upon* the self.[3] Rather than showing us a film with St. John as its subject, Viola renders haptic the act of introspection so that we experience the Saint's internal, private state as material condition.

The interior walls of the cell are white; the floor is laid with earth. In one corner there is a small wooden table, and on it a metal water jug, a glass of water and a 14-cm colour monitor, a further box within a box. On its screen is a colour film of a snow-covered mountain rising from meadows and a forest. Unlike the nervously animated filming of the projected image in the outer chamber, this picture has been shot with a fixed camera and is screened in real time: there are no edits or camera movements. Indeed, the image is so still that it is only with protracted attention to this small screen – a demanding act given the height of the window and the position of the monitor – that one can recognize the almost imperceptible movements of leaves and branches in the trees, and of gently swaying grasses. The still image becomes a focus for concentrated meditation, but it is a meditation that is only possible through a certain suffering that might be understood as a test of the spiritual worth of the experience.

There is a separate sound installation within the room. Its level set just above the threshold of audibility, a voice recites in Spanish four of the poems composed by St.

129

John during the period of his captivity. As with the moving image, here too Viola establishes and sustains a relation between world and self, between what is manifest and what is latent. One can barely hear the small voice of poetry above the roaring wind of the outer chamber, and even then it is hardly comprehensible: merely fragments of someone talking to themself, and through that conversation talking also to God. From the overpowering environs of the outer world – our social selves – we eavesdrop on an inner life.

St. John's poetry couches personal spiritual experience within metaphors that conceive the natural world, from which he has been separated by imprisonment, in terms of both sight and sound. The mystic grounds his encounter with himself – the act of self-reflection that ultimately is an insight to and an encounter with God – in representations of that which he cannot see and that which he cannot hear. As an historical phenomenon, this personal meditation, and its poetic formulation of one's unique relationship to the divine, comes rather late. As an aspect of the Catholic Reformation it reflects those expressions of personal mystical engagement, freed from the mediating intervention of the cleric, that a century or more earlier in Northern Europe characterised pre-Reformation Christianity. In his self-expression and self-scrutiny St. John has something in common with mystical writers of the fourteenth and fifteenth century such as Dame Julian of Norwich and Richard Rolle. Essential to all these figures is a degree of antagonism towards institutional authorities and the social framework of religion: all insist upon an individual relation to the godhead. In their written descriptions of that relationship we witness the emergence of a private self: we can understand these writings as 'autobiographical' in their consciousness of an identity emergent in the act of inscription. And yet this individuality, seemingly fixed as text, is paradoxically evanescent: its emergence *as writing* depends upon its elision of its author. We know of individual self-consciousness only through the expression of its annihilation within a higher spiritual presence. Identity is conferred through its negation, the step beyond the self as it passes into otherness.

Viola makes a connection between St. John and the earlier mystics, tracing a history back to Dionysius the Areopagite in the fifth century CE, and suggesting

parallels with both the American mystical tradition (one largely collective rather than individualistic) typified by the Shakers, and with the Eastern traditions of Buddhism.[4]

In an interview with Jörg Zutter he remarks:

> The basic tenets of the Via Negativa are the unknowability of God: that God is wholly other, independent, complete; that God cannot be grasped by the human intellect, cannot be described in any way; that when the mind faces the divine reality, it becomes blank. It seizes up. It enters a cloud of unknowing.[5] When the eyes cannot see, then the only thing to go is faith, and the only true way to approach God is from within. From that point the only way God can be reached is through love. By love the soul enters into union with God, a union not infrequently described through the metaphor of ecstatic sex. Eastern religion calls it enlightenment.
>
> The essence here is individual faith, and since God is said to reside within the individual many aspects of it bear a close resemblance to Eastern concepts and practices. The Via Negativa represented a place where Eastern and Western religion found themselves on common ground, but through the forces of the Inquisition and beyond, the Via Negativa was eventually dominated by the more familiar Via Positiva of today, a method of affirmation that describes positive, human attributes such as the Good and All-Knowing to the image of a transcendent God. Although still beyond all human understanding, the divine has an important connection to the human world through the attributes, expressed in orders of magnitude, quantitative rather than qualitative differences.[6]

What Viola here describes as the *via negativa* is a philosophy of progress by negation, of spiritual development through the dissolution of the self. As with T. S. Eliot in *East Coker*, we find ourselves only by losing ourselves: 'What you own is what you do not own/ And where you are is where you are not.' The step into a 'heightened' and refined subjectivity is a step into a transcendental void. In the writing of St. John of the Cross, this manifests itself in a negative poetics and in the

combination of metaphors of transcendence with those of sexual ecstasy, as Viola rightly observes, but also with those of wounding and bodily harm: 'O living flame of love/ How tenderly you wound/ And sear my soul's most inward centre!'[7].

But what observes this disappearance of the self into the loving arms of God is, of course, the subject as author. Forever changed, the subject nonetheless comes back as 'I' – only now one that is authoritative because of the experiences to which it has been subjected. History authorizes presence through absence, dignity through abjection. St. John can write: 'Not living in myself I live/ And wait with such expectancy/ I die because I do not die.'[8] But the description of that death necessarily demands a withdrawal from it, and the withdrawal is into 'ignorance' – 'Nor can I say what I discerned/ For I remained uncomprehending'[9] – or rather into a condition of 'unknowing', as Viola puts it. But what, here, is the unknown? Is it self or other? St. John, much in the manner of a subject in Nauman's *Going Around the Corner Piece*, sees himself from where he is not and is, literally, in no position to judge his identity.[10]

If the cell at the heart of *Room for St. John of the Cross* is a model of the self, as Viola remarks in his notebooks,[11] is it that camera to which the Renaissance scholar withdrew for privacy, study and contemplation?[12] Is it a space of knowledge, both of self and world, juxtaposed to an aporia – the world – which one comprehends through the act of isolated reflection? Or is the world the space of knowledge and the self, the cell, that to which we have no insight? Although the material structure of the work suggests otherwise, we might allow that, rather than a clear definition between spaces, there is a border which is necessarily trespassed upon by both sides to such an extent that it is simultaneously recognized and occluded. The mystical relation between self and world requires an oscillation that involves, on the one hand, dying to oneself – in a spiritual sense – so that one might live eternally, and on the other, living in the world so that one will die a mortal death. The self, otherwise, remains an aporia, a space where it does not know itself – it is where one remains 'uncomprehending', and where one remains, uncomprehended.

Self-knowledge is conditioned by the insight of others, and others are changed by their knowledge of us. *Room for St. John of the Cross* thus proffers a model of rela-

tion instead of a directly antagonistic confrontation between self and world, individual and religious authority. Viola's installation allows us to see that the mystical 'quietist' tradition does not exist in isolation from the Church as institution, any more than authors within that tradition are isolated from each other.

While there are quietists whose relationship to institutions is disastrous, or at best problematic – for example Meister Eckhart – others, such as Catherine of Siena and, I'd suggest, St. John of the Cross, are nurtured within institutions, even as their presence creates internal tensions and conflicts. St. John is wholly cognisant of the mystical poetry of St. Teresa of Avila – a sanctioning authority in his own rise within the Carmelite order – and could be said to have used the quietist tradition to produce his own historical effects on behalf of that institution, rather than as simply a solitary, vulnerable figure subject to the effects of ecclesial power.

In St. John's poetry and religious writing, the dissolution of oneself into otherness – the knowledge of God through immersion in transcendence – sustains an illusion of authorial and authoritative agency which is simultaneously that of the individual and of the religious institution. This illusion involves a movement between aporias: a play of negation and coming into being that occludes the possibility of relation and understanding between individuals, even as it both initiates and depends upon it. At the same time as one dies (in order to live in Christ), there is a step back in order to describe one's 'death'. How else can we say 'I am not'? And to whom do you say it?

The condition of the individual as an annihilated being implies a consciousness of identity as finite being, even at the point at which the representation of that identity passes it off as something else. I'm not suggesting that what we have in such a state of consciousness is that which contemporary theorists too easily imagine as the unproblematic agency of the Cartesian *cogito* – without the detailed scrutiny of historical conditions undertaken by recent scholars.[13] Despite its articulation as self-consciousness, identity emerges here as uniquely fallible, conscious of its own inadequate agency, its finite limits and a very human vulnerability that is reiterated throughout the poems. (Though as we shall see that expression of individual vulnerability has its institutional uses.) As Jean-Luc Nancy observes, nihilism – that which

obliterates itself – is 'itself an implicit form of the metaphysics of the subject (self-presence of that which knows itself as the dissolution of its own difference)'.[14] Nihilism is a strategy for the individual that seeks to overcome finitude through finitude, in a gesture of self-erasing agency. We might understand the privileging of failure, in this context, as failing to impute to the subject the self-consciousness of dissolution that underwrites its identity.[15] This, I'd suggest, is exactly the strategy of St. John of the Cross: a reformed and active Carmelite order could only emerge from the collapse of individual identity into a more profound relationship with God. But that new collective awareness and agency is completely underwritten by the authority of St. John: an effect authorised not only through the divine's own writings, but by the subsequent writing of the divine into the order's history.

Room for St. John of the Cross seems to me to express, spatially and symbolically, the complex dynamics of an engagement between self and world that would pass itself off in terms of straightforward dualisms. Rather than simply reiterating the mystical claims of St. John's poesis, Viola inverts the terms by which transcendence is attained, and therefore rethinks the terms in which individual identity is understood. This confusion is expressed through the intercalation of what are apparently defined spaces in the installation, by the flexure of the boundary between one state and another. Consequently, while the work appears at first to replicate the unresolved antagonisms of Christian faith – the contradiction between personal and communal that 'lies at the heart of Christianity, along with that between contemplation and action, and between the church as institution and the church as mystical body'[16] – it does so by aligning the space in which the self is broken and abandoned, *and* the space in which the spectator as subject suffers, with the social domain. Perhaps *Room for St. John of the Cross* does not, after all, offer us easy relationships between self and void, or parallels between hermetism and passivity.

St. John of the Cross, after all, did not live an eremitic lifestyle; unlike that earlier doctor of the church, St. Jerome, whose life became a kind of paradigm for scholarly reclusion in the Renaissance, St.John was a figure with an important institutional role. His period of captivity was a consequence of the division between reformist (Discalced) and conservative (Calced) factions within the Carmelites, and reflected

conflicting positions of political power as much as it did disagreements over niceties of hermeneutics. Juan de Yepes was imprisoned because he was a senior figure within the Discalced Carmelites. Following four years of study at Salamanca University, he had become rector to a Discalced college in 1571, and a year later was appointed confessor to the Calced Carmelite convent at Avila, where St. Teresa was a somewhat dissident prioress. It was at this time that St. Teresa 'was working upon her meditations upon elements of the Song of Songs'. Brenan remarks:

> Although Juan could never be described as her pupil... his close
> intercourse with her at this time must have been a stimulus to
> him. We may suppose too that she lent him some of the works on
> mystical theology that had most influenced her, such as those by
> Francisco de Osuña, Bernadino de Laredo and García de Cisneros.[17]

Brenan dates St. John's earliest poetry to his residency at Avila, and suggests that it is a response to St. Teresa's work.[18] Thus we have in St. John an informed and significant figure, both in the traditions of religious literature and in contemporary discourses of ecclesiastical politics. The eight months in which he was held captive in Toledo by the Calced Carmelites seems to have been the only period of St. John's life when he had any degree of protracted isolation.

One of the vital characteristics of *Room for St. John of the Cross* is the play it establishes between interiority and exteriority, so that what is experienced subjectively is manifested within the world. The structure at the centre of the installation is simultaneously spatial, conceptual and lexical. It represents at once the topological forms of St. John's captivity; the intangible notion of the self, as a kind of structure located first within the body and then within the world; and, I'd suggest, it symbolizes the exchange between self and world. While modelling the specific conditions of the Saint's imprisonment, Viola allows us to apprehend that one is never wholly private, and indeed that to insist on the privacy of the self is to perform an act of self-disclosure that necessarily violates the solipsism we wish to inhabit.

For if the cell is a kind of model for identity for Viola, it is one in which at the same time as knowledge both of God and the self is drawn into the structure of one's being, the operation reverses itself in order to bring back to the surface those very

proliferating, unstable, and perhaps unbearable, experiences that have just been encoded and apparently sealed within language. So it is that there are particular elements of the larger space of *Room for St. John of the Cross* that are seemingly representations of an inner experience which might otherwise be properly confined to the cell at its core. This, certainly, is Kurt Wettengl's understanding of the work:

> In the third verse of Coplas hechas sobre un éxtasis de alta
> contemplación (Verses written on an ecstasy) we are told of the
> loss of perception in view of the meeting with knowledge which
> exceeds all knowledge. Possibly this image corresponds to the
> abrupt swing in the black and white projection which produces
> a feeling of disorientation:
>
> > *I was so caught up and rapt away*
> > *In such oblivion immersed*
> > *That every sense and feeling lay*
> > *Of sense and feeling dispossessed;*
> > *And so my mind and soul were blessed*
> > *To understand not understanding,*
> > *All knowledge transcending.*
>
> In this poem, St. John also uses the image of the dark cloud
> which brings light to the night. "The more he climbs to greater
> heights –/ to understand the shadowed cloud/ Which there
> illuminates the night" – a mystical concept which Bill Viola referred
> to in several interviews, and which may be reflected in the black-
> and-white... pictures of the mountains shrouded in clouds.[19]

St. John's poems are essentially private documents: they speak of the communion between the self and God in the language of that most intimate of modes, love poetry. They describe his feelings, his passions. And yet they are made public. St. John chose to disclose this intensely personal relationship with God to a larger audience. The circulation of the work began almost immediately: according to St. John's biographers, among his first acts on escaping was the recitation of some of these verses to the nuns of a Discalced convent in Toledo where he took refuge. It is

through the disclosure of what is most secret, so that it is no longer secret, that the process of becoming a saint begins. Private is made public: the internal ecstatic experience is turned outward and that transcendent experience which cannot be rendered in words, is rendered in words. For Juan de Yepes to become St. John of the Cross, there is also a process of authorization. His experiences are validated by his order as they are disclosed, and that disclosure depends upon a narrative, which in turn is facilitated by the increasing dominance of the Discalced Carmelites within their order – a dominance to which St. John's revelations contribute.

To a degree, then, the cell at the centre of Viola's *Room for St. John of the Cross* is more than topological model of a cell, or conceptual modelling of the self; it is also a symbolic object, symbolic of our encounter with the Saint and of the Saint's historical situation. The private articulation of language – whether the writing of poetry that meditates on one's rapturous, mystical union with God, or the reading of that poetry so quietly that it can barely be heard – constructs a space in which the privacy of one's experience is conspicuously announced. Our relationship to St. John, which Viola renders both spatial and experiential, is also fundamentally textual; it proceeds from the poems and from the meditations in *The Dark Night of the Soul*. St. John as an historical figure writes to us through his own death. To that extent, identity here is no more than text, and effectively is an aporia, an unknown subject, coded within its own inscription. The annihilation of identity produces autobiography; and the process of writing that autobiography, the description of one's destruction, simultaneously implies a process of coming into being by being read.

The poems establish Juan as a transformed figure of importance to his institution as he steps back into the world from the captivity in which he has been held. The step outside the cell is a displacement of identity. What also characterises that step is a turning inside out of the crypt in which he has been 'buried'.[20] Not only does Juan escape from privacy and privation, but privacy and privation – as poetic narratives of private suffering – escape from him in a steady leakage. It is as though the wounds that have been inflicted upon him could never be healed, and as though – in a gesture that parallels the medieval tradition of the *ostentatio vulnerum*, where representations of Christ displayed his wounds as soteriological guarantees – it was

necessary for our continued faith that they never could be. Aporia is made manifest, and therefore understood, as aporrhoea. We only know a secret if it is told to us, and thus no secret. We can know that a secret is held without knowing its content; but the obviousness of the declaration 'I hold a secret' solicits us to open the hiding place and interpret the contents. So it is with the transformed Juan de Yepes: the first statement is that because of his transformation, he carries a secret; subsequent statements begin to disclose what those secrets are. The contour between inner and outer experience, between what has been written on the body by captivity and what has been written on the soul, undergoes a convulsion, an opening out of the interior to tell its own story.

Through our reception of those narratives we become St. John's audience as much as those Carmelite nuns were on that first morning of freedom in Toledo; he solicits readings from us of that which is, by the cryptic terms of its enclosure, its privacy, the aporia of the individual's intimate relationship to God. But what such disclosures also do is elevate the suffering subject to the empowered position of Christ: the degraded and abased Juan de Yepes becomes, as St. John of the Cross, an elevated figure through whom others may find the path to spiritual enlightenment. Accompanying this inversion of personal abjection into authority is a performance of vulnerability that has institutional effects, connecting the individual aporia to the world where history shapes individuals. This inversion suggests that one aporia conditions another, in what Jacques Derrida calls 'A plural logic of the aporia',[21] and implies that there is necessarily a passage between them. (Just as, in *Room for St. John of the Cross*, one space shapes our experience of another; just as there is a passage between that larger room and the framing institution of the museum and the gallery in which the installation is located.)

The notion of the spiritual narrative composed of secrets addressed beyond the self, and of its being constructed within a cell, suggests a further analogy for the material structure of Viola's installation. This is the space of the confessional. Confession within the Catholic faith had largely been a communal activity until the early sixteenth century. After this date, the act becomes increasingly personal and, it might seem, private. There is a shift towards the use of confessional spaces –

138

cubicles with a window granting limited access to both penitent and priest; enough space for a narrative of the self to pass through. That cubicle, for the penitent, is itself symbolic of a stringent precursory self-scrutiny. As the 'Catechism of Agen', 1677, puts it: 'What must I do to examine my conscience well?'; 'First, you must retire to a private place...'[22]

Privacy in the act of confession was, however, profoundly qualified. The community in which the individual lived was generally small enough for one to be recognized as being on one's way to, or from, confession. The structure of the confessional booth itself, with the priest sometimes sitting between two penitents and communicating with both, maintained a certain transparency. (Indeed, being seen to confess would become briefly fashionable in court circles in France towards the end of the seventeenth century.) Furthermore, there was a clear relation between the individual and their confessor. Priests knew the names of their parishioners: late sixteenth-century handbooks like the *Instructions to Confessors* of St. Charles Borromeo recommended that priests keep a record of the state of the soul of each penitent. Influenced by similar guides, more elevated members of a religious order, such as Juan de Yepes, often had a regular confessor with whom they mapped their spiritual progress. *Room for St. John of the Cross* puts us in the position of an audience/confessor: through the window in its cell we are granted an insight into the Saint's spiritual condition. The poems are whispered to us, as the narrative of spiritual failure might be whispered in a confessional.

The poems of St. John of the Cross would suggest that the privacy of the confessional is displaced first spatially into the cell and, secondly, conceptually, from the priest as interlocutor with God to direct relationship with God himself. The publication of those poems, however, shifts that narrative of personal fallibility which is the content of the act of confession, confined by the confessional space, into a social register where, illustrating piety, they are transformed into a narrative of distinction. Viola's embedding of the spectating subject might be understood as working in much the same way: engaged privately in our meditation upon the Saint's story, we are nonetheless witnessed by those around us. Our private, subjective experience becomes public knowledge. I would suggest that here we

have the sophisticated extension and redeployment of those strategies of subjective exposure that developed in post-minimalism's early use of video. There, the intercalation of the spectator into the space of installation (and the intercalation of those spaces into each other through the temporal properties of the medium) was a consequence of an overt meditation on the role of the spectating subject; here, it is a consequence of narrative, but it is a narrative constructed as much in spatial relations as it is in objects or images.

The nihilism of St. John's negative poetics paradoxically reinforces his standing in the world. But perhaps it is not such a paradox after all, since the model for spiritual life – that of Christ – depends precisely upon such an inversion, where transcendence is achieved through the corporeal manifestation of one's suffering. Power, in Christ – the physical manifestation of the ultimate authority of the universe – turns itself inside out so that it may reveal how powerful, how authoritative it is. That which structures Christian faith – the seemingly irreconcilable relation between interiority and exteriority, between privacy and publicity, between a God who is all encompassing and simultaneously internalised; all powerful and vulnerable – is both represented and critiqued by the structural model of space in *Room for St. John of the Cross*. The sustaining duality is replicated in the relationship of cell and screen; the place of captivity which is also the space of identity, where the infinite can again be held within and contemplated. We encounter its critique in the transgression of the apparently solid parietal surfaces of inner and outer worlds within the installation. Interiority becomes publicized; the contemplation of the inner life becomes the subject of our attention. Is it at this point any longer 'interiority'? We step into an unknown world, and it steps into our equally uncharted subjective space. Each changes the meaning of the other. And each of those steps is accompanied by a certain death. In a recent essay addressing the emergence and disappearance of the human subject, Jacques Derrida uses a play on the word *pas*, as both a term for a step forwards and a negation. Being involves a certain step (*il y va d'un certain pas*) which can be a reciprocal movement between terms; which can be going forward at a steady (or certain) pace, towards one's death, towards 'I am not'.[23] Juan de Yepes, encountering God in his captivity,

'died to himself' – obeyed that injunction of personal faith which proclaims that only by the annihilation of the self can one find eternal life, and thus not die.

If the haptic space at the centre of *Room for St. John of the Cross* is also the space of that intangible entity, the self, it is never a self in isolation. We understand the cell within a cell only through the exchange between spaces, and in particular through our insight into the crypt in which St. John was both detained and formed. The act of looking through that window becomes equivalent to reading the life of the subject, to hearing its confession. What we see and hear is not given to us solely by the subject but rather is a consequence of our location in space and time, of our address to the subject. If the negative poetics of the Christian mystical tradition announce that one is made through loss, the inner cell of Viola's installation would seem to mirror those terms in a more complex and ambiguous play – a step back and forth – between being and nothingness, between self and other. Further, it allows us to imagine that movement as more than just the individual against the world, but rather as a search for individuality whose pursuit puts the self into awareness.

32 *Hatsu-Yume (First Dream)*, 1981

CHAPTER 7

THE FREQUENCY OF EXISTENCE
Bill Viola's Archetypal Sound

RHYS DAVIES

There have been two distinct phases within Bill Viola's oeuvre. In the 1970s and 1980s he produced a body of work that developed the technical possibilities of the video art genre. Viola became a leading figure in a generation of experimental video makers who redefined the function of video from being a utilitarian alternative to visually superior photosensitive film, to a creative medium with a visual language that transcended a notion of gestalt and shallow reflection.

The second, current, phase sees Viola apply this methodology to the three dimensional framework of the installation. This process in itself results from developments in video projection and imaging technology, combined with the artist's confidence in removing the objectivity of the completed, edited and presented video-work, confined as it was to the two dimensions of the television screen. In its place he turned to the multi-screened environment, which demands a personal and entirely subjective interpretation based on interaction and the individual's cognitive processes.

Here is an artist who has made the transition from pioneer to master by a sustained focus on certain themes. This persistence could have marginalized Viola as those ideas found their way into the mainstream. He has escaped this fate, partly because he invariably seeks new methods and techniques to present his core themes, but also because those themes, cycles of life, darkness and light, the space of air and water, and the sound archetypes which are their binding signification, are vital to our understanding of being. Here I examine Viola's approach to these themes in *Migration*, 1976, *Hatsu-Yume (First Dream)* (**32**), 1981, and *Five Angels for the Millennium*, 2001, addressing his increasingly sophisticated use of the archetypal sound shape.

FROM GREEK TRAGEDY TO A NEW HOPE: THE CREATIVE PROVENANCE OF THE ARCHETYPAL SOUND

The device of low frequencies eliciting an emotional response has been used since humans first tried to understand their place in existence through creative expression. It is the sound made by balls of lead dropped onto stretched animal skins to signify the intervention of the Gods in classical Greek tragedy. It is the thunder sheet in nineteenth century melodrama, part of the almost compulsory storm sequence that worried and nagged at the existential nerve of a new industrial landscape.

In film too, the archetypal sound is used to make the watcher sensitive to the action on screen. Sound is not confined to the visual frame and therefore enjoys a greater freedom of expression, particularly when it is contextualized by diegetic elements. It is perhaps significant that the beginning of Viola's career coincided with a new benchmark for sound design in mainstream cinema: *Star Wars: A New Hope*, by (George Lucas, 1977) introduced the THX digital mastering process. Lucas's film was amongst the first to use Dolby's surround sound system. That cinematic revolution involved the positioning of two dimensional action sequences within a three dimensional aural environment. This led to the audience being drawn into the visual sequences by sounds that originated outside both the edge of the screen and the proscenium stereo sound. However, if the presentation of these sounds was the result of radical technological development, nevertheless, the origination and subsequent manipulation of those sounds, for that one film at least, employed traditional techniques and methodologies.

The true innovation within the sound design for *A New Hope* was the archetypal nature of the designed keynote signifiers for its action sequences, particularly those taking place in space. Previously, the signification of futuristic machines was achieved through the use of VCO synthesis and white noise generation. However, the inspiration behind the keynote signification of the space vehicles in *A New Hope* is to be found in a more primeval place. It's significant that Darth Vader's space fighter sounds like the angry scream of a hungry and dangerous predator: our reaction to it is part of our DNA core programming. We cannot help but be affected by it.

The sound design manifesto for *A New Hope* is established in the very first shot.

The musical coda, used in all subsequent Star Wars films, signifies the end of the title sequence and the start of the narrative. The camera, seemingly positioned in space, pans down to reveal a colossal star-ship. We understand that it is a giant structure because the long tracking shots encourage us to make that rationalization. However, if these optical techniques assist our suspension of disbelief, then we are manipulated into knowing *instinctively* that this star-ship is huge because of the sound it makes. In fact, the sound precedes the image and we are obliged to anticipate size and bulk. I'd suggest that this sound is fundamentally similar to the ambient sound found within *Five Angels for the Millennium* and indeed, the opening sequence of *Hatsu-Yume*. It is the sound a continent makes as it moves across the surface of the planet. It is the sound of the world turning and we recognize it and are in awe of it.

To compare Viola's sound design with that of one of the most commercially successful, epochal films of the twentieth century might seem critically opportunistic. But the mutual recognition of the universal semiotic force of the archetypal sound provides a bridge between the work of Lucas and Viola. The comparison gains credibility when we see that both men have travelled down similar technological pathways. Whilst Lucas explored the potential of computer based animation and image rendering, Viola was exploiting the fruits of Sony Corporation's research through his pioneering use of their computer based motion controlled camera systems for *Hatsu-Yume*. Indeed, by 2003, Viola had reached the point where his tools – though certainly not his budgets – were much the same as those used by Lucas in *Attack of the Clones*, 2002: namely Hi Definition Digital Video and hard disk based editing systems. Most notably, Viola now sometimes employs a professional sound design team, providing a vast palette of sounds that were not necessarily originated with the imagery.

RINGING THE CHANGES: *MIGRATION*, 1976

> I was particularly interested in the idea of resolution, i.e., that even if you can't see something because it is too far or too small, it exists nonetheless.[1]

In Viola's early work, one production strikes me as an intriguing example of how a single sound, through cultural signification and archetypal resonance, transcends the thematic constraints of images upon narrative function. *Migration*, 1976 (**33**), pro-

duced five years before the completion of what is arguably Viola's first major work, *Hatsu-Yume*, is by comparison a leaner, more accessible piece. Both are visually poetic, yet where *Hatsu-Yume* is a sprawling epic, set in multiple locations and employing a virtuoso's range of visual and aural scenography, *Migration* is a haiku, stripped down, elegant and emotionally potent.

> I was interested in the traditional cosmology, (going back to the ancient world) of the microcosm and the macrocosm, the idea that everything that occurs on a higher level or order of existence has its correspondence on the lower orders, (i.e. heaven and earth).[2]

The visual style of *Migration* is instantly recognizable, not least because its production process has been replicated by subsequent generations of video artists and students. Creative experimentation is common to practitioners with a newly acquired access to sophisticated production techniques. Viola's exploration of the 'traditional cosmology of the microcosm and macrocosm' is perhaps in part motivated by his access to macro lenses. These allow the resolution of an image in minute close up, so that a rational apprehension of the framed object is no longer possible. Watching *Migration*, one senses that it is the work of an artist using new technology to develop and refine a visual articulation - a common practice in the early history of video art as fresh tools became available. The opening sequence is in itself an investigation of visual resolution. Viola begins with a macro close-up of a TV monitor displaying an image from a second camera of the table and chair in medium long shot. As the first camera pulls out, the second camera zooms in. This creates a progressively larger image on the monitor that matches the close-up camera's widening field of view for each shot. The objects in the image never change size, only resolution.[3]

Migration is, in essence, a passion play investigating the cycle of life. The visual style reinforces this cyclicality, as the work develops into a series of images that cross fade into each other. This technique lets Viola create a sense of fluid movement through a progression beginning with the medium long-shot of the table and bowl and ending with a macro close-up of the drops of water as they emerge from the pipe. The distorted reflection of the artist in close-up is contained within each drop of water.

The presence of the artist is vital. His focus becomes ours as we share his fascination with the process. If we harbour any uncertainty as to the specific area of his interest, then the shot progression removes it. This is a statement of intent by the artist. In *Migration*, as in much of his subsequent work, truth is contained within the actions of water. However, it is significant that Viola chose not to record the sound of the water dropping into the containing vessel. A water drip is an archetypal sound: within the context of the work, one might suppose that it would be an appropriate accompaniment to the action. Instead, the artist uses the sound of a chiming bell. Viola's decision to utilize a sound that contains such cultural and indeed iconic significance, whilst muting the natural sound of water is initially rather perplexing. As one reviews his oeuvre it is clear that Viola frequently uses the sound of water. Why then, given this perfect opportunity, does he spurn the chance in *Migration*?

The answer, I feel, has much to do with our responses to this particular effect. The sound of a drop of water falling into a pool is not one we would normally associate with inclusiveness and spiritual fulfilment. It is a cold sound, usually signifying remoteness and isolation. It is difficult to imagine a dramatic context where such a sound would signal an abundant temporal or spiritual prosperity. In our mind's eye, we picture cold and damp buildings on rainy winter nights. The shelter we seek and the warm comfort we crave is denied by this sound. The force of this signification can be emphasized by acoustic properties specific to the sense of space achieved by reverberation. A large reverberation will evoke a great space dominated by hard unyielding reflective surfaces – a prison or disused warehouse or an empty church. A dense and close reverberation will present us with images of leaky taps that rob us of sleep. The slow drip of water is perceived as insidious, meagre and frustratingly perpetual.

This is not true of certain water sounds. Oceans and fast flowing rivers are seen as life giving and life affirming and their potential destructiveness perceived with awe and wonder at the incarnation of such natural power. In *Migration*, Viola's vision of the inter-connectedness of all things, symbolized through the action of water and the resolved image, would have been undermined had he included the auditory reality of the framed action. In its place, he chose a sound which embodies a universal signification; one that dates back to the very beginning of human civilization.

33 *Migration*, 1976

A chiming bell is not itself an archetypal sound, though its significance within certain contexts can mean that it functions in that way. A genuine archetypal sound can only exist in nature. It is the sound of waves breaking on a shore; of thunder, wind, and lightning. It is the roar of a predator, and the cry of a newborn. It is both a heartbeat and a great natural disaster. These sounds invariably elicit an emotional response because their manifestation has always had a direct impact upon the human psyche. The presence of a signal archetype in the landscape can mean both the continuity of the cycles of life, and the arbiters of change within those life cycles.

Similarly, the significance of a ringing bell is defined by a broader context. It can signpost the time of day or a call to prayer. It will sound in celebration of victory and as warning in times of peril. Consequently, when we hear a church bell ringing, not as a call to worship or as a measurement of time, we understand that it signals a change. That is the job of any bell, be it a school bell or even a doorbell: its function is to ring the changes. The survival of the bell within our culture identifies it as an icon of an un-altering continuity and familiar reassurance.

The chime in *Migration* was not created by using a conventional church or hand bell. The initial percussive tone lacks the bright clarity one would expect and the tonal decay does not exhibit the more consistent harmonic register of a bell shaped, brass object. A series of distinctive tonal fluctuations led me to suspect that the chiming

vessel was filled with water, possibly a Tibetan chiming bowl. The vessel on the table looks like such a bowl and I wrongly concluded that this was the source of the sound.

> I was striking a large metal gong, actually a sawed off iron gas cylinder. The sound was recorded separately, without the video present. Two individual recordings were made and laid onto the A and B video source reels used for the dissolves. As the video was faded between the individual camera positions, the audio followed, with the gong strikes on each channel in random relation to each other.[4]

It is interesting that Viola describes the sawed off iron gas cylinder as a 'gong'. A gong does not produce a clear tone, but an initial soft percussive boom, followed by a 'shimmer' as the sound waves travel from the centre to the outer rim. The sound in *Migration* does not shimmer. Perhaps the best distinction to be made is that a bell, through its robust construction, contains the physical manifestation of the chime. The physical distortion as the generated sound waves manipulate the metal is far less that that of a gong, which contains a proportionally larger and much flatter surface area and therefore is physically affected to a much greater extent, oscillating to produce the 'shimmer'. Whilst the initial volume of sound produced can be significant, the construction means that this initial intensity is quickly dissipated, making it unsuitable for most applications where a direct and clear tone is required.

A sawed off iron pipe is closer in shape and robustness to a conventional bell. The tone produced is clearly bell-like, although the thickness and simplicity of its con-

struction and its size results in a darker tone than that achieved by a manufactured tubular bell. As *Migration* develops into a series of self-contained cycles of action, the bell chime provides an almost dirge like and funereal quality. The manner in which it was recorded and then reproduced gives it a sense of hesitancy.

The bell sound in *Migration* lacks a visual context. Its function is to comment upon and reinforce the action from which it is separated. However, whilst the bell is culturally ubiquitous, nevertheless, its signification or symbolic meaning is not universal within different cultures: this blurs the possibility of a specific signification within *Migration*. In the Catholic ritual of excommunication, the tolling of a bell signified the loss of the individual to evil. In medieval Europe, amongst other causes, church bells were rung to ensure both a good crop harvest and to ward off evil spirits. The tolling of a bell has always been a bad omen for sailors, foretelling of shipwreck and death. In its cultural uses the bell embodies an ambiguity which becomes an intrinsic part of *Migration*. Perhaps Viola is concerned with presenting the broad-brush strokes of signification and the bell is included to signpost a spiritual complexity by unleashing those superstitions that surround the tolling of a single bell.

THE SOUND OF BEING: *HATSU-YUME (FIRST DREAM)*, 1981

With *Hatsu-Yume*, Viola adopts a very different approach to the designed sound. Where *Migration* employed a single keynote, albeit with a strong archetypal resonance, *Hatsu-Yume* is a filled canvas, employing non-specific and pitch-treated archetypal sound 'colours' in a context where we are encouraged to hear them as 'real'.

> I remember one time when my grandfather came up from Florida to
> visit us at our apartment in Queens, New York. He came into the room
> that I shared with my brother, Bob, just to see our toys and spend time
> with us. I must have been about eleven years old. We had the window
> open; it was summertime. And he went over to the window, looked
> out, and said, "What's that sound?" I said, "What sound?"
> And he said, "That sound. Are we near the ocean?"[5]

Required to construct a conventional representation of sceneographic 'realism',[6] a sound-designer defines the keynote signifiers within the visual environment.

Were *Hatsu-Yume* a mainstream documentary or drama, the designer would select signifiers to reinforce the notion of reality and the requisites of narrative context. As a general rule, the wider the visual frame, the fewer keynotes are appropriate, particularly for natural, non-industrialized environments. Consequently, a mountain terrain might contain only one or two keynote signifiers. The sound of wind as it flows over the uneven landscape could be the defining keynote, generally accepted as appropriate to that location. Other keynotes are optional, their inclusion dependent upon specific factors, especially time-frame and location. Should the imagery suggest the middle of the day, the use of birdcalls would act as a positive reinforcement, although for truthfulness the designer would be restricted to birds of prey. This is because we may, through associative past experience, collectively preconceive their presence within this environment, and so the designer is free to utilize their cries without requiring their physical manifestation within the defined frame.

Alternatively, should the image show the landscape at sunset, it might be appropriate to include the sound of cicadas.[7] The intensity of this effect is determined by the strength of the setting sun that, regardless of auditory reality, establishes the location and climate of the region. Indeed, Viola would later use this technique to signpost the 'Creation Angel' in *Five Angels for the Millennium* (**34**).

Within the linear narratives of documentary and dramatic fiction sound design is frequently used to establish an emotional context. If we were to take an image of the mountain terrain at sunset and bed in the wind and the cicadas, the emotive focus would depend on narrative context. If this context sought to create a sense of foreboding then it would be entirely acceptable to include a rumble of thunder, reproduced at a signal level. The location of the thunder within the stereo or quadraphonic image would depend upon whether the designer wished to signpost the current narrative or foster a sense of anticipation.

Viola's approach to sound design in *Hatsu-Yume* is contrary to such conventions: he does not attempt to isolate the keynote signifiers of location. His contextualizing of the image through the use of designed sound requires that it appears to be free from any reductive process. Therefore, the viewer is confronted with both diegetic and ambisonic sounds. These are a mix of keynote signifiers and background noises that

we associate with the audio recording of the environment we see. As observers we will be entirely familiar with those sounds captured by the camera microphone. In fact, twenty years after *Hatsu-Yume*'s production we are more familiar with this kind of sound, if for no other reason than, since 1981, there is a much greater public accessibility to video cameras. The panoramas at the beginning of *Hatsu Yume* contain sounds that appear to be the non-selective audio captured by the camera microphone during filming. What then are the elements that provide for this kind of realism?

> The sound... was recorded in two ways. I used a Plumicon tube
> professional Sony video camera with a separate ¾ inch cassette video
> recorder. I was always rolling sound with camera, which had a mini-
> shotgun microphone mounted on it. Other times, Kira (Perov) would
> hold or tripod mount a bar with two directional cardiod microphones
> in a 90 degree binaural configuration, in general my preferred mode
> of recording because it captures the spatial field.[8]

Let us first take the sound of wind: imagining it will perhaps induce a mild emotive response, due to its archetypal nature and perhaps its dramatic associations. In imagining this sound, we are also recalling a landscape, for our memory is visual and we need a context. Perhaps we are in Viola's desert, or possibly an urban environment, the wind shaped and confined by large reflective surfaces. The sound of the wind is a tone, varying in pitch in direct relation to the force it applies. When we try to imitate the sound we purse our lips and produce an effect that is half breath and half whistle, moving our lower lip laterally to produce those changes in pitch. Doing this, we are distilling and transforming auditory reality, creating, in effect, a tone poem.

Wind recorded through a camera microphone bears scant relation to our conception of how wind should sound. Instead of the continuous pitch shifting tone, we are confronted by a loud percussive thud, with a relatively slow attack as the sound waves bounce off the condenser-recording capsule of the microphone. Because the recording process within the camera employs a system of automatic gain, it will compensate for this percussive force by reducing the recording volume and so obscure any other sounds within the environment. The result does not evoke mystery and awe, but rather a sense of disruptive and indiscriminate violence.

We recognize this very different incarnation of wind sound and we associate it directly to the domestic video camera, which we then associate with the amateur video-maker. Having accepted this, we readily accept that all audio contained within the visual sequence is 'reality'. This is reinforced by other incongruous sounds associated with the 'video tourist' – the mechanical whir of the camera in operation, the clicks and rustles of the operator and similar noises that bear no relation to the visualized image. Having established these preconceptions, Viola can introduce treated, designed sounds in the post-production stage.

The opening of *Hatsu-Yume* contains a series of stills and slow motion shots of great waves approaching a deserted shore. Initially, the sequence is silent. An archetypal sound is introduced, that of waves. The sound is pitched down, but not incongruously because the images are presented in slow motion. The final image of a wave cross fades into a sequence of mountain panoramas, shot from an equal or higher perspective as the audio cross fades into the percussive wind effect. This sequence continues, images and audio are cut together and the sound in particular has an abrupt quality as the volume and aural density changes from shot to shot, strengthening the preconception of an 'assemble' or 'in-camera' edit.

153

> I knew that we lived far from the sea. I went over next to him
> to listen, and for the first time in my life I heard the "undersound"
> of the city – the accumulation of all the traffic and all the people's
> movements – this low level, deep rumbling sound. It was
> constant and continuous, but I had never noticed it.[9]

It is difficult not to accept the veracity of the sound used to represent the waves in the opening sequence. It is certainly an archetype, with a low constant roar and the frequency response of an underwater recording. This is in itself revealing since the accompanying image is not shot underwater. We might conclude that this sound is not the recorded actuality and has been sourced from elsewhere. Indeed it is likely that this effect is an urban or even industrial sound, pitched down an octave using varispeed with the high and high mid frequencies (3 – 15k) reduced or muted. This process can imitate an underwater recording as the pitch is lowered. Significantly, this sound is faded in over the established image and is even permitted a 'lagged'

cross fade out. No other aural sceneographic element within the work is allowed such latitude. Perhaps this in itself is a creative statement by Viola, one that does much to declare the presence of artifice within the sound design, and encourage us to question the conventions of authenticity that compose the audio/visual structure.

> Listen to the soundtrack in the night driving scene, an abstract
> rumbling, at a faster speed and you will hear Elvis Presley's
> "Love Me Tender" playing on the car radio in places.
> It felt like I was opening up the seams in reality.[10]

The technique Viola describes is not confined to the night driving scene. The ship at sea scene also contains a vague rumbling that, speeded up, is revealed as a radio message. Viola is playing with the 'colours' of sound here; in the same way he plays with visual imagery in *Hatsu-Yume*. These low, droning archetypes are non-specific 'stem cell' sounds that can be relocated and applied to any visual sequence.

As a sound designer, I am entirely familiar with this process. The inclusion of non-specific, archetypal sounds within an aural environment where they do not belong is a way of bypassing the rational, particularly when the sound is presented at a low level, contextualized and disguised with keynote signifiers of the visual location. I see it as a means of guiding the viewer/listener into particular forms of receptivity to the narrative. If the story demands the sound of a man crying, how much more potent would it be if one were to take the sound of a baby crying and pitch-shift down to that of a man? Rationally, we hear a man crying but subconsciously, emotionally, we respond to the specific intonation of the baby.

What I find particularly intriguing are those occasions on which Viola, evading an aural sceneography of heavy, low-pitched archetypes, chooses a more restrained design. The most striking example of this is set within the rural sequences early in the work. These images go some way to explaining Viola's notion of the harmony of existence. He presents us with a subtle though conventional narrative centred on the movement of the truck. We see it first at night, the headlights shining over the calm water of a harbour. The truck is in fact a narrative device, which will lead us from harmony to conflict, from rural existence to an urban lifestyle, from a natural to an artificial mode of life.

We cut to a series of pans and stills of a woodland environment. The sounds we hear are keynotes: birdsong, insects. There are sounds of agricultural machinery in the distance. It presents a rural idealism, where even the distant sound of farm machinery is perceived as inclusive. Viola then introduces the sound of the truck passing by at an invasive level, and its presence is detrimental to the harmony of the environment. We follow the sound of the truck as it fades and Viola allows us a glimpse of humanity at one with the natural world. The tractors serve the needs of the managed fields, and their engines do not dominate the aural sceneography, but contribute to it. This is the last time we experience such harmony. The next time we are shown humanity reaping the benefits of the natural world, it is presented as an act of exploitation for an urban mass market. The sound-scene underpins this notion as Viola renders separate and disjointed elements into an archetypal roar.

> It's the sound you can hear when you're standing on a bridge
>
> looking out at the city, with the evening air still and nothing
>
> moving nearby. This under-sound exists at all times, even far
>
> out in the desert. Once I had heard it, I could never not hear
>
> it again. I think of it now as the as the sound of Being itself,
>
> and I've used it in my work many times.[11]

The sound of 'being' is the central cohesive force that propels *Hatsu-Yume* from the ocean to the city centre. Its design is disguised by the lack of a reductive process. Indeed, there is no reduction, only augmentation. Viola builds and combines the archetypal sound shapes and colours until any sense of physical location is suppressed by the imperative to transform our cognitive faculties from the rational to the instinctive. Viola narrows our perception of the world into abstractions of light and darkness. It is, however, the non-specific sounds shaped into a primal noise that provide the dark spectrum of his palette.

> Generally I'm interested in the space within/beneath the
>
> things of the world and sound is no exception. Almost
>
> all the sounds in *Hatsu Yume* were slowed down in post.
>
> This opened up extraordinary textures and buried secrets.[12]

FIVE ANGELS FOR THE MILLENNIUM: TATE MODERN, JULY 2003

> If you are going after the experience, you don't go after the
> literal description of the thing. If you want to put someone
> out in Death Valley, and we're in a room in New York City
> in some museum, you turn out the lights.[13]

Entering the installation I first experienced a temporary blindness. The entrance was set at an oblique angle to the five projections. In that sense it was unlike walking into a cinema auditorium, where one is confronted by the dominance of the projected image. Instead, I was stripped of sight, aware of individuals around me, but unable to fix their exact locations. I felt vulnerable, left exposed to the ambient sound manifested as a low background roar containing no specific sounds yet evoking the sense of a vast space. My response was equally archetypal. I felt insignificant and before my eyes adjusted to the low light leaking from the projections, before I regained my rational sense of self, I had been transported to a place where I was dwarfed by space and time.

As an enclosed multi-screen video installation much of the individual's initial perception is dependent on their arbitrary point of contact within the cyclical time-frame. When I entered the space, there was no overpowering visual effect. Had I entered just a minute later, I would have experienced a very different set of visual and aural sensations, as the 'Birth Angel' and the 'Departing Angel' cycled into their most dynamic phase, an intense passage of slow motion, high definition images of bodies in water, shot underwater. As it was, my perception was that of a dark space and an archetypal background roar – an example of Viola's 'sound of being'.

I'd argue that the sound design for Five Angels for the Millennium is a much more effective use of the archetypal environment than was accomplished in Hatsu-Yume. There are in fact two true archetypes present. The most apparent is the sound of water. This is predominantly real sound, pitched down in direct proportion to the slow motion images. The initial percussion as the figures strike the surface fades into the background sound of water in a large space. Mixed into this wash of sound colour are a subtle range of defining keynotes, including air bubbles escaping the figure's clothing and water dripping from the emergent figures.

34 'Departing Angel'; 'Fire Angel'; 'Birth Angel'
from *Five Angels for the Millennium*, 2001

This is a much more subjective and expansive use of the sound archetype. The lowering of pitch performs a very different function than in *Hatsu-Yume*. Viola's decision to take one sound and manipulate it through varispeed to signify his metaphysical visual landscapes was an attempt to create an aural vocabulary distant and distinct from the confines of reality. The result was an emotive recognition of both sound and vision, juxtaposed with an alienation of the rational cognitive process.

The water sounds in *Five Angels for the Millennium* create a greater sense of inclusiveness. In reproduction, the aural landscape is cleaner and more defined and we are able to both feel and think the experience. The lowering of pitch includes rather than alienates the individual and establishes a palpable force that augments the sense of ceremony and ritual.

> In *Five Angels*, I wanted to subjectify the sound, to take it
>
> away from the one to one correspondence to normal reality,
>
> and also to open up the spatial sound field in the room.[14]

The second archetype in *Five Angels* is the sound of crickets and night insects that accompanies the projection of the 'Creation Angel'. There is no obvious narrative reason why Viola would choose to include these particular archetypes. However, in his generous and specific replies to my questions concerning the technical and strategic uses of sound in his oeuvre, he commented: 'Creation Angel is the only one of the five where the camera was placed out of the water, looking down from the pool from above. I wanted to have air sounds on the soundtrack to reflect that. Like the underwater ambient sounds, night insects function as a kind of drone, a state of continuously evolving, unbroken sound that highly interests me.'[15]

We might, however, postulate that the inclusion of the insect sounds also serves a pragmatic purpose; a need perhaps to ameliorate the coldness that one might associate with vast bodies of water, particularly when they are presented using dramatic and cinematic low-key lighting. The insects evoke a sensation of dry heat and perhaps represent the other vast, significant space within Viola's thematic and visual lexicon, the desert.

Five Angels for the Millennium is effective because Viola does not strive for intellectual understanding, but rather provokes the recognition of our place within universal cycles of existence. Consequently, it is not our function as 'receivers' of this work

to dismantle the poetic vision into a series of rational absolutes. Our job is to simply feel and it is the collective act of 'feeling' that signposts the existence of a universal truth. In this way, *Five Angels for the Millennium* is the direct descendant of *Migration* – the product of a distillation into a distanced act of repetition – that of assimilation.

THE FREQUENCY OF EXISTENCE

Bill Viola works with grand themes, yet he is less concerned with the human condition when it is set apart from the other cycles of life. His interest is in the idea that if you examine an object minutely, or view it from a great distance, they become fundamentally identical in substance and often possessed of great beauty. If you take an image and reduce or magnify it to the point where cognitive function is bypassed, then that image becomes abstract. One could argue that this process isolates the significant form of the object within the expressionist framework of waking dreams. Alternatively, one could say that the colours are beautiful. For Viola, both observations are valid.

159

The same is true for the sound design within his work. It is a straightfoward process to take a sound and transform it into an archetypal evocation. The density and the cognitive obscurity of Viola's soundscapes is not a challenge to discover rational meaning. By taking a sound, manipulating it into an archetype, and then placing it within a different visual context, Viola is not trying to trick us. He is not saying, 'See what I did there?' To Viola the sound of being, heard from a distance, is the combination of all the disparate elements that make up the infinite variety of sensations and physicality, resolved into a constant low rumbling – the frequency of existence.

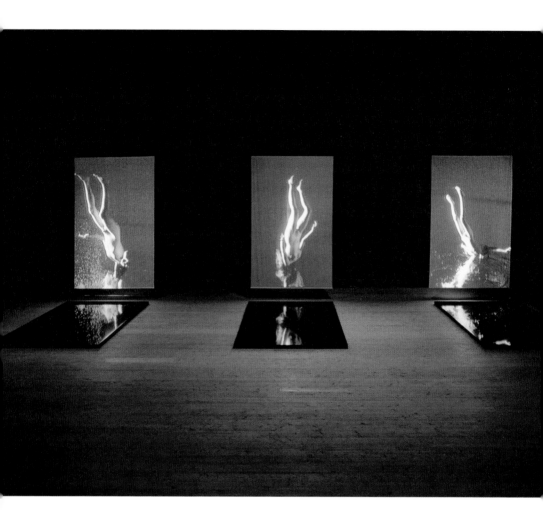

35 *Stations*, 1994

SOMETHING RICH AND STRANGE

Bill Viola's Uses of Asian Spirituality

ELIZABETH TEN GROTENHUIS

Biographical notes about Bill Viola invariably mention his sojourn in Japan, 1980–81, his practise there of Zen meditation and 'Zen ink painting', his wide-ranging interest not only in Japanese Zen Buddhism, but also in Tibetan Buddhism, in Hinduism and in Islamic mysticism. These Asian connections are no doubt heartfelt; Viola is an artist who translates his earnest spiritual quest into absorbing, intense and meditative reflections on the human condition. The associations with Asia have certainly bestowed a kind of cachet on the artist, whose sources of inspiration include the two Eastern thinkers, D. T. Suzuki from Japan and Ananda Coomaraswamy from Sri Lanka. Suzuki's and Coomaraswamy's insights into their own cultures were mediated by universalist Western philosophies, so it is not surprising that Viola attributes to these men his 'return' to Western culture. In this essay, I explore some of Viola's representations of traditional Asian thought, as he responded to concepts proposed by Suzuki and Coomaraswamy that resonated with his own Western cultural and religious predispositions and inclinations. Because these representations are creative works, they inevitably become, to some degree, misrepresentations. Ultimately, of course, the sources of Viola's work – real or imagined – are marginal compared to the work itself. And misappropriations may be less interesting than unconscious appropriations. After discussing Suzuki and Coomaraswamy, I turn to other, perhaps more subtle and less conscious appropriations of Asian modes of thinking and representing in Viola's work, in particular, Viola's presentation of images related to the number five.

Viola is well read and articulate: let him, therefore, speak for himself about the Asian influences in his work. The following reflects over twenty years of serious study of Asian philosophy and religion on Viola's part:

After moving away from my Christian upbringing, I got interested
in Eastern culture, and I went to Japan, and I was practicing
Zen meditation.... Then when I came back from Japan, I studied
more intensively people such as the great Japanese lay Zen scholar
Daisetz Suzuki, and another very important person for me, Ananda
Coomaraswamy, the Sri Lankan art historian and scholar who
redefined how Asian art was discussed and analyzed. Both Suzuki
and Coomaraswamy were raised in the East in direct contact with
ancient unbroken traditions, and spent their later years in the
West, specifically America. Then, when Suzuki, Coomaraswamy,
and a number of other Asian intellectuals got to the West, they
began to study Western history looking for the same connections,
which they knew to be there. They began writing about people
I was not familiar with, such as Meister Eckhart, St. John of the
Cross, Hildegard von Bingen, and Plotinus, as well as Plato and
Aristotle. They recognized these people not as individuals, but as
part of the other side of the Western tradition, a tradition that was
carried on in the East and developed well beyond the advent of
rational positivistic thinking (which took over in the West) and
right up into the twentieth century. Then I started reading about
very early Christianity, about the desert fathers in the Nile valley
and Syria, staying out in the wilderness like Zen monks on retreat,
studying with their spiritual masters. It was a revelation for me
to find these roots in my own religion's history.[1]

Elsewhere, Viola remarks:

Don't forget that one of the great milestones of our century has
been the transporting of ancient Eastern knowledge to the West by
extraordinary individuals such as the Japanese lay Zen scholar D. T.
Suzuki and the Sri Lankan art historian A.K. Coomaraswamy, an event
on a par with the reintroduction of ancient Greek thought to Europe
through translations of Islamic texts from the Moors in Spain.[2]

Viola's understanding of D. T. Suzuki (1870–1966) derives mainly from the articles and books in English that Suzuki wrote and that Viola no doubt began to read whilst studying at Syracuse University in the early 1970s. Suzuki's encounters with the West and with Western philosophy are more complex than Viola's comments might imply. Suzuki spent eleven years in the United States as a young man and his encounters with Western thought at that time shaped his response to the Zen Buddhism of his own culture.

Suzuki had become proficient in English whilst at high school and taught the language in elementary schools until he moved to Tokyo in 1891. There he became a special student at Waseda University and began studying Zen at the Kamakura City monastery Engakuji, under the guidance of the abbot Shaku Soen. Soen represented Zen Buddhism at the World's Parliament of Religions in Chicago in 1893, where he presented Buddhism as a universal religion in harmony not only with other faiths but also with philosophy and science. While in Chicago, Soen met the industrialist Paul Carus, who was deeply interested in Asian philosophy and religion. Soen arranged for Suzuki to go to Illinois in 1897, where, until 1908, Suzuki worked with Carus on translation projects. During this critical period Suzuki absorbed Carus's Religion of Science. A monist, Carus held that there was no basic difference between scientific and religious truth, and that religious faith was a belief in this unified truth. Although Carus believed in the essential unity of all religions, by the time Suzuki came to work with him Carus had concluded that Buddhism came closest in essence to his Religion of Science. Carus admired Buddhism for being, in his view, rational, empirical and scientific. By the end of Suzuki's apprenticeship with Carus, Suzuki was writing about the unity of religious truth and the accord between the basic teachings of Christ and the Buddha.[3]

163

In 1908 Suzuki travelled to Europe returning to Japan in 1909. He married an American, Beatrice Erskine Lane, in 1911 and taught English until 1921, when he accepted a chair in Buddhist Philosophy at Otani University in Kyoto. After his return from the West, Suzuki was greatly influenced by the work of his friend and colleague, Nishida Kitaro (1875–1945), Japan's most important twentieth-century philosopher. Nishida completed his training in Western philosophy as a special

student at Tokyo Imperial University. The publication in 1911 of his first book, *A Study of Good*, was critical to the introduction of Western philosophy into Japan. Greatly influenced by Bergson, William James and the German Neo-Kantians (especially, Wilhelm Windelband, Heinrich Rickert and Hermann Cohen), Nishida introduced a notion of 'pure experience'. Nishida emphasized 'pure', 'unmediated' or 'non-dual' experience, marginalizing ritual practice and doctrinal learning. *A Study of Good* begins with the following:

> To experience means to know things just as they are. It means to know them by casting aside one's own artifices completely and be guided by things themselves. Since people usually include some thought when they speak of experience, 'pure' is used here truly to signify the condition of experience just as it is without the addition of the slightest thought or reflection. For example, it refers to the moment of seeing a color or hearing a sound that takes place not only before one has added the judgment that this seeing or hearing is related to something external or that one is feeling some sensation, but even before one has judged what color and sound themselves are. Thus, pure experience is synonymous with direct experience. When one has experienced one's conscious state directly, there is not as yet any subject or object; knowing and its object are completely at one. This is the purest form of experience.[4]

Building on the work of Nishida, Suzuki was soon presenting 'pure' or 'direct' experience as the most important characteristic of Asian religion in general and Zen Buddhism in particular.

Suzuki remained at Otani University until his retirement in 1950. The same year, under the auspices of the Rockefeller Foundation, he moved to New York, where he lectured on Buddhism and Zen at a number of colleges and universities, most frequently at Columbia. He continued to travel, lecture and write until his death in Tokyo in 1966.

Although Suzuki had a sound understanding of the complex history of Zen Buddhism in China (where it is called 'Chan') and in Japan, the aspects of Zen that

Suzuki emphasized in his lectures in the West concerned its essentially trans-historical, transcendent nature. He presented Zen as pure, unmediated experience, highlighting (often through stories about Zen eccentrics) its anti-intellectual, anti-ritual and iconoclastic features. He spoke about the four basic statements of Zen:

A special transmission outside the Scriptures;

No dependence upon words and letters;

Direct pointing to the soul of man;

Seeing into one's own nature and the attainment of Buddhahood.

This sums up all that is claimed by Zen as religion.[5]

Concerning the inevitability of human suffering (the first premise of Buddhism), Suzuki writes:

How does Zen solve the problem of problems?

In the first place, Zen proposes its solution by directly

appealing to facts of personal experience and not to book-

knowledge. The nature of one's own being where apparently

rages the struggle between the finite and the infinite is

to be grasped by a higher faculty than the intellect.[6]

During the 1950s and 1960s, Suzuki almost single-handedly created the intense interest in Zen in the United States that is still felt today. However, as Robert Sharf points out:

Those aspects of Zen most attractive to the Occident –

the emphasis on spiritual experience and the devaluation of

institutional forms – were derived in large part from Occidental

sources. Like Narcissus, Western enthusiasts failed to recognize

their own reflection in the mirror being held out to them.[7]

Suzuki and his younger colleague, Shin'ichi Hisamatsu, also interpreted Japanese art and culture largely in the context of Zen. They popularized the concept that Zen was the basis for almost all of Japanese art – for example, ink painting. There were no drama robes and masks; no tea ceremony architecture and utensils; no gardens, particularly tea and dry landscape gardens. A whole generation of artists, notably members of the Abstract Expressionist school and members of the

Pacific Northwest school of painting, reflected a connection to Zen modes of thinking and representing, as interpreted in the writings of Suzuki and Hisamatsu.[8]

In 1980, Viola wrote in his journal about 'pure seeing'; a kind of seeing that seems directly indebted to the 'pure' experience taught by Nishida, Suzuki and others:

> This sense of seeing – or seeing the sense of an object – is what
> I have been after. I have sensed…that intense unrelenting camera
> vision can be compared to concentrated vision, which heralds a
> shift in consciousness… The object doesn't change, you do. This
> is what is behind the Buddhism brought from India to China to
> Japan – this is exactly what the suiboku-ga (ink) painters were
> doing. They painted rocks, grasses, a heron – yet these things
> shone with a light that penetrated far deeper than their pictorial
> form or even their concepts conveyed by the viewer's words.
> This is pure seeing.[9]

In Japan, between 1980 and 1981, Viola practised meditation and ink painting with a Zen master, Daien Tanaka. In Japan at that time, as in America, many Chinese and Japanese ink paintings were routinely called 'Zen paintings'. It is certainly legitimate to speak of such works as 'Zen paintings' if, for example, they show patriarchs or eccentrics specifically associated with the tradition. Yet it should be made clear that ink paintings of non-Zen subjects – for instance, flowers or mountains or birds – are often more appropriately linked to the non-Buddhist ink painting traditions of China that are associated with scholars or literati and with the Daoist tradition.

Take, for example, the ink painting *Orchids, Bamboo, and Brambles*, by Gyokuen Bonpo (*c.* 1348–after 1420), published in 1970 in a catalogue from the Museum of Fine Arts, Boston, entitled 'Zen Painting and Calligraphy'.[10] Its publication in this catalogue reflected the current practice of designating most ink paintings as 'Zen', largely thanks to the writings of Suzuki and Hisamatsu. This painting of graceful orchids growing from behind an angular rock, from which bamboo emerges to the right and brambles to the left, is done in ink alone, the subtle gradations of tone the result of ink and water mixed in different intensities. Although the work was painted by a Japanese Zen Buddhist priest, it could just as easily have been made by a Chinese

Confucian literatus or a Daoist philosopher. Orchids are symbolic of highly educated men who may have been powerful Confucian officials but who were always morally upright. In times of trouble, for example, if political tides turned against them, these literati might retire and live in lofty seclusion, immersing themselves in Daoist nature imagery. The poem in the foreground of the painting is somewhat abraded but phrases such as 'crane curtain', 'the recluse of North Mountain' and 'dew on the orchids' indicate that Bonpo was aware of a literary work from the late fifth century CE, Kong Zhigui's *Beishan yiwen*, which dealt with the circumstances and virtues of reclusion.[11] Nothing in the subject matter or in the calligraphy of this painting is specifically Zen Buddhist, or even Buddhist. In fact, the legendary introduction of Zen into China is dated to the sixth century CE, well after Zhigui's work had appeared. At certain periods, the orchid embodied content even more specific than the association with the literatus or recluse. After the fall of the native Song dynasty in 1279 – a hundred years before this painting was created – the nobility of character associated with the orchid became tinged with political overtones. The orchid was now associated with loyalty to the old regime and with righteous refusal to cooperate with the new, non-Chinese Mongol dynasty.[12]

With this fine ink painting in mind, let us examine some of Suzuki's comments on sumi-e or 'ink painting'. (Viola's suiboku-ga, which can be literally translated as 'water and ink painting', is another term for 'ink painting'.) Suzuki talks about the simultaneous control and spontaneity necessary for ink painting. Unlike painters who work with oil paint, artists who use ink cannot rework the painting; ink strokes and washes cannot be covered or removed. Suzuki goes on to associate the 'purpose-lessness' he observes in ink painting with the purposelessness of Zen. Comments like these betray the essentially non-historical approach Suzuki practises in his treatment of Zen and of the many art forms he associates with it. These comments also suggest the 'pure experience' or 'pure being' derived from Nishida and, ultimately, Western philosophers:

> There is always an element of unexpectedness or abruptness in
>
> sumi-e. Where one expects to see a line or a mass this is lacking,
>
> and this vacancy instead of disappointing suggests something

beyond and is altogether satisfactory.... It is strange that the absence of a single point where it is conventionally expected should achieve this mystery, but the sumi-e artist is a past master in this trick. He does it so skillfully that no artificiality or explicit purpose is at all discernible in his work. This life of purposelessness comes directly from Zen.[13]

On another occasion, Suzuki remarks:

We can see now that the principle of sumi-e painting is derived from this Zen experience, and that directness, simplicity, movement, spirituality, completeness, and other qualities we observe in the sumi-e class of Oriental paintings have an organic relationship to Zen.[14]

Viola has also said that the writings of Ananda Coomaraswamy (1877–1947) helped to shape his thought and influenced his work. Coomaraswamy, however, was not a pure exponent of Asian thought. He was, in fact, immersed in Western culture from his childhood. Born in Ceylon (present-day Sri Lanka) to a Tamil father and an English mother, Coomaraswamy was educated in England. After taking a doctorate in Geology at London University, he returned to work in Sri Lanka in 1902. Six years later, and strongly influenced by William Morris (1834–96) – the English author, craftsman and socialist – Coomaraswamy published his first important non-geological work, *Mediaeval Sinhalese Art*. Abandoning geology, Coomaraswamy moved to India where he began the studies of Indian art that would introduce this field to the world. He also published books on Hinduism and Buddhism, lecturing often in England where he maintained a home.

In 1917, Coomaraswamy moved to the United States to accept the post of Curator of Indian and Islamic art at the Museum of Fine Arts, Boston. During the years that he worked in Boston, Coomaraswamy published a number of scholarly books and articles on Asian art. From 1931 on, when he left the employ of the Museum, Coomaraswamy wrote prolifically. These later works, focusing largely on India and the medieval period in Europe, investigated the nature of traditional religious art and culture. With elegance and conviction, Coomaraswamy probed

myths and aesthetics, metaphysics and theology, forms and symbols from Asia and the West, often from a comparative viewpoint, producing books that were both factual and visionary, and that appealed to both scholars and laypeople. Absorbed in traditional cultures in which knowledge and art were primarily religious, Coomaraswamy became far more a philosopher and religious thinker than an analytic art historian. I suspect that Viola read some of those later works, perhaps *The Transformation of Nature in Art*, 1934, *Hinduism and Buddhism*, 1943, or *Time and Eternity*, 1947.

Coomaraswamy, along with René Guénon, Frithjof Schuon and a number of lesser luminaries, belonged to a twentieth-century school of thought called Traditionalism which honoured the perennial philosophy underlying the various world religions and traditions. Briefly, this philosophy teaches that through contemplation we can perceive, in a pure state, the insight that is variously expressed in many religions, in many languages, in many metaphors. All phenomena are manifestations of a divine principle that is grasped intuitively rather than by reason. Traditionalists are also devoted to the preservation and explication of the traditional forms that lie at the heart of each religious tradition, constituting that religion's integrity and spiritual efficacy.[15]

As a Traditionalist, Coomaraswamy did not believe in 'art for art's sake'. He could honour simple utilitarian ceramics as much as noble religious paintings or places of worship because all these works embodied not only the natures of the individuals who created and used them, but also the natures of the civilizations they represented. An underlying premise of his vision was that precious objects from the past were threatened, were under assault from the relentless progress of modernism. Modern art, which from the Traditionalist point of view includes Renaissance and all post-Renaissance art, is subjective and personal, and remote from enduring, transcendent values. This art derives from a profane, secular philosophy that denies the spiritual nature of human beings and their relationship with the Absolute.[16] Coomaraswamy did not mince his words when he wrote about contemporary artists:

> Our artists are "emancipated" from any obligation to eternal verities,
> and have abandoned to tradesmen the satisfaction of present needs.

> Our abstract art is not an iconography of transcendental forms but
>
> the realistic picture of a disintegrated mentality.[17]

In these terms, Viola is not a modern artist. Acknowledging a debt to Coomaraswamy, Viola seems to seek 'eternal verities' and 'transcendental forms'. I imagine that Coomaraswamy would have been surprised and pleased to be acknowledged as an inspiration for this modern and yet not-so-modern artist.

Viola has mentioned that Suzuki and Coomaraswamy introduced him to the thought of Meister Eckhart. As early as 1955, in an essay published in the Buddhist journal *The Middle Way*, Suzuki quoted Coomaraswamy on the subject of Meister Eckhart:

> Ananda K. Coomaraswamy is one of the great exponents of Indian
> thought and art. In one of his works, *The Transformation of Nature
> in Art*, we have this: "Eckhart presents an astonishingly close parallel
> to Indian modes of thought; some whole passages and many single
> sentences read like a direct translation from Sanskrit... It is not of
> course suggested that any Indian elements whatever are actually
> present in Eckhart's writing, though there are some Oriental factors
> in the European tradition, derived from neo-Platonic and Arabic
> sources. But what is proved by analogies is not the influence of
> one system of thought upon another, but the coherence of the
> metaphysical tradition in the world and at all times."[18]

Suzuki and Coomaraswamy may have revealed to Viola the worlds of Meister Eckhart and other Christian mystics, but what is ironic and thought-provoking is that they were, contrary to popular opinion, never hermetically immersed in the Asian cultures they represented.

Hans Belting, in an interview with Viola, comments on his use of Asian sources when he could just as easily find similar ideas in the Western tradition:

> Viola (quoting the Sufi poet Rumi): 'He who sees
>
> only his own reflection in the water is not a lover.'
>
> Hans Belting: 'Most Latin poetry is exactly of this type.'

Belting then quotes what Ovid says of Narcissus in *Metamorphoses*, namely: 'He

loves hope without a body. What he takes for a body, in fact is water. What he sees, he does not know, "since it was the shadow of an image".'[19] Belting goes on to remark in the interview: 'You know, Bill, it is one of your tricks to choose a historical mask, but then, when you look closer, the model from history does not help very much in understanding what is really going on.'[20]

And this may be the crux of the matter involving sources and creativity. Viola may appropriate or misappropriate sources, Asian or Western, but, in the end, the sources are obscured or transformed, often beyond recognition, in making an artwork that his uniquely his own. What emerges as paramount is the new, creative work itself. As Arthur Danto remarks, recalling Suzuki's 'transmission' of Zen to the West: 'Perhaps the most one culture can do for another is to give it something it can creatively misunderstand and make its own.'[21]

Thus far, we have examined some aspects of Viola's work in relation to his explicit comments on Asian sources. I would like now to touch on a facet of his work that he seems not to have discussed, namely, work structured or conceived according to the number five. Viola mentions diptychs and triptychs as organizing principles, but he does not talk about 'quintychs', if one can coin such a word.

For the American Pavilion at the 1995 Venice Biennale, Viola created five installations. Marilyn Zeitlin, the Pavilion's curator, described the works as five independent installations although they were given a collective title, 'Buried Secrets'. In her press release for the Biennale, Zeitlin wrote: 'Together they describe a journey or movement, both physical and conceptual, through interrelated themes of darkness/light, internal/external, past/present, and matter/immaterial.'[22] The first four installations showed videos and explored sounds that seemed related to Viola's earlier work. The fifth installation, *The Greeting*, was arrestingly new. It was a slow-motion presentation of three women meeting and talking, based on Pontormo's sixteenth-century altarpiece *The Visitation*.

How closely related to each other the five parts of 'Buried Secrets' are may be open to question, but there can be no doubt about *Stations*, 1994 (**35**), Viola's first major, integrated five-part work. This powerful installation presents five cloth screens, about three metres high, that can be viewed from either side, showing upside-down

male and female bodies immersed in liquid up to their necks. The screens hang above polished granite slabs that reflect the bodies. Accompanied by aquatic noises, the bodies float and disappear and then suddenly erupt back into view. The cyclical nature of each projection may suggest birth, life, death and rebirth.[23]

Works organized around the number five are also associated with the series 'The Passions', which Viola began in 2000. Much of this new work is indebted to his studies in the 1990s of Western art, particularly medieval and Renaissance devotional painting. A sub-group of 'The Passions' from 2000, the 'Quintet or Portraits' series – *The Quintet of the Astonished, The Quintet of Remembrance, The Quintet of the Silent* and *The Quintet of the Unseen* – explores the universal human emotions of sorrow, pain, anger, fear and joy. Inspired by the four men surrounding the fifth figure of Christ in Hieronymus Bosch's painting *Christ Mocked*, Viola presents five groups of figures in each of the 'Quintet' videos.[24]

Catherine's Room, 2001 (**36**), is a five-part video presentation of a day, a year, and, by extension, the lifetime of a woman called Catherine. In the first video, we see her engaged in morning activities such as performing yoga, eating an apple and reading. The tree outside the window is in spring flower. In the second video, with afternoon light streaming through the window, she sews and mends clothes. The leaves of the tree outside the window indicate summer. The third video, chronicling late afternoon and sunset, shows Catherine at a desk, seemingly struggling to overcome writer's block. The tree outside has autumn foliage. The fourth video shows her lighting candles in a devotional setting during the evening. The tree's branches are now bare. The final video sequence shows Catherine going to bed at night; the window reveals no tree, only a black void suggesting a place beyond time. Catherine asleep reminds us of her inevitable death.

The quintuple form of *Catherine's Room* is inspired by a modest five-part predella on an altarpiece depicting five scenes from the life of St. Catherine of Siena. This sequence of small narrative panels by the fifteenth-century CE Sienese painter Andrea di Bartolo had attracted Viola's attention when he was a Fellow at the Getty Research Institute. Predellas, which usually appear at the bottoms of large altarpieces, presenting narratives to complement the devotional images above, are

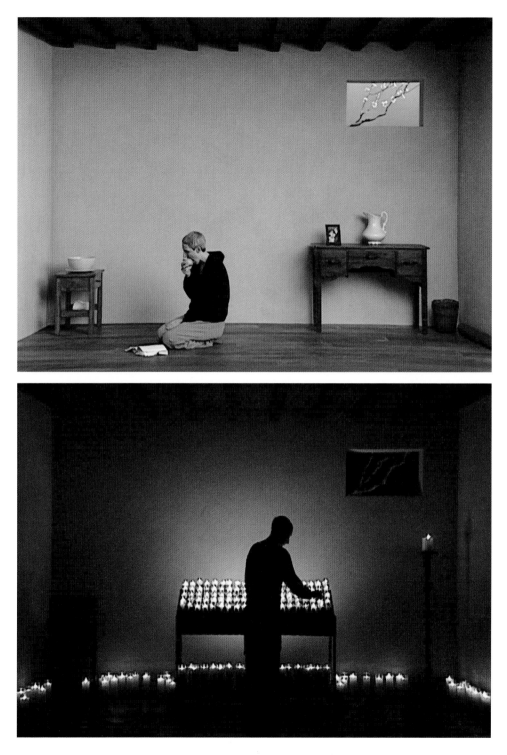

36 *Catherine's Room*, 2001

found in a number of different divisions. Fivefold is certainly one form, but it is not the only, or even the dominant, form.[25]

Going Forth By Day, 2002, is another recent work with a five-part structure. Five thirty-five-minute video sequences are simultaneously projected directly onto the walls of a large room. Examining cycles of birth, death and rebirth; relations between the individual and society; and the interplay between the temporal and the spiritual, Viola cites as his primary source of inspiration Luca Signorelli's fresco cycle showing the end of the world, painted between 1499 and 1504 on the walls of the Orvieto Cathedral. Viola's work is set in the present day: 'Fire Birth' shows a naked human figure, swimming in what seems to be a montage of fire and water, suspended in an unconscious state between death and rebirth. 'The Path' shows a vast panorama of forest through which people of all kinds and ages walk at their own speed, as if in an intermediate space between two worlds. 'The Deluge' (37) shows people walking back and forth in front of a newly restored stone building. Panic ensues when a flood bursts out of the building's doors and windows. 'The Voyage' depicts the death of an old man in a small house on a hill overlooking a body of water. After his death, he reappears on the shore and is greeted by his wife, and the two board a boat with their possessions. 'First Light' shows rescue workers who have been labouring all night to save people caught in a massive flash flood in the desert. A woman, waiting for her son, fears he will never return and, in fact, she is unable to see him when he ascends like a ghost from the water.[26]

Viola cites specific sources from Renaissance painting for all these works, but he sets his video sequences in the present day, and the sources would not be apparent to most of us if he did not point them out. What interests me is that from the whole field of medieval and Renaissance painting, Viola should have been inspired to create images that evoke the number five or that are shown in five-part sequences. Five is not as significant in Western art and in Christianity as certain other numbers, such as three ('Three Fates', 'Three Graces', 'Three Marys at the Sepulchre', the 'Trinity') and seven ('Seven Gifts of the Holy Spirit', 'Seven Liberal Arts', 'Seven Sacraments', 'Seven Sorrows of the Virgin'). James Hall's Dictionary of Subjects and Symbols in Art lists only one entry under 'five', namely, the 'Five Senses'.

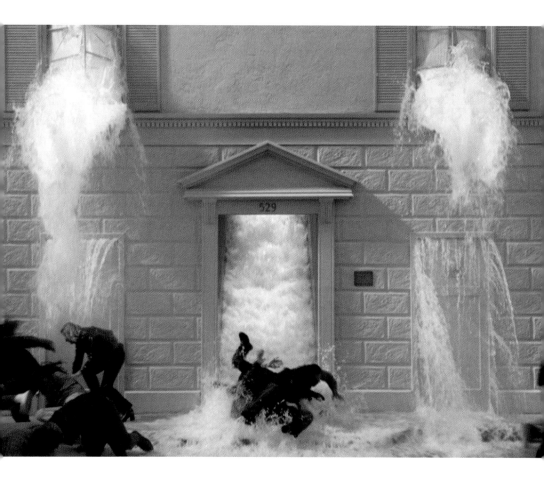

37 'The Deluge' from *Going Forth By Day*, 2002

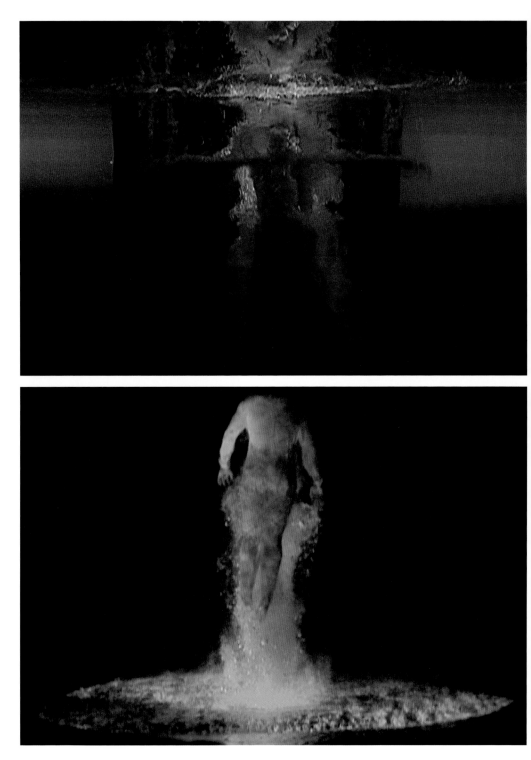

38 'Fire Angel' (top); 'Birth Angel' (bottom) from *Five Angels for the Millennium*, 2001

The situation is quite different, however, when we turn to Asia. Viola himself alerts us to the importance of the number five in a page in one of his notebooks, where he lists the *Five Skandhas*, the five constituent elements of all existence, according to Buddhist thought – form, feeling, perception, concept, consciousness.[27] A quick glance at a *Dictionary of Japanese Buddhist Terms* reveals multiple entries related to the number five that reflect the pan-Asian Buddhist religion: the five Mahayana sutras or holy texts; the fivefold merit of enlightenment; the five Buddhas of Esoteric Buddhism; the five pitchers used in Esoteric rituals; the five wisdoms of Esoteric Buddhism; the five elements; the five great kings of wisdom; the five great revered ones; the five-platform ritual; the five paths; the five disorders; the five kinds of meritorious acts; the five-letter sacred chant; the five objects of sensation and perception; the five-piece monk's robe; the five defilements or pollutions; the five meditations for stopping unwholesome thoughts; the five precepts for laypeople; the five wrong views; the five-pronged vajra (ritual implement); the five sense-organs; the five teachings; the five tastes; the five mindful practices; the five powers obtained by the practice of the five roots of goodness; the five wheels or discs; the five-section pagoda; the five colours (blue, yellow, red, white and black); the five right practices for attaining birth in the Pure Land; the five mutually distinctive natures of sentient beings; the five aggregates (skandhas); the five kinds of practices; the five kinds of rituals of Esoteric Buddhism; the five kinds of priests in the Lotus Sutra; the fivefold meditation for realizing Buddhahood; the five-aspect practice of spiritual union; the five marks of decrepitude; the five body members (head, arms, legs); the five desires; the five divisions of Buddhist scriptures.[28] Descending from the sublime to the ordinary, we should remember that Viola lived in Japan where – perhaps because the word for the number four [shi] is a homonym with the word for death – material and visual culture is oriented towards the number five. Cups and saucers and dishes, for example, are sold in sets of five.

I end with a discussion of another recent work by Viola, *Five Angels for the Millennium*, 2001 (**38**). Once again, we see a five-part division of form, although Viola does not point to a direct source for this work in the art of earlier centuries. The five video sequences present watery worlds, a recurrent theme in Viola's work.

Attracted to the transformative and reflective properties of water, Viola explores the ways in which water gives life, sustains and blesses life, and takes life away. The video sequences in this work are slow and meditative, and take time to absorb. The original takes ran for only thirty-five to forty seconds, including the preliminary still-ness, the plunge of the figure and the sinking. But each sequence was slowed down (so that it might take some ten to fifteen minutes), then extended or accelerated, and programmed so that explosions would occur at the intervals Viola desired. Since the five videos are not synchronized, an element of randomness is present in the work.[29]

This powerful, meditative work comprises five large video sequences (each 2.4 by 3.2 metres) projected onto black walls in a large gallery space. I saw the installa-tion in London at Tate Modern, where a label at the entrance announced that the five projections dealt with birth, death and the unfolding of consciousness. I entered the gallery and turned to my left to confront the 'Ascending Angel': still water, then a demarcation as if water and sky were meeting at the horizon (like a Sugimoto seascape), and then a growing mass of bubbles until the sea seemed to bubble over, blue-purple and Turneresque, and then a further bubbling and eruption, accompa-nied by the sound of crashing waves. With a crescendo, the figure of the 'Ascending Angel' appears, floating face down (as if drowned?). At a right angle to the 'Ascending Angel' on the adjoining wall appears the 'Creation Angel', in which the erupting figure, seen from the back with outstretched arms, suggests Christ and the Crucifixion. Turning again to the right revealed the third wall with two scenes of 'angels. First, the dramatic 'Fire Angel': a projection suffused with the deep blood-red of the water, a striking contrast to the blues, greens, purples and greys of the other projections. The 'Fire Angel' sequence reminded me of an Asian fire festival (here performed in an impossible aquatic environment), where defilements are obliterated in the purifying flames of fire. The angel rises in a column of fire punctu-ated by a golden orb. Moving down the wall, we encounter the 'Birth Angel', in which the figure seems to shoot through its frame as the ambient sound reaches a climax. The 'Birth Angel' is juxtaposed at a right angle to the fourth wall of the installation, the 'Departing Angel'. In the 'Departing Angel' sequence, light glimmers through the water, and the figure floats into view as the sound rises and air bubbles make

their way to the surface. Because of random interactions between the two video pro-jections, I saw arresting correspondences between the 'Birth Angel' and the 'Departing Angel'. The 'Departing Angel' rose to the surface of the water and then the same figure seemed to shoot through the surface of the glistening water in the adjoining 'Birth Angel' vision. The next time the images appeared, the 'Birth Angel' arose first, before the 'Departing Angel', and the two angels seemed unrelated.

Viola has described *Five Angels for the Millennium* in a manner that recalls the philosophy of Nishida and Suzuki. Viola's 'deep seeing' seems to relate to the 'pure seeing' and the 'pure experience' discussed earlier:

> There are no cuts in the sequences, no montage in the traditional
> sense. There is only a gradual permutation in the continuous,
> inexorable progression toward or away from the moment of the
> plunge into the water... This 'deep seeing' is a vital part of human
> experience that draws on our powers of inner concentration
> and identification, both characteristic of the visionary experience.[30]

Viola creates work that may refer to other art or to intellectual ideas, but he trans-forms his sources so that they are hidden from view in the presence of his new vision. Drawing on the image of water that he himself often uses, we could say that Viola's work represents a sea-change. In Shakespeare's *The Tempest*, Ariel is tormenting Ferdinand, who thinks that he alone has survived a shipwreck, while his father and all the others have drowned. (In fact, all are safe and reunited in the fifth act.)

> *Full fathom five thy father lies,/ Of his bones are coral made;*
> *Those are pearls that were his eyes;/ Nothing of him that doth fade*
> *But doth suffer a sea-change/ Into something rich and strange.*[31]

The gist of this song is that all the poor mortal stuff of the father, the stuff that can 'fade' (bones and eyes), has undergone a wonderful transformation or 'sea-change' into some precious, enduring material (coral, pearls). Viola's reading of Suzuki and Coomaraswamy, among other thinkers, has helped the artist to subject a mixture of Asian and Western philosophy to a 'sea-change', turning it into visual imagery that offers the viewer something rich and strange.

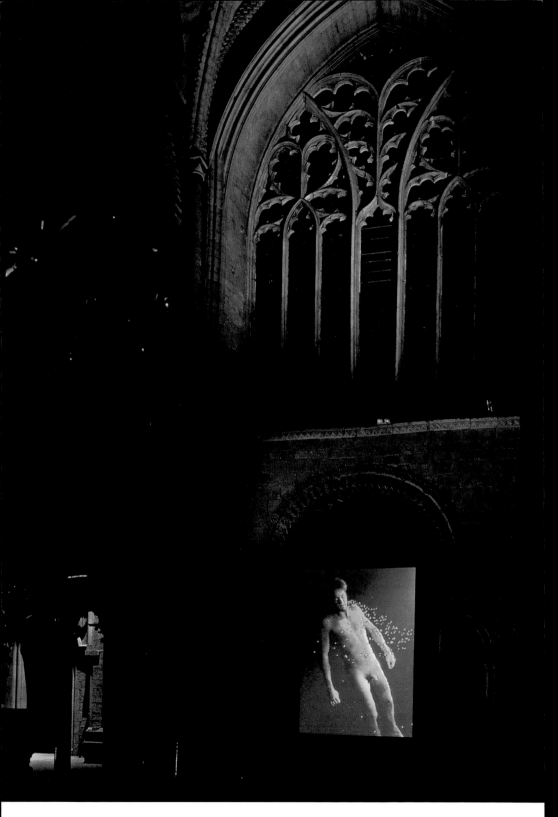

39 *The Messenger*, 1996

CHAPTER 9

SCREENING ANGELS

The Messenger, Durham Cathedral, 1996

DAVID JASPER

To the European mind the reverberant characteristics of the interior of
the Gothic cathedral are inextricably linked with a deep sense of the
sacred and tend to evoke strong associations with both the internal
private space of contemplation and the larger realm of the ineffable...
Cathedrals, such as Chartres in France, embody concepts derived
from the rediscovery of the works of the ancient Greeks, particularly
those of Plato and Pythagoras, and their theories of the correspon-
dence between the macrocosm and the microcosm, expressed in the
language of sacred number, proportion and harmony, and that mani-
fest themselves in the science of sound and music. These design
concepts were not considered to be the work of man, or merely func-
tions of architectural practice, but represented the divine underlying
principles of the universe itself.[1]

Christianity and the biblical tradition have always been ambivalent about the notion
of sacred space. King David is forbidden by the Lord from building a temple in
Jerusalem (II Samuel 7), and even when Solomon completed his elaborate structure,
his first words to God indicate the limitations of his achievement: 'Behold, heaven
and the highest heaven cannot contain thee; how much less this house which I have
built!' (I Kings 8: 27). In the New Testament, the idea of the Temple is located in the
body of Christ, and from earliest Christian times there is an understanding of the
people of God themselves as the place of God.[2] In time, as Christianity developed a
more public face, with more elaborate forms of worship, the buildings in which the
people met took on increasingly complex symbolic values. On the one hand, they

were frequently the last resting place of a saint or martyr. On the other, they were where the sacraments were celebrated, and above all the sacrament of the Eucharist, that is the real presence of Christ in the gathering of the community. By the time of the great medieval cathedrals, such buildings had acquired immense theological and symbolic importance. They touched virtually every aspect of the life of the community, not simply as places of prayer and liturgical activity, but also as places for activities as diverse as games and theatre, and were even used for storage and defence.[3] (Durham Cathedral itself was famously described by Sir Walter Scott as 'half castle 'gainst the Scot'.) In short, if such buildings evoke the larger realm of the ineffable, they have always functioned within the whole physical and social demands of the Christian community, and have therefore always been places of ambivalence, as is probably inevitable in spaces where the invisible is made somehow visible.[4]

This ambivalence can become acute when art, which does not necessarily subscribe to the demands of a particular faith or tradition and yet is deeply responsive to the presence of the sacred, interacts with the fabric and life of these buildings. Such was the case in 1996, when Bill Viola revealed his installation *The Messenger* (**39**) in Durham Cathedral at the instigation of Canon Bill Hall of the Chaplaincy to the Arts and Recreation in North East England, as part of the celebrations for the UK Year of the Visual Arts. I was invited by Canon Hall to attend the opening and contribute a theological reflection on the work in the context of the Cathedral. In fact, this task proved to be even more challenging and complex than I could have imagined as the work immediately became the trigger for a controversy that hit the national press, raising questions that were, in many ways, incidental to the piece itself.

The Messenger is a work of video art that is easy to describe and almost impossible to comprehend. Beginning with a primal darkness, initial lights appear twinkling like stars. As in the first creation, they begin to coalesce into a form and eventually take the shape of a man coming up from the depths of water until finally he breaks the surface with a mighty gasp, drawing in his first draft of air as his eyes open, only to fall back into the depths to be lost until the cycle begins again. All around the vast space the air is filled with strange noises.

The setting for this huge installation was the great west wall of the Cathedral, and to view it down the length of the nave was to look through the fretwork of the font, the place of Christian baptism. The man is primal and naked – to be otherwise would have been absurd – and that was the cause of the trouble. In a place where the public could freely wander, the Cathedral authorities were informed, this could be the cause of moral outrage, an obscenity. So it was decided to place canvas screens around the image to allow those who did not wish to see it, or wished not to allow their children to see it, to pass by unharmed. As a result, however, the full glory of the work, as it engaged with the building and became part of it, was lost. Somehow the interests of morality, and perhaps a loss of nerve, had closed a door on glory and veiled the presence of an angel. (The Greek *aggeloz* means 'messenger'.)

For me, now, there were two distinct issues. First, there was the theological challenge of *The Messenger* – a work of art inspired by both the Cathedral, as a massive achievement of medieval technology, and by the technology of the late twentieth century – taking its position within the sacred space of the building, while never yielding its own authentic voice. Second, there was the public debate, which was in some ways a distraction from the true challenge of the piece, but nonetheless raised important questions about the nature of art, the sacred and their place in our society. I must admit immediately that the second issue was of limited interest to me, except insofar as it had the effect of drawing people's attention to the piece. The overwhelming response of the public proved to be far more mature than that of those who assumed to themselves the protection of society's morals. Indeed, as Viola himself pointed out in a television interview, this reaction simply created the impression that here was an obscenity, and encouraged those who were so inclined to peep through the gaps in the canvas screens to glimpse – not the installation itself, but the momentary sight of a man's penis. The true obscenity, as Viola went on to say, would have been to have clothed this primal, mysterious figure, this messenger come to speak to us in the extraordinary place of Durham Cathedral, in, what – a pair of Y-fronts?

Of what does this man speak? When I first saw the work – the video runs for about twenty-five minutes, but as it is continuous I sat before it for some hours, allowing it to enter into my consciousness slowly and in its own time – I was fasci-

nated by the conversations that I heard around me in the Cathedral. Many people seemed to want to see *The Messenger* in purely Christian terms. Viewed through the font, it was interpreted as an image of the mystery of Initiation, of the baptismal immersion with Christ and the rising with him into new life. As St. Paul expressed it in Romans 6: 3-4, such immersion indicates not simply washing but the burial of the old person 'so that as Christ was raised from the dead by the glory of the Father, we too might walk in newness of life'.[5] But the complex, universal symbolism of water was appropriated by Christianity as it drew upon a rich heritage of biblical stories – from the myths of creation to Noah's flood, the Exodus through the Red Sea, the crossing of the Jordan into the promised land of Canaan, and the baptism of Jesus by John.[6] Mircea Eliade, however, draws upon a wide range of cultures and periods to indicate that 'water symbolizes the whole of potentiality: it is the fons et origo, the source of all possible existence... Water symbolizes the primal substance from which all forms come and to which they will return.'[7]

Viola's work is deeply religious, affected in particular by the mysticism and the *via negativa* of Western and Eastern traditions – in his writings Viola indicates the influence on him of Jalaluddin Rumi, Chuang Tzu, St John of the Cross and Meister Eckhart – but it is certainly not specifically Christian. *The Messenger* resonates within the spaces of Durham Cathedral both easily and as a challenge to its specific theological tradition. That, perhaps, is its true scandal, born of the four basic elements.

Deprive the lungs of air for agonizing minutes, and as the surface of the water is broken, the gasp deafens us in its struggle for life. It is a primal moment beyond language as air rushes into the lungs like a mighty wind, renewing life. In the beginning, 'the earth was without form and void, and darkness was upon the face of the deep; and the Spirit [or wind] of God was moving over the face of the waters'. (Genesis 1: 2). From such watery chaos, before any act of creation, we emerge, and to it we return.

The water is like the desert in which we die, and yet, there, life has always been sought in eternal struggle. Deserts, too, have been a continual preoccupation in Viola's work, and he wrote in 1994:

The Desert has occupied a central place in my work for the past 20 years. A recurring theme and motif, the desert is an essential crossover point and meeting place of the inner and outer worlds of human being, and I have approached its terrain not only as the raw material of landscape but of the human psyche as well.[8]

In the deep waters, in the desert, there is a crossing point in human experience, and so *The Messenger* rightly faces the great Cross that is set on the altar of the Cathedral at the east end, separated by the huge spaces of nave and choir.

Christians have sought baptism with water, but baptism also with fire as another dramatic symbol of death and purgation, of destruction and life. In *The Crossing*, an installation shown in Durham Cathedral at the same time as *The Messenger*, a man approaches the viewer and stands while he is slowly consumed by fire, beginning at his feet, until nothing remains. Simultaneously, on a second screen, a man approaches, stands, and is consumed by water which begins as a trickle running over his head and eventually swallows him in its deluge. The cycle is repeated. Fire and water, and in their midst, the figure of the man, and one is reminded of the great Pentecostal hymn of John Wesley which draws on Leviticus 6: 13:

> *There let it for thy glory burn*
> *With inextinguishable blaze*
> *And trembling to it source return*
> *In humble prayer and fervent praise.*

But the art is both more and less than Wesley's Christian piety. It lives in the four elements of air, water, earth and fire: the primal images from which emerge, usually uncomfortably, opportunities for theology, or even many theologies, and which are always deconstructed by the experience that makes them conceivable again. Viola's art, between abstraction and representation, not only provokes questions which open up possibilities, but which restructure the categories and paradigms that govern our thinking and imagination. Here we stand in the crossover point between time and eternity, between space and infinity, and here 'things' look and feel very different. And, given time, in the time given, space explodes the frontiers that we impose on it, and we find another edge between the finite and the infinite. We are

40 *Nantes Triptych*, 1992

granted something of the insight of the fourteenth century anchoress and mystic Dame Julian of Norwich, to whom God showed:

> A little thing, the size of a hazelnut, on the palm of my hand,
> round like a ball. I looked at it thoughtfully and wondered,
> "What is this?" And the answer came, "It is all that is made."
> I marvelled that it continued to exist and did not suddenly
> disintegrate; it was so small.[9]

Viola's art is embedded in the technology and aesthetics of its time, with its elements of panic and disintegration, as well as graceful moments of aging, dying and rising. Having grown up in the America of the sixties, Viola uses his sophisticated knowledge of the developing technology of video to deconstruct the efficiencies of the technocrats and their rationalizations. In many respects his

starting point is the same as that of Theodore Roszak, with his fear of the repression of religious sensibilities and his sense of 'religion in its perennial sense' and 'vision born of transcendent knowledge'.[10] Like so much of the radical art of the late twentieth century that has moved away from the specifics of the Christian faith of the West, Viola's installations yet continue to draw profoundly for their conception and inspiration on the great European tradition of religious art. In *The Greeting*, 1995, 'animating the frozen moment characteristic of a painting'[11], he looks back directly to a work by the Florentine artist Pontormo. Elsewhere, Viola repeatedly works with traditional Christian forms and themes, for example the altarpiece and Passiontide devotion to the 'Stations of the Cross', in *Nantes Triptych*, 1992 (**40**), and *Stations*, 1994.

A theological reading of these paintings might go further, without implying that Viola is deliberately using theology. Rather, his central concerns provoke the possibility of theological reflection and inhabit the extremes of human experience that

theology seeks to articulate. The narratives of our mortality, from birth to death, are visited in elemental spaces that engage with the sacred spaces of religious tradition, disturbing their limits and revealing their infinities. The imagery of water is everywhere, often, propelling us back to the words and narratives of Scripture. As the figure beaks the surface with a great gasp in *The Messenger*, one is reminded of John 3: 5 and the words of Jesus to Nicodemus that 'no-one can enter the Kingdom of God without being born from water and spirit'.

Like all great art, Viola's work focuses on the profound mystery of creation itself, a *poihoiz* (literally a 'making') suspicious of the coercive power that lurks within traditions of mimesis and representation. In company with thinkers like Michel Foucault and Jacques Derrida, Viola observes that 'today our communication so often depends on representation or demonstration, instead of the energy of creating the universe'.[12] This energy emerges in Viola's art, almost liturgically, as visual images, as sound and movement, and in different experiences of the passages of time. The technology of video enables him to negotiate sacramental movements in crossings of space and time, breathless moments of eternity in which our being is both slowed and quickened, and which render absurd the literalism of those who accused *The Messenger* of obscenity. The venerable space of Durham Cathedral extended to art a hospitality which, it seems, our theologies and established moralities have barely begun to recognize, let alone understand.

For me, as I contemplated its unexpurgated form, *The Messenger* became a figure of hope in the dark, ancient air of the church. This, indeed, has always been the vocation of the artist – to link the past and its inherited cultures and beliefs with the changing demands of the present and the future. Artists, instinctively religious, have always memorialized the past in the present by projecting it onto a possible and hopeful future. That is why art is so necessary for the well-being and health of the human soul. Early in his career, Viola was influenced by Frances A. Yates's remarkable study of Classical and Renaissance aesthetics and psychology, *The Art of Memory*, 1966. Certainly it is easy to identify a close intellectual affinity between his installations and the 'memory systems' of St. Thomas Aquinas and Giordano Bruno, or the 'Memory Theatre' of Giulio Camillo in Renaissance Italy.[13] Just

as Aquinas, and Dante (in *The Divine Comedy*), convert abstract summa into corpo-
real and vivid universal images, and examples for memorizing hell, purgatory,
heaven and the drama of religious belief, so Viola fixes on the memory a powerful
combination of sensual impressions that in his 1983 installation *Room for St. John
of the Cross*, for example, actualize for us the extraordinary inner vision of the
Spanish mystic and poet. I was left wondering if the moral conventions of
our society were, in the end, little more than our prison cell hiding us from the
scandal of beauty and the word made flesh.

Like the great canvases of Rembrandt with their haunting, haunted and inward-
gazing figures – Saul, Bathsheba, the artist himself – the works of Viola draw in the
viewer physically and intellectually until one no longer merely sees and feels but is
given the eyes and touch, as in a sacrament, to realize a sense of Being itself.
And there is more. Viola is deeply influenced by the mystical philosophies and
religions of the East. He frequently refers in his writings to the work of the Sri
Lankan art historian Ananda Coomaraswamy, who distinguishes between Western
art which conceives a picture as seen through a frame or window, and the art of the
East where a different sense of structure neither freezes the image in a moment of
time nor fixes it 'out there' as an object, but reflects it back into the space of the
viewer's mind. Similarly, Viola's art fixes us precisely in neither time nor space, and
is thus a perfect reflection of the ambivalent and mysterious sacred space of the
Cathedral. As a contemporary artist we might place him in the broad Structuralist
movement of twentieth-century thought, looking back to the 'natural' science of
Bacon, Galileo, Newton, and Giambattista Vico's *The New Science*, 1725, which
concentrates on the internal relationships within structures bounded merely by
their own shapes and forms.[14]

At the same time, Viola's art emerges from a very different tradition from that of
Vico and Newton, who foreshadow the deep secularism and scepticism of the twenti-
eth century. For Viola reopens the possibility, indeed the necessity of, fundamental
theological thinking. His holistic vision, contiguous with Romantic thought and art,
raises questions for theology at it very root, that is, questions of ontology unified with
perception and the most acute problems of the nature of creation itself. Such art,

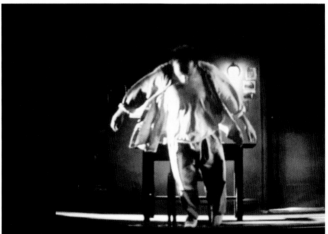

41 *Déserts,* 1994

in the Judaeo-Christian tradition at least, has always, and perhaps of necessity, had a scandalous dimension.[15] It turns the given of theology back upon itself, so that it becomes not simply derivative of 'God' but is fertile in its realization of the divine; scandalously and gloriously creative of that which sustains creation itself. Such art ceases to be the dehumanizing and detemporalizing enterprise which tends to be the fate of most modern theological, and indeed moral, thinking,[16] and becomes instead a celebration of an awareness in the world which makes theology possible in spite (indeed precisely because) of its very deconstruction.

In his writings Viola continually warns art against the demands and discipline of a particular religious tradition, admitting that in his art 'there is a kind of religion... In the original sense of 'religion', as opposed to, let's say, Christianity today.'[17] His art, sometimes dangerously, retreats from the constraints and architectures of system to the spaces where it might be possible to recognize that language beyond words, from which the necessary, though always finally inadequate, languages of theologies emerge, and to which they must return for sustenance and purification. In his installation *Déserts*, 1994 (**41**), Viola evokes those places where religion has always been sought and realized – the deserts of the mind, the city, the bare room – that is, those frightening places where we are confronted with our naked selves, and in which, alone and unexpectedly, we will encounter again our disappearing gods. (In this sense, the best commentary on his art might be the poetry of Friedrich Hölderlin with its deeply religious sense of vanished divinities.) *Déserts* shares with *The Messenger* a profound postmodernity, as both find in the wastelands of our wrecked or uncreated worlds that truth which the Desert Fathers of the fourth century sought in the sands of Egypt. They recognize that 'theology has never, ever, not dealt in the aporetic, the desert experience, the via negativa'.[18]

Viola's art is born out of a highly technical appreciation of contemporary electronic image-making. In the magnificent medieval achievement that is Durham Cathedral, Viola recognizes that this technological awareness has always been present in great art which struggles with those physical media that prompt the question 'how', and relentlessly asks the question 'why'. Painters, sculptors, poets and musicians live and struggle with technical innovation in their specific medium.

However, from the earliest days of civilization, the development of technology, which has now hugely accelerated, has preceded the spiritual and intellectual capacity of human beings to keep up with its demands. In this dilemma the masters of society seek, often naively, to protect us from the base instincts agitated by technological skills, so that Viola as an artist insists that:

> Today, development of the self must precede the development
> of the technology or we will go nowhere – there will be condominums
> in data space... Applications of tools are only reflections of the users –
> chopsticks may be a simple eating utensil or a weapon, depending
> on who's using them.[19]

The most basic materials – atoms, fire, water, hammers – can become instruments for great good or for enormous destruction, and the artist is continually encouraging us to beat our swords into ploughshares, challenging our perceptions in the process. The danger that Viola so acutely perceives is the terrible tragedy of Paul Klee's watercolour *Angelus Novus*, whose subject, as Walter Benjamin famously observed, stares backwards into history while it is being blown helplessly into the unseen future by the 'storm of progress'.[20] Viola's art, liturgically open to past, present and future, opens our eyes and ears to the immediate and crucial necessity of overcoming the tragic split between the head and the heart, the body and the spirit, the object and the subject, which afflicts the nostalgic soul of modern humankind. His art articulates afresh an aesthetic that re-establishes our sense of being in time. Drawing upon the art of sixteenth-century Florence, in *The Greeting* a homely encounter between three women is slowed down from a 'real' time of 45 seconds to a screen time of 10 minutes. Without explaining anything, the piece shifts the perspectives of both time and space so that a momentary human experience becomes rich in the assumptions of the past and projects forward to the possibilities of the future.

In art which hovers between abstraction and representation, Viola's highly personal *Nantes Triptych* leads the eye, in the tripartite form of the traditional Western altarpiece, from the moment of birth towards the moment of death, and, between them, to a figure suspended underwater as though in space. Thus we live our lives in

fragile suspension. No God answers our questions, but we are left to respond either with love or with fear, perhaps both. The question arising after contemplating this work is 'what do we say?' The articulation of an answer to that question is the task of the theologian – not to work from a fabricated given, but to work through an infinite complexity towards a revisiting of that which, for some of us, rests on the hidden altar presumed by the triptych. From birth to death – the two moments which we all, without exception, share in our lives, but which none of us ever actually experience in the fragmentariness and forgetfulness of our conscious selves. This articulation will spring from seeing, hearing and being involved in an art which gives us ears and eyes to realize a wholeness which, in our fallen condition, we have lost or forgotten. Perhaps, we may now dare to think, it has not forgotten us.[21]

As I contemplated my task in Durham Cathedral, that is to reflect as a theologian on *The Messenger*, I was both distracted and troubled by the controversy that immediately surrounded the work. At one level, it was understandable. And yet are we offended by Michelangelo's magnificent marble statue of *David*, or Rembrandt's tragic, and bare-breasted *Bathsheba*? On the other hand, it has to be said that Michelangelo's great *Risen Christ* in Sta. Maria sopra Minerva now stands disfigured by a prudish apron, shrouded by what Leo Steinberg has called our 'modern oblivion' that is 'profound, willed and sophisticated'.[22] Or is it that our oblivion is a necessary, perhaps inevitable, response to the baffling complexity and sheer power of the images and symbols of art as they fund the languages of our moral and theological codes and systems?[23] The potency of the human body for acts of creation or destruction is productive of a fear that we control by screening it from our gaze, giggling nervously when we catch a glimpse. Like Adam and Eve after the Fall in Eden, we are afraid before God because we are naked (Genesis 3: 10).

The Cathedral authorities were placed in a hopeless position by the threat of possible prosecution for obscenity, and took the easier path by placing screens around *The Messenger*, so that it could no longer be seen down the full length of the church. But its exchanges with the ambivalent sacred space of the Cathedral nave were muted and its message hidden in a corner where it could be safely forgotten. Once again, it seemed, the Church had imposed its authority and limits upon the artist,

as has happened so often in Christian history. Viola, it seemed to me, had never intended people simply to see and hear *The Messenger* as such. Rather, it was intended to be seen as part of and in the context of the whole cathedral: a messenger or angel (which is the same thing) from beyond time and space, never to be fully understood or its message articulated. That was the point, perhaps – that its message was a mystery, reminding us that not just Viola's installation, but also the cathedral and the gospel for whose proclamation it was built are scandals and stumbling-blocks, as was Christ himself, according to St. Paul. (I Corinthians 1: 23). In this way, I suppose, the work had been successful. Persecuted for the wrong reason, something of its truth became apparent to many people, as was demonstrated in a subsequent television programme on the work in which many visitors to Durham spoke wisely and movingly of its effect. *The Messenger* is more than simply a work of art, in the sense that it has moved beyond the rather cloying limits of the contemporary 'art scene'. But what is the message of this strange, anonymous man?

From the infinite, that which is without form slowly assembles into a body and gasps for breath in the unfamiliar, necessary air. His message comes to each of us in the waiting and watching and listening: there is no prepackaged formula that requires little real attention. But it is a waiting upon – what? – God? Waiting, watching, listening – not confusing our minds with answers or conclusions too quickly formulated, appropriating the experience each in our own way but yet within our common humanity. Peter Baelz, the late Dean of Durham Cathedral, begins his book *The Forgotten Dream*, 1975, with the account early in the 'Book of Daniel' of King Nebuchadnezzar who had a dream that troubled his spirit. His men of wisdom offer to interpret his dream if he will but tell them what it was. But therein lay the real problem, and the King already knew that his counsellors were frauds. His difficulty was that he had forgotten his dream, and needed to be told what it was – for the dream had not forgotten him. Is this, I wonder, the true message of the angel? Is it to remind us of the forgotten dream in the opening up of the possibility of something else, something outside the limits of the imagination to which our eyes and ears are closed? As the screens were placed around *The Messenger* I found myself reflecting on the words of Isaiah 6: 10:

Make the heart of this people fat,

and their ears heavy,

and shut their eyes;

lest they see with their eyes

and hear with their ears,

and understand with their hearts,

and turn and be healed.

In the self-embodying impulse of the artist, we are given the opportunity to open our eyes and unblock our ears in a creation of air, water, earth and fire, in time and in space then realized as sacred space. Jesus said to his disciples after one his great miracles: 'Why are you afraid? Have you no faith?' As Jacques Derrida admits at the end of his *Memoirs of the Blind*, 1993: 'I don't know, one has to believe...'[24]

195

42 *Venice TV*, 1995. Evgeny Asse, Vadim Fishkin and Dmitry Gutov.

CHAPTER 10

KNOCKING AT A FOREIGNER'S HOUSE
When the Russian Art Community Met Bill Viola

ANTONIO GEUSA

'Only the poet and the saint can water an asphalt pavement in the
confident anticipation that lilies will reward his labour.'

W. Somerset Maugham, The Moon and Sixpence

'Every birth is unique.' Bill Viola

In 1995 the Arizona State University Art Museum chose Bill Viola to represent the
United States of America at the 'Olympics of the art world',[1] the Venice Biennale,
which, incidentally, that year celebrated its 100th birthday. It was the first time ever
that a video artist had been invited to undertake such an eminent assignment.
Grouped under the title 'Buried Secrets', Viola set five installations in five separate
rooms in the US pavilion.

The next-door neighbours to the US pavilion were the curator Viktor Misiano
and the Moscow artists Evgeny Asse, Vadim Fishkin and Dmitry Gutov: the team
commissioned to install the Russian pavilion. Although separated by thousands of
dollars in their budgets and by the degree of sophistication of equipment used to
present the works to the same audience – clearly to the advantage of the US in both
cases – video also played a dominant role in the Russian space. Aptly, the Moscow
team chose a quotation by Karl Marx to christen their pavilion, 'Reason Is Something
the World Must Obtain Whether It Wants It or Not', a maxim charged with deliberate
irony in the aftermath of the recent collapse of the Soviet Union and the political
upheavals of the four-year-old Russian Federation.

The centrepiece of the whole exhibition was *The Story of One Place* (**43**), a ten-
minute video documentary projected onto a single screen in the darkness of the

43 *The Story of One Place*, 1995. Evgeny Asse, Vadim Fishkin and Dmitry Gutov.

central hall. The place in question was the Cathedral of Christ the Saviour, one of the outstanding landmarks of post-Soviet Union Moscow; and today's most exemplary and explicative monument of the boisterous and ostentatious re-appropriation of those long-buried religious characteristics of pre-Revolutionary Russian identity. The video showed a selection of images taken from archival material spanning seventy years in the life of the cathedral, telling the story of its rebirth – a 'truthful story' that 'obviously illustrates a cyclical and self-contained nature of Russian history, with its evident tendency for destruction and utopia'.[2] The cathedral was blown up in 1931 by Stalin, who wanted to build on the same spot of land the tallest skyscraper in the world, the House of Soviet, intended to house several governmental bodies from all over the Soviet Republics. The original plan also included, on top of the building, a 100-metre-tall aluminium statue of the Bolshevik leader Lenin. Yet this ambitious enterprise had to be abandoned when the ground proved to be geologically unfit to hold the massive building. An open-air swimming pool took its place until 1994, when the mayor of Moscow, Yuri Luzhkov, laid the cornerstone of the new cathedral.

199

Another video welcomed visitors at the beginning of the path leading to the room in which *The Story of One Place* was being exhibited. On a television stand mounted on the wall at the entrance of the gallery, a TV showed a looped 90-second video of the unknown singer I. S. Fadeev, from the Volokolamsky region, whistling Tchaikovsky's 'Songs of Naples' (42). The footage displayed here was also taken from archive material, specifically, extracts from a 1930s film.

It is evident that in making these two works, which, incidentally, were the very first Russian videos to be shown at the Venice Biennale, the three artists and the curator craftily took upon themselves the roles of editors and historians in adapting a non-fictional story which had already been documented on film. To underline the encyclopaedic value of both video documents it is relevant to point out that what came out of the editing room contained neither added visual nor sound effects, in line with what Misiano identified as the exhibition's aesthetic programme, namely the 'documentation of the social event'.[3] Clearly, something completely different was being shown in the pavilion next door.

When asked about his neighbour's work, in a conversation in June 2003, Dmitry Gutov's first memory was of walking the black corridor of the *Hall of Whispers*, the first installation along the route that Viola set up through the US pavilion.[4] His recollections were vivid and detailed, despite the fact that more than eight years had passed. For him, above all, the encounter with Viola's work was a sensory rather than intellectual experience. Lined up along both sides of the corridor small monitors displayed talking heads uttering words that were impossible for a foreigner who does not speak English to understand. However, Gutov also commented that he had the feeling that those words were not meant to be understood in the first place. At the same time, those indecipherable whispers, according to Gutov, made the whole experience of being in the middle of the room almost transcendental, overcoming as they did the limitations of the spoken text by placing on the same level those who did not understand the whispers and those who did. As he moved on through the space, the state of confusion that he felt in the darkness of the corridor soon gave way to a deep and sincere admiration for the technical accomplishment of the works shown in the other four rooms, Viola's video installations *The Veiling*, *Interval* (**44**), *The Greeting*, and the 'auditory experience piece'[5] *Presence*. To Gutov those works seemed to dissolve the discrepancy between intention and practical achievement which is felt by any artist when transforming their inspiration into a concrete work of art. To Gutov, they were the 'realization of the impossible'. Furthermore, these were works that received a particular type of attention from the audience, the response that every artist surely hopes for – that is to say a certain degree of commitment. It was impossible when coming out of the last room not to feel spiritually enriched, whether through disturbance, confusion, rage, anger or calmness. Summarizing the exhibition, Gutov remarked that Viola's works were – and still are – 'real American art'.[6]

By extension, saying that Viola's works are genuine examples of an art understood as in all ways 'American' implies a specific function for video within that category of 'real American art'. In other words, video is an art form that is not and cannot be quintessentially Russian – indeed its vocabulary offers no translation for the formula 'video art'. Yet the transliteration of the English phrase into one single word 'videoart' was adopted about ten years ago to label this new type of art form.

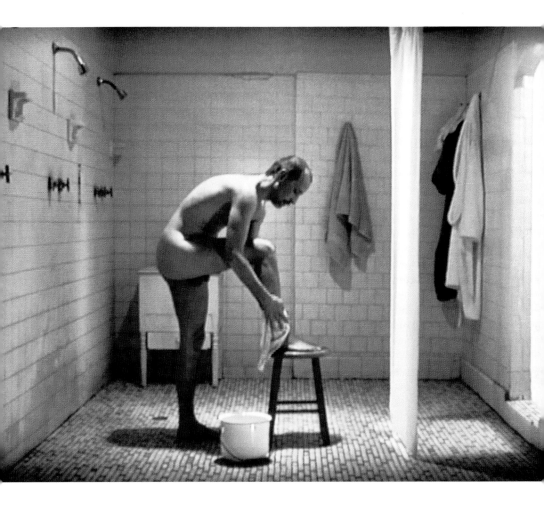

44 *Interval*, 1995

Gutov's astonishment in the American pavilion also came from seeing the 'future stage' of a medium that in Russia was still in its initial, and wholly experimental, phase. In 1995, Russian artists were just 'starting out in video'.[7] In the realm of video art, 1995 was to Russia what 1965 was to the United States, when 'most of the...video work was for the most part devoted to finding "the unique characteristics of the medium" '.[8] Those fortunate few in Russia who were able to get hold of a video camera and editing equipment experienced what the first generation of American video artists had gone through thirty years before, hurrying 'to understand the technology, acquire the technical experience and knowledge, and develop craft and technique'.[9]

Video art came to Russia as an imported product. At the end of the eighties, Gorbachev's Perestroika brought the first video cameras into the shops, but buying one was de facto impossible, since the price of a camera was the equivalent of two years of an average salary. For a Russian artist to make a video was therefore impossible. Russian art communities became acquainted with what was, for them, a radically new way of expressing the inner self, through exhibitions of other, foreign artists' work devoted to the 'independent creative potentialities in the sphere of video'.[10] This work was brought in from abroad as a result of cultural programmes. In particular, Viola's works played a substantial role in the diffusion and development of 'videoart' from the very beginning.

The first exhibition of American video art in the capital of the Russian Federation took place in November 1992 at the TV Gallery. Founded the previous year by Dr Nina Zaretskaya, this was one of the first independent contemporary art galleries in Moscow. The process of importing video art had started in the early months of the TV Gallery's operation, through the tenacity of Dr Zareskaya, a journalist, academic, TV producer and presenter. The exhibition of videos from the United States, straightforwardly entitled 'American Videoart', was organized with the assistance and participation of the critic and academic Deirdre Boyle, from the Faculty of Media Studies at the New School for Social Research in New York. The original plan had the show running for three days, in which a sort of anthology of America's latest generation of video art would have been presented to the Muscovite audience. The programme included a total of ten videos by Bill Viola, Jeanne Finley,

Shalom Gorewitz, Laura Kipnis, Joan Logue, Daniel Reeves, Rea Tajiri and Edin Velez. Viola's *Anthem*, 1983 (**45**), opened the sequence of works, while his *I Do Not Know What It Is I Am Like*, 1986, closed it.

The exhibition proved to be more successful than expected. In an interview in July 2003, Zaretskaya recalled that they had to change the original plans and prolong the show in order to meet the huge demand from an ever-increasing audience.[11] In the end, the show was extended to ten days, running from 15 to 24 November. The impact of those videos on the Russian audience was profound. In a conversation, the curator, Evgenya Kikodze, recollected both the 'electric atmosphere' in the gallery when watching those videos and the intensity of the whole experience.[12] Eleven years after the event, her abiding memory was of the very beginning of Viola's *I Do Not Know What It Is I Am Like*: the plunge of the video camera into the lake. According to Kikodze, it was as if one could feel the actual impact of the water on the skin. Moreover, watching on screen the self-reflexive act of the artist in his studio editing footage of wild animals on a 'sophisticated piece of equipment', the audience shared a mutual sense of visiting a fair at which the latest achievements in video technology were on display; a feeling not dissimilar to Viola's reflection on the aesthetic revolution: that every technological innovation brings with it the same sort of emotions which might have been felt when, in the fourteenth and fifteenth centuries, you had 'oil paint coming out of tempera paint'.[13]

To Kikodze, and to many others in the audience, the encounter with 'American Videoart' was first of all a learning process; the acknowledgment that what was being shown was something completely new to them. It was something that seemed to belong by right to the world of art but that had never been shown in Russia before, neither in galleries or museums nor on TV. Tatyana Danilova, in her review of the event, noted: 'Quite a few of these transoceanic masterpieces have caused bewilderment amongst our unsophisticated countrymen.'[14]

In Russia in the early nineties, video was considered to be a medium too sophisticated (and expensive) to make art with. Consequently, in Boyle's opinion, the expression 'Russian video art' seemed, at that time, to be a contradiction in terms: video art was a language still not spoken in the country. This sense of an absence of

203

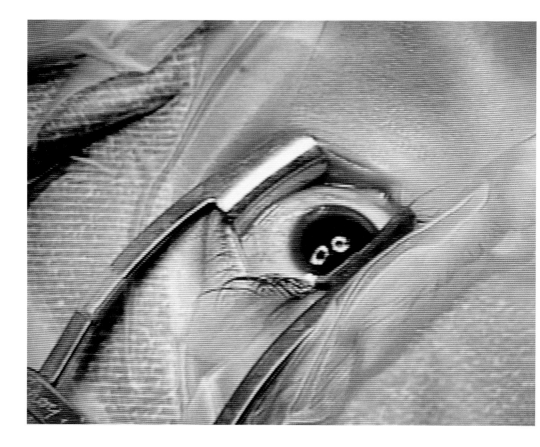

45 *Anthem,* 1983

language was expressed several times during the open discussions organized around the exhibition, and was reiterated in an interview with Tatyana Danilova in a Russian TV magazine: 'I spent more than two months in your country and I watched lots of TV. Also, I have been shown several tapes. But I'd prefer to call everything I saw a 'TV show' or 'video film' rather than 'video art'. At the same time, I hope that it soon arrives in Russia too.'[15]

The huge success of the 'American Videoart' exhibition demonstrated that the mark those videos left on the 'bewildered' community of Russian artists was deep and undeletable. At the beginning of *Anthem*, a girl in a white dress screams in the eerie emptiness of the central hall of Los Angeles's Union Station. That scream, which opened the TV Gallery exhibition, did not end when the screen was switched off; it kept echoing in the mind of those who had experienced it. Indeed, it is possible to see in it the validity of Viola's epiphanic remarks on the place of the work of art in the world.

In an artist's statement read by his wife, Kira Perov, at the international confer-

ence 'Contemporary Photography and Video Art', organized in 1996 for the exhibition 'Along the Frontier' in St. Petersburg (more of which later), Viola wrote: 'The real place [where] the work exists is not on the screen or within the walls of the room, but in the mind and heart of the person who has seen it. This is where all images live.'[16] This statement was adapted from a previous text that had appeared in 1995 in a collection of his writings, *Reasons for Knocking at an Empty House*:

> I have come to realize that the most important place where
> my work exists is not the museum gallery, or in the screening
> room, or on television, and not even on the video screen itself,
> but in the mind of the viewer who has seen it. In fact, it is only
> there that it can exist.[17]

But the 'mind of the viewer' is not a shelf in a library or a hook in a gallery on which the painting hangs, nor even a television set or a projector transmitting a video. The 'mind of the viewer' remembers the work the way it was experienced at the time. The 'mind of the viewer' is never passive. Every work of art engages the viewer in a dialogue with the artist's experience, which that particular work retells.

In his novel *The Moon and Sixpence*, Somerset Maugham observed that experiencing a work of art always means reliving the artist's tormented adventure that brought him to create 'beauty' out of the 'chaos of the world'.[18] Viola suggests that this adventure is a powerful experience, one that is not only relevant to the artist's personal life, but which also radically affects the viewers of the work, to such an extent that a 'new fire' starts in them:

> As people drawn to the field of art, it is, most fundamentally,
> the basic human characteristic of wanting to share and give others
> an experience that has been profound and important in our own
> lives. If it is our desire to perpetuate our own experience of personal
> meaning and transformation, then the question becomes, how do
> you start the fire in the individual? You can't just reach in there and
> strike a match – they must do it themselves. The fire, once ignited,
> will grow to consume all the necessary fuel in its path, a process
> we call "an individual educating themselves".[19]

In the case of Russia at this time, that 'fire' was the fire of video art. Dr Zaretskaya, then, played the role of the modern Prometheus, bringing to her exhibition some of the best examples of what, for Russia, was a new revolution in the realm of contemporary art. In doing so, she did not steal fire from the gods, but rather borrowed it from artists such as Viola, who had already written their own history, had performed their experiments and explorations through the evolution of the medium in the 1970s. At the same time, it is essential to underline that she – together with all those people who worked ceaselessly for the diffusion of video art in Russia – could see beyond the novelty of the video as a work of art. They shared Viola's belief that 'the medium of video' was 'clearly the most relevant visual art form in contemporary life'.[20] The videos that Zaretskaya exhibited were not rarities shown as freakish phenomena to satisfy the appetite of an art community always demanding to taste something new. Zaretskaya believed that video art was a gospel to be preached, that the words of artists like Viola had to be spread, and that the fire had to be started. The girl's primordial scream in *Anthem* was a call to action for Russian artists. *Anthem*, and all the other works on show, were not merely products. They were an illustration

of a whole new process of artistic creation; the preface to a book that, in Russia, had not yet been written. Before too long the price of such a 'sophisticated piece of equipment' as a video camera would come down and become affordable; editing equipment would become available. Then it would be a question of Russian artists having 'to educate themselves'. And, matter-of-factly, so it was.

Viola's first appearance in an exhibition in Moscow provided the spark. A few months later, the first videos made in Russia were already being shown in official exhibitions.[21] James Yood's considerations on the fast growing use of video as an international form of artistic expression apply to Russia too: 'The genie [was] out of the bottle.'[22] Viola's work was vital to this upsurge of activity. Gradually, the evolution in video art that had occurred in the United States in the 1970s and 1980s, and in all those countries already boasting their own different histories of video art since the 1960s, began to take place in Russian museums and galleries, so that 'video...moved from background to foreground'.[23] Today, this is still a work in progress, but the sheer volume of exhibitions including video in Russia parallels Jillian McDonald's comments on the role of video in the exhibition space: 'Video used to be shown by the bathroom. Now it's in the main salon, and whole shows are devoted to it.'[24] In Russia, however, despite the enthusiasm for the new medium, Nam June Paik's 1965 prediction that 'the cathode ray tube will replace the canvas'[25] is still far from being true.

Nevertheless, there were no canvases on show in 'Along the Frontier', an exhibition of video installations by four contemporary American artists organized in 1996 at the Russian State Museum's Marble Palace in St. Petersburg, one of the most active and variegated cultural stages in Russia. To 'push the envelope of modern art's technological and expressive ambitions' was – and still is, in fact – the credo of Aleksandr Borovsky, the Museum's Director of the Department of Contemporary Art.[26] The American curators – Leanne Mella and Charles Stainback – brought over the works of Viola (*Science of the Heart*, 1983 (**46**)) and Bruce Nauman (*Antro/Socio (Rinde Facing Camera)*, 1991), while Anne Hamilton and Francesc Torres had each created installations, respectively entitled *Volumen* and *La Furia de Los Santos*, which were inspired by their sojourn in the city. The exhibition ran for two months from 14

June to 20 August – and, if we can judge by attendance figures, it was a huge success. The general reaction can be summarized by Kelly Klassmeyer's review of the show in *The St. Petersburg Times*:

> Its stimulating, provocative multimedia installations occupy a place
> somewhere between film, theatre and sculpture. This
> unconventional exhibition provokes, disturbs, annoys and amuses
> in a powerfully fresh manner that is impossible to ignore.[27]

Most of all, the exhibition was perceived as breaking with tradition; a provocative exception to what museums usually offered to their audiences. With 'Along the Frontier', the Russian State Museum presented itself not just as a museum of contemporary art, but also a contemporary museum, where 'contemporary' stands as antonym of 'traditional' and signifies a new role for the museum and a new way, for Russia, of thinking about art. With this show, the museum entered into the discourses of the European Kunsthalle and the American institutions, proclaiming a new role for modern art within Russian culture and, perhaps, a changed relationship with both international artists and the art market. Without doubt, the four installations on show were, as a review in the weekly issue of *Smena* pointed out, 'contrary to local custom and in conformity with the etiquette of Western professionalism'.[28]

Turning the museum into a video salon meant opening the doors of the eighteenth-century Marble Palace to high technology, marking the exhibition as groundbreaking both in terms of innovation and in the sophistication of the equipment used for the show. As a matter of fact, most of it was shipped from the US, or from London, in Viola's case. High technology had crossed the border, allowing the museum space to be pushed to its own physical and discursive limits. It is interesting to note that the Russian name for the exhibition, 'U predela', comprises the double valence of 'along the frontier' and 'to the limit'. (The latter was in fact wrongly reported as the name of the exhibition in an article published in the *St. Petersburg Review*.)[29]

Viola's *Science of the Heart*, the oldest of the four installations, was specially adapted for the Marble Palace. In an interview, Dr Olesya Turkina, one of the exhibition curators from the Russian side of the frontier, explained the institutional constraints that led to these changes. It was not possible to paint the museum walls

46 *Science of the Heart*, 1983

black, so a special wooden room was built within the museum.[30] (Such a practice is, of course, commonplace in video installation; Russian curators were only just learning the different demands placed by video installations upon exhibition spaces designed to display paintings and sculpture.) This dark room had at its centre an empty brass bed, in front of which a screen displayed images of a chest opened in surgery. Inside the chest cavity a human heart beat at irregular intervals until it stopped completely, then started a few seconds later with the same incongruous succession of accelerations, decelerations and stops. It was an installation that destabilized the time of perception, which varied according to the moment at which the visitor stepped into the room. It was also an experience that placed itself both along the frontier and to the limit, the open chest displaying the pulsing heart representing the geographical frontier or limit in the human body between life and death. The moment the surgeon's scalpel brings to the surface the heart, an internal organ whose regular functioning guarantees life, all the danger of death is clearly felt by the viewer – in fact, the heart does stop beating. The frailty of life, the fear of death are encoded on the screen, itself a frontier since it allows the spectator to cross the border of the museum room and step into the one created by the artist with the video. Furthermore, the experience of sharing the space of the aseptic room with an empty bed, that is to say a reminder of everyday life as well as of illness and death, made the spectator feel even more 'distressingly frail'.[31]

Turkina recalls that the audience often seemed overwhelmed by Viola's work, to the extent that the elderly had to be warned about the 'emotional danger' that it possessed. One journalist, in his review of *Science of the Heart*, amused readers with the anecdote of being asked, when visiting the show, if he had already been into 'the chamber of horrors'.[32] Yet Viola's work seemed to play a key role in the popularity of the exhibition. Turkina ascribes the success of his installation to the intimacy compelled by the combination of bed and heart. This peculiar combination connected the 'domesticity' of an object belonging to everyday life with the unfamiliar, because unseen, 'physiology' of an organ of our own bodies.[33] Similarly, Ekaterina Degot wrote in her review of 'Along the Frontier' that, like a soap opera, the installation did not distance itself from its viewers. Rather, it demanded an emotional identification

that became self-identification the moment the one single immaculate white pillow caught the spectator's attention. At the same time, added Degot, the darkness surrounding the viewers obliterated any interference from the outside, so that they were absorbed by the images on the screen and the spot-lit bed.[34] With well-balanced irony, Degot also dubbed Viola the 'chief virtuoso' as well as the 'Spielberg of contemporary art', recalling the colossal queue outside his pavilion at the Venice Biennale and the huge popularity of the artist all over the world.

Although almost four years had passed between 'American Videoart' and 'Along the Frontier', and although Russian video art was by then an established practice among Russian artists, the gap between what was shown in Russia and what was imported from the other side of the frontier remained extraordinarily wide. Viola's heart could not be transplanted into the Russian body, where the technology and curatorial knowledge to make sophisticated installation art possible was not yet a reality. A reviewer of the St. Petersburg show for *Smena* magazine wrote that 'attaching the magnificent, shining, terrifying perfection of the American artificial limb to the flabby and podgy body of the local art environment had proved to be unsuccessful'.[35] Dr Borovsky himself, although he had envisioned the installation (and with it video art) as the future of the museum's exhibitions, also admitted at the conference 'Contemporary Photography and Video Art' that, as far as installation art in Russia was concerned, the contractions were felt, but 'no babies [were] being delivered'.[36]

Taken together, 'American Videoart' and 'Along the Frontier' demonstrated to the Moscow and St. Petersburg art communities that – to borrow John Baldessari's simile – video was actually a pencil and art 'one of the things you can do with it'.[37] This comparison of video to something as simple as a pencil brings to mind Viola's considerations on the high degree of sophistication of today's children's toys. Toys are becoming 'more and more "advanced" loaded down with gadgets, gimmicks, flashing lights, and anything else manufacturers can think of to throw in. A block of wood can be anything from a boat to a spaceship.'[38] Russian video artists, in the ten-year history of Russian 'videoart', have been playing with that block of wood: creating from it their own brilliant and original video works, while refraining from loading their block with gadgets, gimmicks or flashing lights. Even today, in Russia, what in

Jean-Cristophe Ammann's opinion is Viola's priority in his video installations, that is to say 'the large projection', is not essential.[39] However accelerated the evolutionary pace, video art in Russia has not yet reached the point encountered by American artists in the early 1980s, when video moved decisively beyond the small TV screen.

Viola's videos arrived in Russia at the precise moment when artists were about to map out their own territory within video art, as cameras became available some thirty years after they did in the US. But if the 'great common primordial soup of the sixties'[40] in fact developed in the nineties, Russian video artists nonetheless relived much the same experience as their American counterparts. Viola wrote:

> Video was being invented and simultaneously so were its myths
> and culture heroes.... Someone thought that young curators,
> writers, and artists were looking for a way into the already
> crowded art scene and were simply interested to stake claims
> and legitimize the medium as soon as possible.[41]

There is a sort of symmetry in this. But it is a symmetry that does not belong to the rationality of geometry. It belongs instead to the reality of vision, the beyond of the trance. Several times in his writings Viola has drawn a parallel between the shaman and the (video) artist; both possess the visionary power of seeing beyond. Borrowing the imagery of the cosmonaut from Viktor Mazin and Olesya Turkina's essay 'The Golem of Consciousness: Mythogeny's Lift-off', included in the catalogue for 'Along the Frontier', we can see in him the specular image of the shaman. Both cosmonaut and shaman are indeed performers; both travel in a space beyond, that is to say both live the same experience as the viewer, where the screen is the frontier beyond which a new space and time is presented.

Transported by magic to the edge of *The Reflecting Pool*, 1977–79, the Russian shaman/astronaut/video artist does not find Viola's reflection in it, because it has disappeared from the surface of the water. The symmetry is nevertheless still there. Viola's videos, like reflections on water, have their after-lives in the memories of those who attended the two exhibitions.

NOTES

INTRODUCTION PP. 6 – 23

1 D. Hickey, 'After the Great Tsunami: Beauty and the Therapeutic Institution', in *The Invisible Dragon: Four Essays on Beauty* (Art Issues Press, 1993), p. 53.
2 See D. Marshall, *The Surprising Effects of Sympathy: Marivaux, Diderot, Rousseau and Mary Shelley* (University of Chicago Press, 1988), p. 101.
3 See M. Fried, *Absorption and Theatricality: Painting and the Beholder in the Age of Diderot* (University of California Press, 1980), p. 55.
4 P. Bickers, 'Marriage à la Mode', *Art Monthly* No.261, November 2002, p. 4
5 'After the Great Tsunami', p. 59.
6 Examples of this might include fascism's harnessing of modernist technologies whilst investing in a counter-modernist aesthetics, or, from a more contemporary point of view, Hollywood's narrativising of technological dystopia in movies such as *The Matrix* whilst depending on the deployment of that technology both for the global reach of corporate capitalism and the subjectively disabling spectacle that is the film. (*There is a degree to which The Matrix is already the matrix*).
7 'After the Great Tsunami', p. 54.
8 J. Crary, *Suspensions of Perception: Attention, Spectacle and Modern Culture* (M.I.T. Press, 1999) p. 1.
9 J. H. Marrow in *Passion Iconography in Northern European Art of the Late Middle Ages and Early Renaissance* (Ars Neerlandica, I, 1979), cites as an example of the concentration on the image in personal devotion, the *Little book on the meditation on the Passion of Christ divided according to the seven hours of the day*, by Pseudo-Bede (c. 1250–1300). The preface comments: 'It is necessary that when you concentrate on these things in your contemplation, you do so as if you were actually present at the very time when he suffered. And in grieving you should regard yourself as if you had our Lord suffering before your very eyes...' See, D. Freedberg, *The Power of Images: Studies in the History and Theory of Response* (University of Chicago Press, 1989), p. 171. This suggests a tradition in which the personal concentration on the unreal image, in order to make it real, is displaced by one in which all the 'making real' is done for the absorbed subject, thereby rendering the activity of concentration upon the image redundant.
10 *Suspensions of Perception*, p. 3.
11 B. Viola, 'Video Black – The Mortality of the Image', in D. Ross & S. J. Fifer *Illuminating Video: An Essential Guide to Video Art* (Aperture/Bay Area Video Collective, 1990), p. 477.
12 W. Benjamin, 'The Work of Art in the Age of Mechanical Reproduction' in Hannah Arendt (ed.), *Illuminations*, (Fontana, 1992).
13 For a stimulating assessment of the transformations of temporal and spatial concepts in modernity, see S. Kern, *The Culture of Time and Space* (Harvard University Press, 1983).
14 See for example Newman's writings in J.P. O'Neill, (ed.) *Barnett Newman: Selected Writings and Interviews* (University of California Press, 1992) and T.B. Hess, *Barnett Newman* (Museum of Modern Art, 1971)

CHAPTER 1 PP. 24 – 45

1 Viola discusses various types of devotional images, ranging from icons and medieval paintings to contemporary family photographs, and emphasizes the continuity he sought between his newer images and older ones that would call the viewer into the work, 'getting lost in its aura'. See H. Belting and B. Viola, 'A Conversation', in J. Walsh (ed.) *Bill Viola, The Passions* (J. Paul Getty Museum, in association with the National Gallery, London, 2003), pp. 202–3.
2 J-C. Ammann, 'Violence and Beauty', in B. Viola, *Reasons for Knocking at an Empty House: Writings 1973–1994* (Thames & Hudson, 1995), p. 13.
3 C. Freeland, 'Bill Viola and the Video Sublime', *Film-Philosophy*, 3:28, (July 1999), http://www.film-philosophy.com/vol3-1999/n28freeland.
4 Arthur Danto chides Peter Schjeldahl for thinking of the sublime as vague and 'innocently gushy'; see Danto, *The Abuse of Beauty: Aesthetics and the Concept of Art* (Open Court Publishing Company, 2003), p. 148.
5 C. Freeland, 'The Sublime in Cinema', in *Passionate Views: Film, Cognition, and Emotion*, C. Plantinga & G. Smith (eds.) (Johns Hopkins University Press, 1999), pp. 65–83.
6 J. Elkins, *Pictures & Tears: A History of People Who Have Cried in Front of Paintings* (Routledge, 2001).
7 Ibid. pp.21, 23, 25.
8 John Walsh explains the influence on Viola of certain paintings he saw at the Prado and at the Getty collection when he was a visiting scholar at the Institute there, and also of a book by Henk van Os, *The Art of Devotion* (Princeton University Press, 1995). See J. Walsh, 'Emotions in Extreme Time: Bill Viola's *Passions* Project', in *The Passions*, p. 31.
9 On Newman, see *The Abuse of Beauty*, p. 143; on Rothko, see *Pictures & Tears*, p. 13.
10 E. Burke, *A Philosophical Inquiry into the Origin of Our Ideas of the Sublime and the Beautiful* (Oxford University Press, 1990)
11 Viola speaks of how empathy 'comes right into our bodies', *The Passions*, p. 201.
12 *Pictures & Tears*, Chapter 9, focuses on a Bouts painting of a weeping Madonna. Elkins comments: 'The sadness of this is in the way her grief is measured out... in Bouts' version she will never stop crying, as long as she lives. Her tears are now everyday tears. The Crucifixion could have happened years ago, for all we know: this is a painting about a state of mind, a permanent low-level mourning... It is a kind of eternal sadness, which will not be dulled by time.' p. 157.
13 Viola says he chose four emotions as primary, 'like primary colors': joy, sorrow, anger, fear; *Bill Viola, The Passions*, p. 200. For his remark about stripping away narrative, see p. 201.
14 On this, see J. A. Russell and J. M. Fernández-Dols (eds.), *The Psychology of Facial Expression* (Cambridge University Press, 1997); in particular, the article summarized in the introduction as follows: 'Fernandez-Dols and Carroll... challenge the traditional assumption that specific facial expressions have a specific meaning independent of the context in which they occur (that the frown is a "facial expression of anger" whatever the context).' pp. 25–6.

213

15 *Pictures & Tears*, p. 213. Compare A. Damasio, *Descartes' Error: Emotion, Reason, and the Human Brain* (Avon, 1995).

16 The suggestion is from M. Poizat in *The Angel's Cry: Beyond the Pleasure Principle in Opera* (Cornell University Press, 1992). I owe knowledge of this book to Elkins; see *Pictures & Tears*, pp. 146–7.

17 'Viola and Belting: A Conversation', *The Passions*, p. 219. Viola also cites a book by Victor Stoichita on Spanish visionary painting – 'the experiencing of an image that takes over the body of the seer', *The Passions*, p. 219.

18 *The Abuse of Beauty*, p. 148.

19 Lyotard, like Jacques Derrida, has written on the sublime in part by offering expositions of Kant's work on this topic. In Lyotard's case, this led to further extended reflections about the role of the sublime in contemporary avant-garde art. These postmodern thinkers are both interested in the ability of reflexive artwork to create certain breakdowns of our conceptual and representational systems. They put this problem as an issue of representing the unrepresentable. See J-F. Lyotard, *Lessons on the Analytic of the Sublime* (Stanford University Press, 1994); and J. Derrida, *The Truth in Painting* (University of Chicago Press, 1987), esp. pp.14–147, 'Parergon'.

20 *The Abuse of Beauty*; E. Scarry, *On Beauty and Being Just* (Princeton University Press, 1999). Scarry is mostly concerned about the damaging effects of an overly sharp dichotomization between the sublime and the beautiful. She is right to emphasize that there were more connections seen between these two aesthetic concepts in the eighteenth century. Burke, for example, in the conclusion of his classic work on this topic compares the two to the colours black and white, which can be combined and blended in a variety of ways; see Burke, Part III, sect. 27, 'The Sublime and Beautiful Compared'.

21 *The Abuse of Beauty*, p. 147.

22 *Pictures & Tears*, p. 18.

23 On the comparison between the devotional diptych and contemporary laptops, see *The Passions*, pp. 202–3. See also *Pictures & Tears* for more on the practice of creating double-hinged portraits of the *Mater Dolorosa* with the Son, p. 154.

24 *The Abuse of Beauty*, pp. 148–9.

25 Ibid., p. 152.

26 Ibid. pp. 155–6. Danto is unfair to Lyotard, whose theory of the sublime is based on a complex Heideggerian account of our relationship to time and, ultimately, to death. Hence the 'fear' in question is something rarefied and metaphysical, not something like ordinary fear. See J-F. Lyotard, The Sublime and the Avant-Garde', *Artforum*, 22, no. 8, 1984, pp. 36–43. (I am indebted to my student Tony Lack for drawing my attention to this and other work by Lyotard on the sublime in art.)

27 *The Abuse of Beauty*, p. 150.

28 Ibid., p. 157.

29 For further discussion of how various people see different things in these works, see 'Belting and Viola: A Conversation', p. 220.

30 Some people cited in Elkins's book *do* seem to feel fear before paintings, for example, in visits to the Rothko Chapel. Elkins also tells about a student who reported being overwhelmed by dread in seeing a painting by Caspar David Friedrich. *Pictures & Tears*, pp. 15–9 and p. 184.

31 E. Kant, *The Critique of Judgement*, 1790, trans. J. C. Meredith (Oxford University Press, 1957) p. 110

32 *Philosophical Inquiry*, Part I, section 7, pp. 36-37.

33 *The Critique of Judgement*, p. 111.

34 See E. Schaper, 'Taste, sublimity, and genius: The aesthetics of nature and art', in P. Guyer (ed.) *The Cambridge Companion to Kant* (Cambridge University Press, 1992), pp. 367–93; also see my 'The Sublime in Cinema'.

35 *Critique of Judgement*, p. 111-112.

36 *Critique of Judgement*, p. 104.

37 This claim is hard to back up within my assigned space. To mention just one example, Kant's hard-and-fast contrast between instincts and reason, as causally determined vs. free, respectively, is notoriously difficult to defend. Also, contemporary research undermines Kant's strong distinctions between sensation and cognition, or between imagination and reason. See, among others, J. Ledoux, *The Emotional Brain: The Mysterious Underpinnings of Emotional Life* (Simon and Schuster, 1998); A. Damasio, *Descartes' Error*; and S. Kosslyn and R. S. Rosenberg, *Psychology: The Brain, The Person, The World* (Pearson Allyn & Bacon; 2nd edition, 2003).

38 *Philosophical Inquiry* , p. 36.

39 *Philosophical Inquiry*, Part I, section 13, p.41.

40 Ibid.

41 *Philosophical Inquiry*, Part I, section 14, pp. 42-43.

42 *Philosophical Inquiry*, Part II, section 3, p. 54.

43 *Philosophical Inquiry*, Part II, section 8, p. 67.

44 *Philosophical Inquiry*, Part II, section 7, p 66.

45 Ibid.

46 *Philosophical Inquiry*, Part II, section 10, p. 68.

47 C. Darwin, *The Expression of the Emotions in Man and Animals* (University of Chicago Press, 1965). For Viola's mention of the Darwin book, see *The Passions*, p. 33.

48 See D. McNeill, *The Face: A Natural History* (Little, Brown & Co., 1998), p. 203.

49 For example, it is now thought that smiling is innate, and that 'social smiles' develop between the age of five weeks and four months. *The Face*, p. 204.

50 Ibid., p. 180.

51 P. Ekman, *Emotions Revealed: Recognizing Faces and Feelings to Improve Communication and Emotional Life* (Henry Holt & Co., 2003), p. 91.

52 For more on Ekman's work on this topic, see P. Ekman, *Emotion in the Human Face*, 2nd ed. (Cambridge University Press, 1982) and P. Ekman with E. Rosenberg, (eds.) *What the Face Reveals: Basic and Applied Studies of Spontaneous Expression Using the Facial Action Coding System (FACS)* (Oxford University Press, 1997).

53 *Critique of Judgement*, pp. 111-112.

54 *Philosophical Inquiry*, p. 42.

55 *Philosophical Inquiry*, Part II, section 1, p. 53.

56 'Belting and Viola: A Conversation' p. 199.

NOTES

CHAPTER 2 PP. 46 – 71

1 'Putting the Whole Back Together. Bill Viola in Conversation with Otto Neumaier and Alexander Pühringer', in *Reasons for Knocking*, pp. 265–83, esp. p. 278.

2 'The Mortality of the Image. Bill Viola in Conversation with Otto Neumaier and Alexander Pühringer.' German version published in *Medusa. Art & Artists Today*, no.1 1994, pp. 91–104; esp. p. 103.

3 'Putting the Whole Back Together', p. 272.

4 Ibid., p. 273. Presumably, Viola does not deny that it is in some sense possible to explain scientifically what happens when a child is born and to determine when someone is dead. What he is concerned with is rather some understanding of what it means to be born and to die. This remains mysterious in spite of all rational efforts.

5 Ibid., p. 274.

6 The huge variety of human possibilities covered by such phrases is listed in *Reasons for Knocking*, pp. 228–31.

7 *Interval* forms one element of 'Buried Secrets'; Viola's contribution to the Venice Biennale in 1995. The other installations within that work are *Hall of Whispers, Presence, The Veiling* and *The Greeting*.

8 'The Mortality of the Image', p. 103.

9 Although *Buried Secrets* is Viola's first meta-work consisting of several installations which form a cycle, the seven installations of the exhibition 'Unseen Images', 1992, already formed a unity which cast light on various aspects of one theme; the role of this greater unity is demonstrated by the fact that some viewers were challenged much more by one of the sub-installations, the *Nantes Triptych*, when it was shown separately in the Tate Gallery in 1994. Viola actually integrated several videos into complex meta-works quite early, e.g., in *Passage Series*, 1973, *Red Tape*, 1975, *Memory Surfaces and Mental Powers*, 1977, and *The Reflecting Pool*, 1977–9. As Viola said in an interview with Raymond Bellour, he intended that the elements of such higher-order works should 'affect each other'. *October* 34 (1985), pp. 91-119, esp. p. 100. This interaction of several images, which connects them into some greater unity, is also manifested in Viola's triptychs, from the *City of Man*, 1989, to *Trilogy: Fire, Water, Breath*, 1996, which 'grew together' from *The Crossing*, 1996, a work that forms a diptych in itself, and *The Messenger*, 1996. Viola's strategy could be seen even better, however, in the retrospective exhibition shown between 1997 and 2000 in Los Angeles, New York, Amsterdam, Frankfurt, San Francisco and Chicago.

10 *The Cloud of Unknowing* is not only the title of a mystical treatise of the late Middle Ages, but was also the title first planned by Viola for what became *Pneuma*. See M. Friedman (ed.): *Visions of America. Landscape as Metaphor in the Late Twentieth Century* (Denver Art Museum, 1994), pp. 236–9.

11 As was emphasized already by Lessing, every work of art is 'created not merely to be given a glance but to be contemplated – contemplated repeatedly and at length'. G.E.Lessing *Laocoön: An Essay on the Limits of Painting and Poetry* [1766], translated by A. McCormick. (John Hopkins University Press, 1984), p. 19.

12 The motif of the man floating in water is developed further in *The Messenger* and inverted there insofar as the man we see is mostly underwater, from which he emerges only to take a deep breath. So in this work, Viola takes up the motif of breathing which is also central for *Pneuma* and for *Seven Attempts to Achieve Immortality*, 1996, a work which presents on a screen the head of the artist who attempts to hold his breath as long as possible (and then rapidly breathes out and in). There are many more motif lines connecting Viola's works than can be dealt with here. In addition, I will suggest only two: there is the burning desk lamp in *Anthem*, 1983, *The Passing, Déserts*, and *Interval* (where it really burns) and images of the artist himself in many works, leading to the introduction of an 'alter ego' in more recent works like *Déserts, Interval* and *Trilogy: Fire, Water, Breath*. These motifs would repay a much deeper analysis and interpretation.

13 B. Chatwin, *The Songlines* (Jonathan Cape, 1987), p. 2.

14 'History, Ten Years and the Dreamtime', in *Reasons for Knocking*, pp.121–35; Viola takes up this matter in other texts, e.g. 'The Visionary Landscape of Perception', pp. 219–25.

15 F. Nietzsche, *The Birth of Tragedy*, translated by F. Golffing (Doubleday, 1956) ff124, p. 142. See also A. Gottlieb, *Baumgarten: Aesthetica* (1750–8) (G. Olms, 1970), p. 441.

16 See Viola's 'Statements 1985', in *Reasons for Knocking*, pp. 149–52, esp. p. 151.

17 'Putting the Whole Back Together', p. 278.

18 'I Do Not Know What It Is I Am Like', in *Reasons for Knocking*, pp. 141–3.

19 'Putting the Whole Back Together', p. 282. Whereas in his earlier works, Viola used the cyclical structure of video to confront us with images that provided some feeling of a greater cycle into which individual life is embedded, in his most recent installations he likes to demonstrate this idea much more directly, including even the multiplication of cycles. For instance, the five 'video frescoes' of *Going Forth By Day* (*Fire Birth, The Path, The Deluge, The Voyage* and *First Light*) are not only arranged into a spatial cycle and 'harmonized' to a projection cycle of thirty-five minutes, but also related to each other by their light (which varies according to the cycle of seasons), and by a sort of dramatic cycle which confronts us with the cycle of life from birth to death and resurrection. In this case, less would have been more.

20 'He Weeps for You', in *Reasons for Knocking*, p. 42.

21 'Putting the Whole Back Together', p. 279. Viola's attempt to revitalize the essence of classical painting through moving images seems to succeed in works like *The Greeting* or the series of *Quintets* (created in 2000), which in some sense visualize the psychological information contained in a painting by transforming it into video, using extreme slow motion to give the impression of looking through a magnifying glass. The same strategy does not work in all cases, however, particularly in those pieces which, like *First Light*, or *Emergence*, 2002, show a resurrection scene. This seems to be a consequence of losing the very 'fruitfulness of the moment which is characteristic for paintings', at least according to Lessing who thought that the 'limits of painting'

required the representation of a moment which 'opens the possibility of free play to our imagination. The more we see, the more we should be able to think; the more we think, the more we have to believe that we can see.' See G. E. Lessing, *Laocoön, op cit.* Seeing the moment of resurrection in a 'frozen' image leaves much more to our imagination than seeing the same process as a sort of 'movie' (which, therefore, doesn't have a special 'truth factor' either).

22 This place is not far from Florence where Viola worked in a video studio from 1974 to 1976.

23 The effect of the 'magnification of temporal phenomena' which is created by the use of slow motion is probably expressed better by the German expression for it, *Zeitlupe*.

24 'Video Black'

25 'Putting the Whole Back Together', p. 278.

26 Ibid.

CHAPTER 3 PP. 72 – 87

1 H. D. Thoreau, *The Maine Woods*, in *A Week, Walden, The Maine Woods, Cape Cod*, The Library of America, 1985, p. 717.

2 B. Viola, in 'Bill Viola', an interview by Michael Nash, in *Journal of Contemporary Art* 3, no. 2, Fall/Winter 1990, p. 72.

3 B. Viola, in C. Darke, 'Feelings along the body', in *Sight & Sound*, 4:1, Jan. 1994, p. 28.

4 B. Viola, in K. Raney, 'Interview with Bill Viola' (2000), in K. Raney, *Art in Question*, (Continuum, 2003), p. 84.

5 B. Viola, in C. Campbell, 'Bill Viola: the domain of the human condition', *Flash Art*, xxxvi: 229, March–April 2003, p. 91.

6 'Bill Viola in Conversation with Otto Neumaier & Alexander Pühringer', in Alexander Pühringer (ed.), *Bill Viola* (Salzburger Kunstverein and Riter Klagenfurt, 1994), p. 144.

7 A handful of early works, *Instant Reply*, 1972, *Il Vapore*, 1975, *He Weeps for You* 1976, do try the viewer out as a participant: in *He Weeps for You*, for instance, a drop of water is shown, magnified by a projector onto the wall, which close-up reveals that both the viewer and part of the room are being reflected in the droplet (filmed by a close-up camera).

8 See, for example, 'Video black'

9 T. Adorno, *Minima Moralia: Reflections from Damaged Life*, (New Left Books, 1974), p. 247.

10 'History, 10 years, and the Dreamtime', in *Reasons for Knocking*, p. 135.

11 'Bill Viola', an interview by Michael Nash, p. 65.

12 'Bill Viola in Conversation with Otto Neumaier & Alexander Pühringer', p. 138.

13 A-M Duguet, 'Passage', in R. Bellour, C. David & C. van Assche (eds), *Passages de l'image* (Fundació Caixa de Pensions, 1991), p. 208.

14 *Bill Viola* (Stedelijk Museum, 1998), p. 14.

15 Viola, in 'Feelings Along the Body', p. 28.

16 Ibid. p. 28.

17 Viola makes the desert burn by placing a gas flame beneath the lens, one of the few instances of the artist distressing the image, troubling it.

18 Witness his mother's body becoming in an 'instant', in his own eyes, just another piece of

material, 'like a pile of clothes or an old chair'. Viola, in Campbell, p. 89.

19 See 'You are creating the conventions of your medium as you go?' 'In a way, yes. I feel that this is still going on when I make work...', in Raney, p. 86.

20 Donald Kuspit, for example, could not be more wrong in claiming that Viola's tapes and installations 'deconstruct presence'. On the contrary, they presuppose presence and seek to reinforce it. 'Bill Viola: deconstructing presence' (1987), in *The New Subjectivism: Art in the 1980s* (UMI Research Press, 1988), pp. 251–60.

21 But see the second paragraph of 'Video black', p. 476.

22 H. von Hofmannsthal, 'From the *Book of Friends*' (1922), in *Selected Prose* (Bollingen Foundation, 1952), p. 358.

23 Raney, p. 87.

24 T. Adorno, *Aesthetic Theory* (The Athlone Press, 1997), p. 6.

25 W. G. Sebald, *Austerlitz*, (London: Hamish Hamilton), 2001, p. 3.

26 Raney, p. 75.

27 A-M Duguet *et al* (eds.), *Bill Viola* (Musée d'art moderne, 1983), pp. 26-7.

CHAPTER 4 PP. 88 – 109

1 *Going Forth By Day* (Deutsche Guggenheim, 2002), p. 69.

2 Ibid., p. 2.

3 Ibid., p. 3.

4 *Bill Viola* (Whitney Museum of American Art, 1997), p. 107.

5 Ibid., p. 143.

6 'Statement, 1989', in B. Viola, *Reasons for Knocking*, p. 173.

7 Ibid., p. 174.

8 'Site Unseen: Enlightened Squirrels and Fatal Experiments', in *Reasons for Knocking*, p. 88.

9 *Bill Viola*, p. 86.

10 'Statement, 1989', p. 174.

11 *Bill Viola*, p. 143.

12 'Vegetable Memory', in *Reasons for Knocking*, p. 87.

CHAPTER 5 PP. 110 – 123

1 Lewis Carroll, *Alice in Wonderland* (Hamlyn, 1965), p. 12.

2 R. Lauter (ed.) *Bill Viola: European Insights* (Munich: Prestel Verlag, 1999), p. 330 Jean-Christophe Ammann relates that Viola witnessed a scene in Long Beach on his way back from his studio where two women were chatting near a telephone booth. He couldn't hear their conversation as his car windows were closed and the air conditioning was on. Suddenly: 'one of them held out her arms... and they embraced warmly. At that very moment, according to Bill Viola, image and movement became one, the chance meeting completed the historical picture. This incident likewise gave rise to the constellation of three woman which was to have certain consequences.'

3 See St. Luke, v.26 –56. Quotation below from The Jerusalem Bible. (Darton, Longman & Todd, 1979). The Visitation

40 *She went to Zechariah's house and greeted Elizabeth,*
41 *Now as soon as Elizabeth heard Mary's greeting*
the child leapt in her womb
42 *and Elizabeth was filled with the Holy Spirit.*
She gave a loud cry and said
"Of all women you are the most blessed and blessed
is the fruit of your womb"
43 *Why should I be honoured with a visit from the*
mother of my lord? For the
44 *moment your greeting reached my ears the child*
in my womb leapt for joy,
45 *Yes, blessed is she who believed that the promise*
make her by the lord would be fulfilled.
The Magnificat
46 *And Mary said*
My soul proclaims the greatness of the lord
and my spirit exults in God my saviour...
because he has looked upon his lowly handmaiden
4 On the concept of the mise-en-abyme, see A. Gide,
Journal, 1889–1939 (Librairie Gallimard, 1951), p. 41.
5 T-H Borchert, *The Age of Van Eyck: The Mediterranean
World and Early Netherlandish Painting* (Thames &
Hudson, 2002), Catalogue 61, p. 247.
6 In response to my questions on performers
and scripting Viola responded: 'As with most of my
work with actors since *The Greeting* (this was the
first one), we held auditions. I videotaped these try
outs and made the decision later. I wanted an older
woman, keying off Saint Anne. [Viola surely means
St. Elizabeth here – JW], Mary's older cousin in
The Visitation. I wanted the arriving woman to be
younger, and to be pregnant. The third woman was
not visualized as precisely. The shock for me about the
casting was that the actors needed a story. I don't work
with this specifically since what I am after is more
submerged and unconscious, something that has
always been very concrete and real for me. So with
the help of my production manager Karin Stellwagen,
we came up with a script of sorts, giving the three
women names and a story to provide motivations for
their characters' actions and reactions. This was very
difficult for me. I tend to do it more often now when
it is required in a specific piece to give the performers
something to grab onto'. Correspondence with Jean
Wainwright, September 2003.
7 Viola often works with the same performers. In *The
Greeting*, Bonnie Snyder is the older 'Elizabeth', Angela
Black 'Mary' and Susanna Peters the blonde woman in
the middle. When Viola was working on *The Quintet
of the Astonished* he got Susanna Peters as well as
performance artist Weba Garretson – who he has often
worked with – to coach him on directing the actors.
8 Elizabeth Pilliod suggests that Bonaccorso Pinadori
provided the colours for Pontormo's *Visitation* as the
family pursued 'a highly lucrative trade providing
artists materials, spices wax and other necessities in
Florence'. She also suggests that Pontormo's friends
and family participated in the confraternity of St.
Sebastian which Pinadori entered in 1528, becoming
Pontormo's patron. See E. Pilliod, *Pontormo Bronzino
Allori. A Genealogy of Florentine Art* (Yale University
Press, 2001), p. 91.
9 Mariotto Albertinelli *Visitation* 1503, Oil on wood,
Uffizi, Florence. Albertinelli ran a workshop with Fra
Bartolomeo. In this 'Visitation' the women embrace

under an arch of perfect perspective. For a full
description of Pontormo's *Visitation* from 1514-16 see
F. M. Clapp, *Jacopo Carucci da Pontormo – His life and
work* (Yale University Press, 1916).
10 See, for example, Vincent Cronin *The Flowering of
the Renaissance* (Pimlico, 1992), p. 165:'Pontormo
makes no attempt to evoke the women's emotion, but
instead concentrates on their voluminous draperies,
making a beautiful pattern of four dominant colours...'
11 Walsh contends that these are women 'of our time
who could be meeting in a college town'. 'Emotions
in Extreme Time', p. 30.
12 Viola states that he discussed the perspective of
the work 'a lot' with Harry Dawson, his cameraman,
and they realized that it would be impossible to re-
stage the painting with a single lens. 'For the top half
of the picture you would need to use a telephoto lens
that flattens the figures so they stack up against each
other, and for the bottom half, from the women's
waists down, you would need a wide angled lens so
that the space bows out and away from you. We
realised that the picture has multiple geometries –
which gives it that strange subjective quality.' Quoted
from an interview with Martin Gayford, 'The Ultimate
Invisible World', *Modern Painters* (Autumn 2003) 16:3,
p. 22. This was not the first time that Viola worked
with Dawson – he collaborated with him for *Arc of
Ascent* in 1992, his first work using a high-speed
35mm film camera.
13 See J. Gage, *Colour and Culture: Practice and
Meaning from Antiquity to Abstraction* (Thames &
Hudson, 1993) p. 129. Gage notes that scarlet was
still by far the most expensive cloth in 15th century
Tuscany. 'In a florentine dyer's manual, crimson was
characterized as "the first and most important colour
that we have" so that it was specifically cited in the
Florentine Sumptuary Regulations of 1464.
14 See M. P. Merrifield [1849], *Original Treatises
dating from the XIIth to the XVIIIth centuries on the
arts of painting* (Dover, 1967); M. Barasch *Light and
Colour in the Italian Renaissance Theory of Art* (1978);
Gettens, Feller & Chase 'Vermillion and Cinnabar'
in *Studies in Conservation* 17, 1972, pp. 45–69;
Feller, R.L. *Artists' Pigments: A handbook of their
history and characteristics*, 1986.
15 *The Passions*, p. 31. See also note 6.
16 *Reasons for Knocking*, p. 241.
17 Ibid.
18 A. Taubin '****' in C. MacCabe, M. Francis &
P. Wollen (eds.) *Who is Andy Warhol?* (BFI, 1997)
19 'Mirror Images: Douglas Gordon Interviewed by
Jean Wainwright, in *Art Monthly* 262, Dec 02–Jan 03,
pp. 1–4. Gordon discusses time in relationship to this
work: from watching Alastair MacLennon performing
and moving 'very slowly' to seeing a Barnett Newman
painting which had a 'very big influence on making
cinematic pieces... Rather than look at it I timed how
long it would take to walk from one end to the other.
This was my first realisation that time and art had a
very close connection'
20 *Culture of Time and Space*, p. 11.
21 For a treatment of painting's (specifically Cubism's)
relationship to Bergson, see M. Antliff, *Inventing
Bergson: Cultural Politics and the Parisian Avant-Garde*
(Princeton University Press, 1993).

22 This idea is developed by Chris Townsend in a forthcoming essay on the relationship of Duchamp's *Nude Descending a Staircase* to the work of Marey and Muybridge.

23 There were five works installed in Venice each one in a separate space: *Hall of Whispers, The Veiling, Interval, Presence* and *The Greeting*.

24 According to Viola: 'The scarf or shawl on Bonnie Snyder was a cooler red, more towards saffron or wine color, than Angela's orange dress. If you see the original master, or now the new DVD version (as opposed to the older analog LaserDisc) you will better distinguish the two hues. There is a lighting change when Angela comes onto the scene. We had a warm toned narrow spot that came up as she entered and raked across her dress. It is subtle but noticeable, but I don't think it had much of an effect on Bonnie's shawl. Lizzie Gardiner, our wardrobe person (she did the Australian film *Priscilla, Queen of the Desert*), was working with different weights in the clothing: Susanna Peters was wearing the heaviest clothes so there would be the least movement and "life" in her; Angela had the lightest cotton dress that moved; and Bonnie had medium weight clothes except for the scarf which was the lightest (almost sheer) of all to get the most movement out of it.' Correspondence with Bill Viola, September 2003.

25 Viola doubled and staggered the second speaking of the words in time: 'After the first phrase, "Can you help me?" the repeat of this comes in again as the voice continues "...I need to speak with you right away." The overlay makes it difficult to make out the sentence. I wanted it to be unclear and dreamlike – like partially remembered speech – felt, not necessarily consciously understood.' Correspondence with Bill Viola, September 2003.

26 J. Berger, 'That Which is Held', in *Keeping a Rendezvous* (Granta Books, 1992), p. 28.

27 See *Reasons for Knocking*, p. 177. Viola, in conversation with Michael Nash, talks of his frustration that more people aren't thinking of the great 'themes in life as being in the domain of art'.

28 Ibid., p. 232, a note made on 27 June 1989.

29 Viola mentions the fluidity of time on several occasions in *Reasons for Knocking*. He also mentions it in conversation with Jean Wainwright, *Audio Arts Magazine*, 19:3, 19:4, tape 2, side 3.

30 *Going Forth by Day*, p. 97. John Hanhardt, in discussion with Viola, talks at length about his practice with particular reference to time and painting.

CHAPTER 6 PP. 124 – 141

1 Campus's installation drawing for *Kiva* is reproduced in *Peter Campus: Video-Installationen, Foto-Installationen, Fotos, Videobänder* (Kölnischer Kunst-verein, 1979), n.p. Viola acted as one of Campus's assistants during the early 1970s.

2 Viola specifies the dimensions of the larger room as at least 9m x 9m, and the smaller as 180 x 150 x 170 cm.

3 A history of the imprisonment of St. John can be found in G. Brenan, *St. John of the Cross: His Life and Poetry* (Cambridge University Press, 1973) pp. 26–38. The sole light in the room initially came from 'a loop-hole three fingers wide and set high in the wall'.

4 A possible relationship between the American mystical tradition and contemporary culture had been explored in video by Dan Graham, in *Rock My Religion*, as early as 1976.

5 Viola is alluding here to an anonymous English mystical text of the fourteenth century.

6 J. Zutter, 'Conversation with Bill Viola', in M. L. Syring (ed.) *Bill Viola: Unseen Images* (Kunsthalle Düsseldorf, 1993) pp. 103–104. My italics.

7 St. John of the Cross, 'Songs of the soul in intimate union with God', in *St. John: Life and Poetry*, p. 163.

8 St. John of the Cross, 'Verses of the soul that yearns to see God', in *St. John: Life and Poetry*, p. 171.

9 St. John of the Cross, 'Verses written on an ecstasy', in *St. John: Life and Poetry*, p. 179.

10 We might want to consider here as an aside that might lead to other, equally productive, readings of subjectivity and space in installation art of this kind, Lacan's formulation *Jamais tu ne me regards la où je te vois* ('You never look at me from the place where I see you') (*Le Séminaire de Jacques Lacan: Livre XI, Les quatre concepts fondamentaux de la psychanalyse* (Éditions du Seuil, 1973), p. 95) as a model for the kind of misrecognition he posits in *The Mirror Stage*. Applied to self-cognition, we might reformulate the maxim as 'I never look at me from where I see myself'.

11 Page from the artist's notebooks displayed in the reading room at the exhibition of Viola's works at the Stedelijk Museum, Amsterdam, 1998.

12 See D. Thornton, *The Scholar in his Study: Ownership and Experience in Renaissance Italy* (Yale University Press, 1997) for an outstanding historical overview of this subject.

13 The simplistic view, and the target for easy assault, is of course Jacob Burkhardt in *Civilisation of the Renaissance in Italy*. The more considered critique, that seeks to embed theories of subjectivity within historical circumstance, while eschewing theories of rupture that see new identities emerge as a consequence of every technological innovation, can be found in the work, *inter alia*, of Hans Baron, Francis William Kent, and Natalie Zemon Davis.

14 J-L. Nancy 'Introduction', in E. Cadava, P. Connor, & J-L. Nancy, (eds.) *Who Comes After the Subject?* (Routledge, 1991), p. 4.

15 Along with St. John and the Carmelites, I'm thinking here of those models of 'failed' subjectivity that produce privileged political positions grounded in sexual difference, in particular J. Butler, *Bodies that Matter: On the Discursive Limits of "Sex"* (Routledge, 1993) and L. Bersani, *Homos* (Harvard University Press, 1995), and, with U. Dutoit *Caravaggio's Secrets* (M.I.T. Press, 1998), which I would suggest are premised upon such an oversight.

16 F. Lebrun, 'The Two Reformations: Communal Devotion and Personal Piety' in R. Chartier (ed.), *A History of Private Life, Vol. III: Passions of the Renaissance* (Harvard University Press, 1989), p. 69.

17 *St. John: Life and Poetry*, p. 25.

18 *St. John: Life and Poetry*, p. 101.

19 K. Wettengl, '*Room for St. John of the Cross, 1983*' in R. Lauter (ed.) *Bill Viola: European Insights*

(Prestel, 1999), p. 259. Where it seemed more felicitously phrased I have substituted the English translation from the German of St. John's poetry, cited by Wettengl from the German edition of St. John's works, with L. Nicholson's direct translations from Spanish into English. (The poem in question is in *St. John: Life and Poetry*, pp. 179–181.)

20 Brenan remarks that St. John's friends had 'given him up for dead', and the poems would suggest that Juan certainly sees himself as having 'died' within the space.

21 J. Derrida, *Aporias* (Stanford University Press, 1993), p. 20.

22 Cited in 'The Two Reformations', p. 76.

23 *Aporias*, p. 6.

CHAPTER 7 PP. 142 – 159

1 E mail from Bill Viola, 3rd September, 2003

2 Ibid.

3 Ibid.

4 Ibid.

5 'Bill Viola interviewed by John G. Hanhardt', in *Going Forth by Day*, p. 90.

6 'Scenographic realism' is a distillation of naturalism or auditory reality. Therefore, a realistic soundscape will be constructed of the archetypes and keynote signifiers of that particular naturalistic location. All other incongruous and non-identifiable sounds are discarded.

7 Any dramatic film, play or television programme that is set in a country with a warm climate will use the sound of cicadas (crickets and night insects) for the exterior night time scenes. It has become a narrative shortcut.

8 E mail from Bill Viola.

9 Viola and Hanhardt, p. 91.

10 E mail from Bill Viola.

11 Viola and Hanhardt, p. 91.

12 E mail from Bill Viola.

13 Viola and Hanhardt, p. 98.

14 E mail from Bill Viola.

15 Ibid.

CHAPTER 8 PP. 160 – 179

1 *Reasons for Knocking*, pp. 282–3.

2 Ibid, p. 244.

3 R. H. Sharf, 'The Zen of Japanese Nationalism', in D. Lopez (ed.), *Curators of the Buddha* (University of Chicago Press, 1995), pp. 117–23.

4 M. Eliade, *The Encyclopedia of Religion* (Macmillan Publishing Co., 1987), volume 10, p. 456. Also quoted in Sharf, p. 124.

5 W. Barrett (ed.), *Zen Buddhism: Selected Writings of D. T. Suzuki* (Doubleday Anchor Books, 1956), p. 9.

6 Ibid., p. 7.

7 Sharf, p. 140.

8 See two seminal books: D. T. Suzuki, *Zen and Japanese Culture* (Princeton University Press, 1959) and Shin'ichi Hisamatsu, *Zen and the Fine Arts* (Kodansha International, 1971).

9 *Reasons for Knocking*, p. 79.

10 J. Fontein and M. L. Hickman, *Zen Painting and Calligraphy* (Museum of Fine Arts, Boston, 1970), no. 41, pp. 97–9.

11 M. Murase, *et al*, *The Written Image: Japanese Calligraphy and Painting from the Sylvan Barnet and William Burto Collection* (Metropolitan Museum of Art, 2002), no. 40, pp. 138–9.

12 *Zen Painting and Calligraphy*, p. 97.

13 B. Phillips (ed.), *The Essentials of Zen Buddhism: an anthology of the writings of Daisetz T. Suzuki* (E.P. Dutton & Co., Inc., 1962), pp. 423–24.

14 Ibid., p. 438.

15 K. Oldmeadow, *Traditionalism: Religion in the light of the Perennial Philosophy* (Sri Lanka Institute of Traditional Studies, 2000), p.viii.

16 Ibid., p. 173.

17 Ibid., p. 33.

18 D. T. Suzuki, *The Field of Zen* (The Buddhist Society, 1969), p. 62.

19 *The Passions*, pp. 206–7.

20 Ibid., p. 212.

21 A. C. Danto, *The Madonna of the Future: Essays in a Pluralistic Art World* (University of California Press, 2001), p. 106.

22 M. Hentschel, et al., *Bill Viola: Stations* (Wurttembergischen Kunstverein, 1996), p. 55.

23 Ibid., pp. 9–23.

24 *The Passions*, pp. 33–7; 66–75.

25 Ibid., pp. 46–7; 118–23.

26 *Going Forth by Day*.

27 *The Passions*, p. 233.

28 H. Inagaki, *A Dictionary of Japanese Buddhist Terms* (Heian International, Inc.) pp. 66–84.

29 *The Passions*, pp. 146–55.

30 Ibid, p. 217.

31 *The Tempest*, Act 1, Scene 1, ll.399–404

219

CHAPTER 9 PP. 180 – 195

1 'The Sound of One Line Scanning', in *Reasons for Knocking*, pp. 154–5.

2 See P. Sheldrake, *Spaces for the Sacred: Place, Memory and Identity* (SCM Press, 2001), Chapter 2.

3 See J. G. Davies, *The Secular Use of Church Buildings* (SCM Press, 1968), Chapter 3.

4 See A. Rouet, *Liturgy and the Arts* (Liturgical Press, 1997), p.105. 'Ecclesial space also denies itself in a way. The hope which Christ gave to the Church cannot be contained in any limited geographical spot. The Good News drives us beyond. The holiness of the person of Christ is shared, exteriorized, and communicated... Christianity is a religion without spatial limits.'

5 See E. Yarnold SJ, *The Awe-Inspiring Rites of Initiation: Baptismal Homilies of the Fourth Century* (St. Paul Publications, 1971), pp. 25–7.

6 See F. W. Dillistone, *The Power of Symbols* (SCM Press, 1986), pp. 65–7.

7 M. Eliade, *Patterns in Comparative Religion* (Sheed and Ward, 1979), p. 188.

8 'Déserts', *Reasons for Knocking*, p. 262.

9 Julian of Norwich, *Revelations of Divine Love*, translated by Clifton Wolters (Penguin, 1966) p. 68.

10 T. Roszak, *Where the Wasteland Ends: Politics and*

Transcendence in Post Industrial Society
(Faber and Faber, 1973) pp. xx–xxi.
11 M. A. Zeitlin, 'Continuities in the Work of Bill
Viola', in *Bill Viola: Buried Secrets*. (Arizona State
University Press, 1995), p. 56.
12 B. Viola, 'On Transcending the Water Glass',
in L. Jacobson (ed.), *CyberArts: Exploring
Art and Technology* (Miller Freeman Inc., 1992),
pp. 3–5.
13 See B. Viola, 'Will There be Condominiums in
Data Space?', in *Video 80*, no. 5, Fall 1982, pp. 36–41.
14 See T. Hawkes, *Structuralism and Semiotics*
(Methuen & Co, 1977), pp. 11–15.
15 'The spirit of Christian iconoclasm is, indeed,
pervasive, and if it does not lead to the actual
banning of images it creates an almost universal
attitude of suspicion and denigration.' G. Pattison,
Art, Modernity and Faith: Towards a Theology of Art
(Macmillan, 1991), p.10.
16 See, R. L. Hart, *Unfinished Man and the
Imagination: Toward an Ontology and a Rhetoric
of Revelation* (Scholars Press, 1985), pp. 37–9.
17 'Putting the Whole Back Together', p. 282.
18 V. Cunningham, *In the Reading Gaol: Postmodernity,
Texts and History* (Blackwell, 1994), p. 402.
19 'Will There be Condominiums in Data Space?',
p. 41.
20 W. Benjamin, 'Theses on the Philosophy
of History', in *Illuminations*, p. 249.
21 See P. Baelz, *The Forgotten Dream: Experience,
Hope and God* (Mowbrays, 1975).
22 See L. Steinberg, *The Sexuality of Christ in
Renaissance Art and in Modern Oblivion*.
(University of Chicago Press, 1996),
pp. 20–21, p. 106.
23 See *The Power of Images*, Chapter 2,
'The God in the Image'.
24 J. Derrida, *Memoirs of the Blind: The Self-Portrait
and Other Ruins*, translated by P-A Brault and
M. Naas (University of Chicago Press, 1993), p. 129.

CHAPTER 10 pp. 196 – 212
1 Arizona State University Art Museum.
'Bill Viola: Buried Secrets'. ASU Art Museum
website, Tampa, Arizona.
http://herbergercollege.asu.edu/museum/viola.htm
2 E. Asse, V. Fishkin, D. Gutov, and V. Misiano,
'Reason Is Something the World Must Obtain
Whether It Wants It or Not', in *Catalogue
of the Russian Pavilion at 46th Venice Biennale*,
1995, p. 3.
3 'La documentazione del fatto sociale'. Conversation
with Viktor Misiano, Moscow, 11 September 2003.
My translation.
4 Conversation with Dmitry Gutov, Moscow,
17 July 2003.
5 *Buried Secrets*.
6 Conversation with Gutov.
7 'The Porcupine and the Car', in *Reasons for Knocking*, p. 61.
8 Ibid.
9 Ibid.
10 Nina Zaretskaya, programmatic manifesto
on the TV Gallery website.
http://www.tvgallery.ru/en/about.htm

11 Interview with Nina Zaretskaya, Moscow,
25 July 2003.
12 Conversation with Evgenya Kikodze, Moscow,
29 June 2003.
13 Clayton Campbell, 'Bill Viola. The Domain
of the Human Condition', in *Flash Art* no 228,
January – February 2003.
14 Tatyana Danilova, 'Video Art in America', in *TV
Review*, Issue n. 2, Moscow, 1993. My translation.
15 Ibid.
16 Bill Viola. 'Artist's Statement' for the international
conference 'Contemporary Photography and Video
Art', The State Russian Museum, St. Petersburg,
June 1996. The State Russian Museum Archive.
17 'Statement 1989', p. 173.
18 W. Somerset Maugham, *The Moon and Sixpence*
(Moscow, 2002), p. 79.
19 'Statement 1989', p. 172.
20 'Statements 1985', p. 152.
21 Gia Rigvava's *They Are All Lying* was the first
Russian single-channel video to be shown at an
official exhibition: the Guelman Gallery Exhibition
'Dedicated to the Russian Deputies VII Congress',
2–11 April 1993, Moscow.
22 J. Yood, in C. Strickland, 'You won't find these
videos at Blockbuster', The Christian Science
Monitor website, Boston.
http://www.csmonitor.com/2002/1213/p13s02-
alar.html.
23 J. McDonald, in 'You won't find these videos'.
24 Ibid.
25 'History, Ten Years and the Dreamtime', p. 130.
26 A. Borovsky, in *St. Petersburg Review*,
June 1996, p. 28.
27 K. Klaasmeyer, 'Video Visions a Provoking Canvas',
in *The St. Petersburg Times*, 28 August 1996.
28 'Deeply Absorbed In This Art' *Smena-Weekend*,
30 August – 5 September 1996, p. 21. My translation.
29 *St. Petersburg Review*, p. 32.
30 Interview with Olesya Turkina, St. Petersburg, 12
September 2003.
31 'Video Visions'.
32 *Smena-Weekend*.
33 Interview with Turkina.
34 E. Degot, 'High Class Video Salon', in *Kommersant*,
June 1996. My translation.
35 *Smena-Weekend*.
36 A. Borovsky, in M. Kuzmin 'Installation,
this is not a Sweet Word', *Szena*, 26 June 1996.
37 'The Porcupine and the Car', p. 70.
38 Ibid.
39 'Violence and Beauty', p. 13.
40 'History, Ten Years and the Dreamtime', p. 128.
41 Ibid., p. 123.

LIST OF ILLUSTRATIONS & CREDITS

NOTES ON CONTRIBUTORS

CYNTHIA A. FREELAND is Chair and Professor of Philosophy at the University of Houston. She has published on subjects in aesthetics, film theory, feminism, and ancient philosophy and is the author of *But Is It Art?: An Introduction to Art Theory* (2001). Her current project is a book for OUP on fakes, forgeries, and authenticity.

OTTO NEUMAIER is Associate Professor of Philosophy at the University of Salzburg, where his main areas of research are ethics, aesthetics, and philosophical anthropology. He is co-editor of two journals, *Conceptus* and *Frame: The State of the Art*. His publications include *Biologische und soziale Voraussetzungen der Sprachkompetenz* (1979), *Mind, Language and Society* (1983), *Wissen und Gewissen* (1986), *Angewandte Ethik im Spannungsfeld von Ökologie und Ökonomie* (1994), *Vom Ende der Kunst: Ästhetische Versuche* (1997), *Applied Ethics in a Troubled World* (1998), *Ästhetische Gegenstände* (1999), *Satz und Sachverhalt* (2001) and *Philosophie im Geiste Bolzanos* (2003).

JONATHAN LAHEY DRONSFIELD is the Director of the Centre for Contemporary Art Research at the University of Southampton, where he lectures in the philosophy, theory, and history of art. He has published numerous essays, primarily on the relation of ethics to art and aesthetics, and is currently writing two books, one on art and time and the other on responsibility.

DAVID MORGAN is Duesenberg Professor in Christianity and the Arts at Valparaiso University (Indiana). He is the author of *Visual Piety: A History and Theory of Popular Religious Images* (1998), *Protestants and Pictures: Religion, Visual Culture, and the Age of American Mass Production* (1999) and *The Sacred Gaze: Religious Visual Culture in Theory and Practice* (forthcoming 2005).

JEAN WAINWRIGHT is Senior Lecturer in Cultural Studies at Kent Institute of Art and Design. She has published numerous interviews on contemporary artists, including chapters in recent monographs on Tom Hunter and Tracey Emin. She is a regular contributor to *Art Monthly*, *PLUK*, *Contemporary* and *Audio Arts*. She is currently completing her doctorate on Andy Warhol's Audio Tapes and writing a book on art and fame.

CHRIS TOWNSEND is Lecturer in the Department of Media Arts, Royal Holloway, University of London. He is the author of

Rapture: Art's Seduction by Fashion, 1970–2001 and co-editor of *The Art of Tracey Emin*. He is currently editing a companion volume to this book on the work of Rachel Whiteread.

RHYS DAVIES is Lecturer in Creative Sound Design in the Department of Media Arts, Royal Holloway, University of London. He has worked professionally as a Theatre Sound Designer and Commercial Composer since 1987. Between 1993 and 1999, he was visiting tutor in Theatre Sound Design and Multi-media in Performance at the Drama Department, Goldsmiths College.

ELIZABETH TEN GROTENHUIS is Professor (Emerita) for Asian/Japanese Art History at Boston University and Associate in Research at the Reischauer Institute of Japanese Studies at Harvard University. Her many publications include *Japanese Mandalas: Representations of Sacred Geography* (1999) and *Along the Silk Road* (editor; 2002).

DAVID JASPER is Professor of Literature and Theology at the University of Glasgow. He has taught at the universities of Durham and Iowa, and has published extensively in the field of literature, theology and the arts. He has recently published *The Bible and Literature* (with Stephen Prickett) and *Religion and Literature* (with Robert Detweiler). His latest book, *The Sacred Desert*, is to be published early in 2004.

ANTONIO GEUSA is a PhD candidate in the Department of Media Arts, Royal Holloway, University of London, dealing with the emergence of video art in post-Perestroika Russia. He has published in the Guggenheim Museum newsletter, and curated two exhibitions of contemporary Russian video art in Moscow.

ACKNOWLEDGMENTS

The publishers and authors would like to thank Bill Viola and Kira Perov for their support of this project, and their assistant Ann Do; also Graham Southern, Harry Blain and Pernilla Holmes at Haunch of Venison; Joe Tougas for his help to Otto Neumaier; and Ylva-Linn Liliegren for her assistance to Chris Townsend.

Special thanks go to Kira Perov for supplying the illustrative material and for checking over the layouts and text throughout the production of this book.

INDEX

223

INDEX